MASTDLIFE

HOTOGRAPHY

HARD GARVEY-WILLIAMS

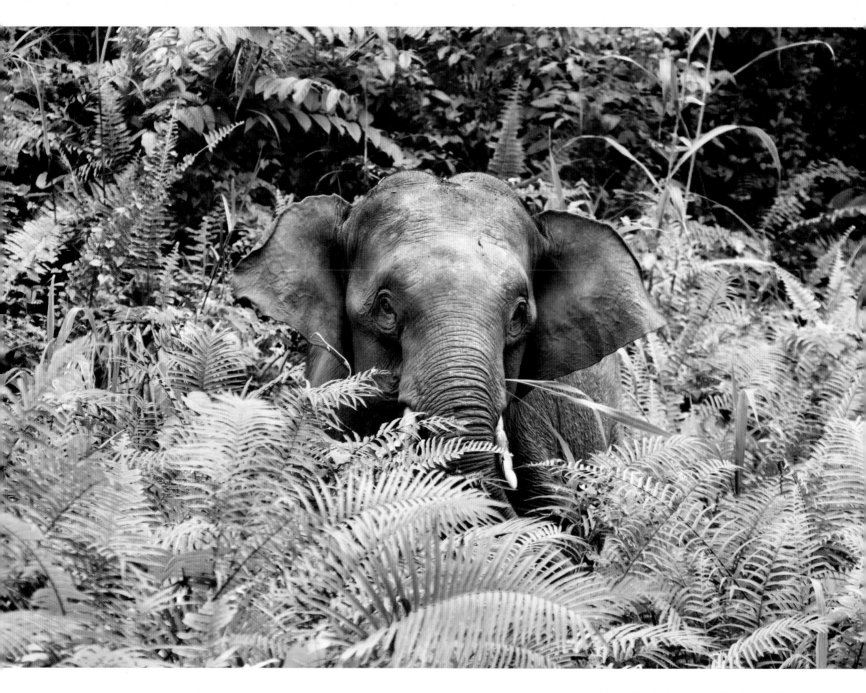

Above: I could have zoomed in closer on this pygmy elephant in Borneo, but I feel that it benefits from the inclusion of a little of its dense forest habitat.

Focal length: 240mm

Aperture: f/5.6

Shutter speed: 1/320 sec.

ISO: 320

MASTERING **WILDLIFE**

PHOTOGRAPHY

RICHARD GARVEY-WILLIAMS

AMMONITE
PRESS

First published 2015 by
Ammonite Press
an imprint of AE Publications Ltd
166 High Street, Lewes, East Sussex, BN7 1XU, United Kingdom

ISBN 978-1-78145-086-4

British Library Cataloging in Publication Data: A catalog record of this
book is available from the British Library.

Editor: Chris Gatcum
Series Editor: Richard Wiles
Designer: Robin Shields

Typeface: Helvetica Neue
Color reproduction by GMC Reprographics
Printed in China

Right: This portrait of a waterbuck is one of a series
that I produced partly as a reaction to the concept of
trophy collection. They are technically clean shots of fine
specimens, gazing at us directly as would wall-mounted
trophies. This is further supported by the "vintage" style of
the processing, which gives them an aged look.

Focal length: 800mm

Aperture: f/5.6

Shutter speed: 1/200 sec.

ISO: 160

Contents

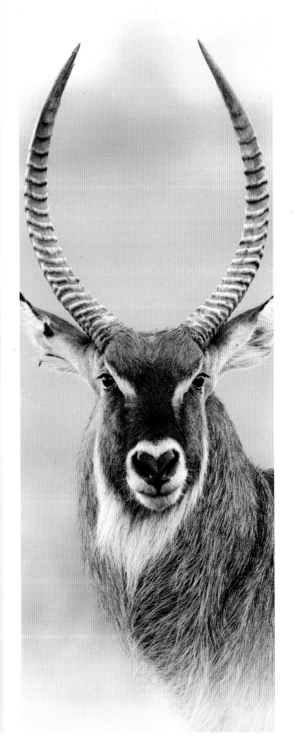

Introduction

It is an exciting time to be a wildlife photographer. Quality equipment is more affordable than ever, and we have opportunities to travel to all kinds of locations and reserves where wildlife is relatively habituated to the proximity of humans. Because of this, the bar is constantly being raised with regard to what images are regarded as being "a cut above the average."

Wildlife photography is a vast subject and whole books could be devoted to the various sub-topics. As the title suggests, this book aims to look at the process of taking your wildlife photography on to the next level to produce really special imagery. Although technical considerations are covered, the emphasis will remain on the skills required for creating photographs with more impact. As you will see, the key factors that determine the merit of a photograph tend to come down to the variables of viewpoint, lighting, composition, and timing.

There are many wildlife photographers who are akin to the hunters of old, replacing guns with long lenses—it is interesting that the terms "shooting," "shoots," and "shots" are used so widely in the photographic world. Some photographers simply strive to amass as many technically clean "shots" of as many species as possible, collecting them like trophies. Much of the thrill of this sort of photography does, of course, come from meeting the challenge of getting a sharp, reasonably tightly framed photograph—"bagging a good shot."

This is all very well, but a lengthy slideshow of these images probably wouldn't capture our imagination for long. Most of us want to convey something more—something about how we feel or relate to the wildlife and what we experienced on that occasion. When we open up to more than just bagging a shot, we find ourselves

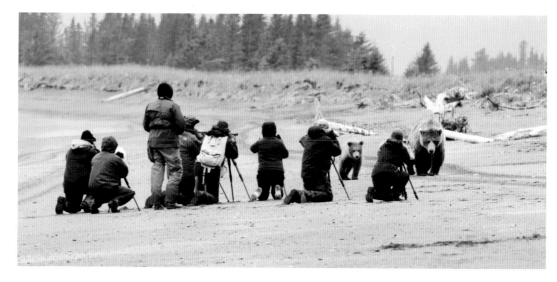

Above: In parts of many reserves wild animals are now relatively accustomed to the attentions of photographers, as with these grizzly bears in the southern part of Lake Clark National Park in Alaska.

experimenting with more creative approaches and also attempting to reveal something about the life of the animal in its surroundings.

So, what are we striving for? Most strong images tend to inform us and effectively convey a message or feeling. They are far more than just "record" shots. They may even do well in the Wildlife Photographer of the Year (WPOTY) competition, which is claimed to be the world's most prestigious nature photography competition. Plenty of practice will enable you to consistently get technically good shots, but here we will look at the principles that will enable you to get technically good shots that are also compelling viewing.

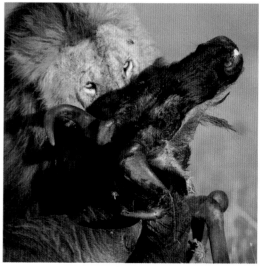

Above: The soft, warm lighting, the positioning of the lion's and the wildebeest's head, and the timing that catches the lion gazing directly at the camera all help with the impact of this photograph.

Focal length: 500mm

Aperture: f/4.5

Shutter speed: 1/640 sec.

ISO: 250

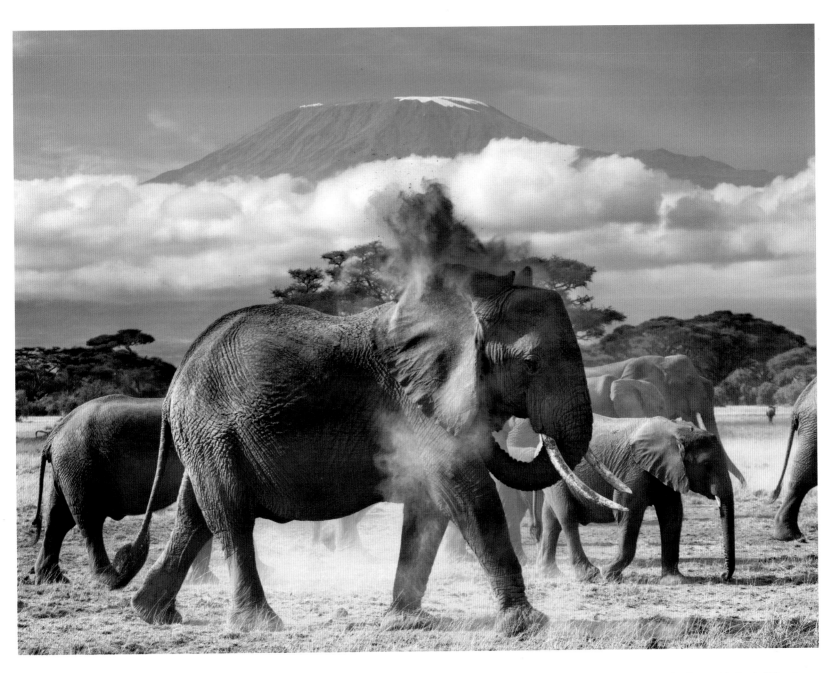

Above: As this elephant herd passed in front of Mount Kilimanjaro, with its shroud of clouds and diminishing summit glacier, I was ready to catch any interesting individuals. Fortunately, this one had read the script and timed its dust bath to perfection. This photograph was shortlisted in the WPOTY competition, 2014.

Focal length: 100mm

Aperture: f/10

Shutter speed: 1/100 sec.

ISO: 320

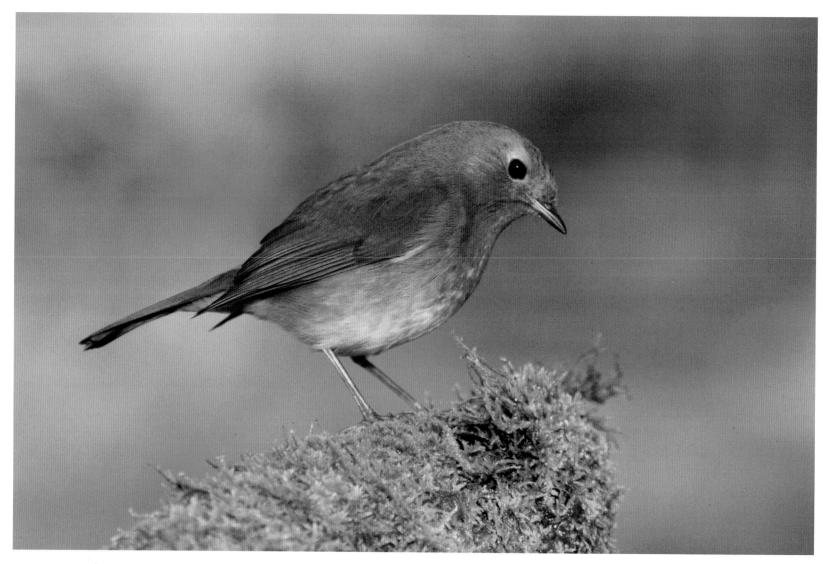

Intention & Message

Photography is an art and form of expression, so there is no best or correct way to photograph any given subject. However, this doesn't mean that we can't strive to express what it is we want to convey more effectively and efficiently.

Throughout the book I will be encouraging you to keep returning to the question of what it is you are trying to do through your photography; what is the message you are trying to convey both through your photography more generally and through each individual photograph? If you can gain some clarity on this, it will make the process

of realizing these intentions much easier. It may be that you simply want to depict the anatomy of the animal in question for the purposes of study and comparison. However, for more emotive imagery, most of us want to express something rather more both about the animals and our relationship with them and the feelings they engender in us.

As wildlife photographers, we will, of course, be deeply fascinated by the natural world, so we are already halfway there—we have a passion to express. What often holds us back is failing to exercise our imaginations and artistry to convey

Above: A typical depictive nature shot, showing a robin clearly and sharply, and in this case, in profile.

Focal length: 376mm

Aperture: f/6.3

Shutter speed: 1/200 sec.

ISO: 250

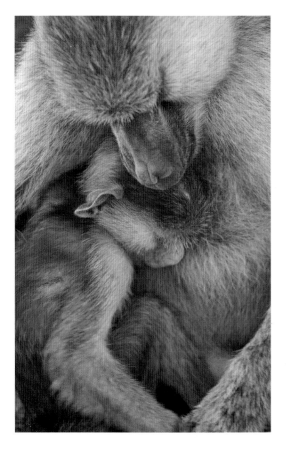

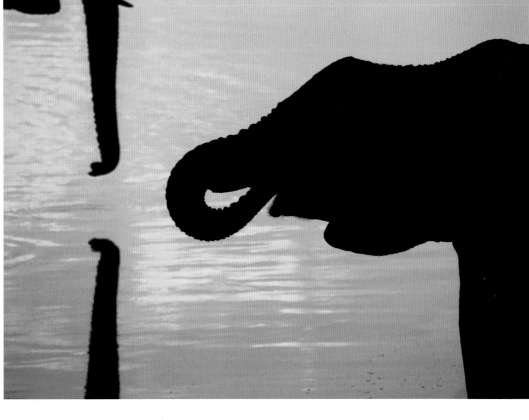

Above: This image tells us little about the anatomy of the yellow baboon, but expresses the nurturing relationship between a mother and her infant.

Focal length: 340mm

Aperture: f/7.1

Shutter speed: 1/50 sec.

ISO: 250

Above: You don't always need a lot of detail to relay messages about your subject matter; sometimes carefully composed graphic shapes and colors can say a lot more. I knew that a drinking elephant will slowly raise its head, so fired off several shots to make sure I captured one with her head aligned horizontally to meet the gap between the distant trunk and its reflection.

Focal length: 330mm

Aperture: f/7.1

Shutter speed: 1/400 sec.

ISO: 400

this sense of a relationship with wild creatures.

A good photograph will often originate in the imagination of the photographer and persistence, patience, and focus are often required before it is eventually realized. During this process, each of us will impart something of ourselves into our images, making them to some degree unique. I have been on safari traveling in the same vehicle as other photographers with very similar camera equipment to mine, and yet when we come to look at each other's images afterward, we are invariably surprised at how different they all are. This is because we are not all drawn to the same things: we have individual "visions" and "styles."

Seeing our subject matter as sentient beings rather than robotic objects is, I believe, helpful, as it enables us to more openly engage with (and relate to) our subjects, giving us more to say about them. It also ensures that we don't do them harm through our endeavors, which leads to an issue that it is important to discuss at the outset—ethics.

Ethical Considerations

Purists in the scientific community will often caution naturalists against anthropomorphism. However, a measure of this is probably unavoidable since we are relational beings, always on the lookout for an individual connection with others.

As wildlife photographers, we have to acknowledge that many photographs actually succeed because of anthropomorphism. Through our tendency to bestow upon the animal the emotions we think we would feel in their position, these images incite a strong emotional response. We can harness this tendency to good effect when we capture a fleeting quizzical or sad expression on an animal's face, for example. Even though it possibly bears no relationship to what the animal is actually feeling, it can be enough to transform a photograph.

As most of us are drawn to wildlife photography through a love of the natural world, we will hopefully be careful to avoid harming what we love. However, I do hear some horrendous stories, where certain individuals—perhaps in their quest for recognition and fame—will go beyond what is acceptable, causing stress or injury to animals or damage to their environment.

One of my guides in East Africa once told me of a photographer client who had persistently urged him to chase hyenas in the vehicle until they were so exhausted they stopped and turned to face him—all for a shot of a panting, drooling, exhausted hyena! I have also witnessed (from a distance) a situation where a hunting cheetah had its attempts to approach a herd of wildebeest thwarted by the over-zealous attentions of tourist vehicles. This could have meant life or death for the nearby cubs.

There is also the debatable issue of netting certain invertebrates such as damselflies and butterflies to refrigerate them so they can be placed on a chosen flower or stem and photographed in their semi-torpid state as they spread their wings in their attempts to warm up. If not done with care, this could be very disruptive to that individual's chances to thrive and reproduce.

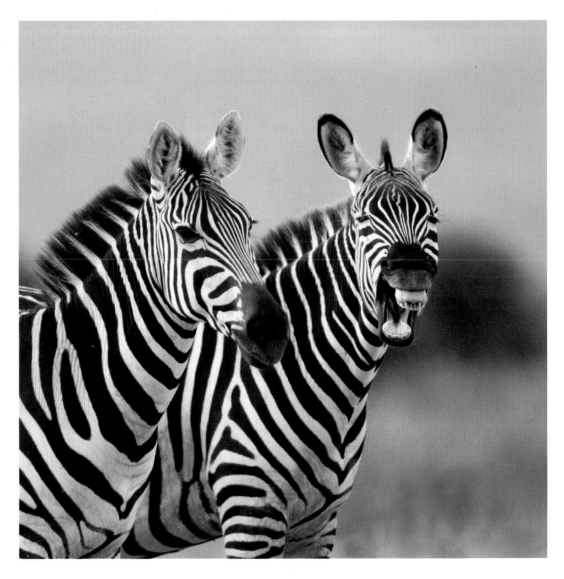

To reach exotic wildlife invariably involves some traveling. So, as conscientious photographers, you might consider measures to off-set some of the consequent carbon emissions. You might also consider how your trip itineraries could be altered to maximize the photographic potential for each flight that you take, or to reduce the amount of road travel within the areas you visit.

There is undoubtedly a positive side to overseas trips involving visits to wildlife and nature reserves. It can be argued that it brings in foreign currency, helping the economies of what are often poorer countries. It also helps finance the running and protection of the parks, and it helps teach the

Above: The fact that most of us would perceive this zebra as laughing while its mate keeps a serious face enables this image to capitalize on our anthropomorphic tendencies.

Focal length: 1120mm

Aperture: f/5.6

Shutter speed: 1/640 sec.

ISO: 250

RECOMMENDATIONS

In general, don't attempt to pick up or move an animal unless you are experienced in handling that type of creature. In many cases this can also ensure your own safety!

Return the animal quickly to where you found it so that it can continue its life without disruption and risk of predation.

Extra respect is required with all types of animal that are raising their young, as there is a risk of them being abandoned if the parents become stressed. For our avian friends, nesting is a very sensitive time.

In general, your motto should be "First, do no harm"—no photograph is worth causing injury or death to an animal. Be aware of the animal's response, and as soon as you sense a level of stress arising in them, it is time to back off, pack up your equipment, and leave them alone. This is particularly important at times of famine or during breeding seasons, when you should be even more considerate.

Always try to ensure that your presence does not interfere with natural processes such as hunting, territorial disputes, nest-building, quest for shade,

and so on. In short, strive to be an invisible and passive observer, allowing life to go on around you as it would were you not there.

Remember that the use of flash can have adverse consequences. Nocturnal species have eyes designed to collect and utilize very low levels of light. This can, of course, be employed to your advantage when a tiny bit of flash is reflected from the back of the animal's eyes to produce a soft colorful glow that adds a little drama to a photograph. Using a light source can also help you to locate many species at night due to this phenomenon. However, on the downside, excessive light levels can damage the eyes of the animals, rendering them temporarily blind. This could put them in danger from predators or at a disadvantage in terms of finding food.

Be respectful of the environment, "leaving nothing but footprints" when you leave. A bit of subtle pruning of a tree to get a free view of a perch where a bird frequently settles may be acceptable, but chopping down saplings to create a path to access a site may not.

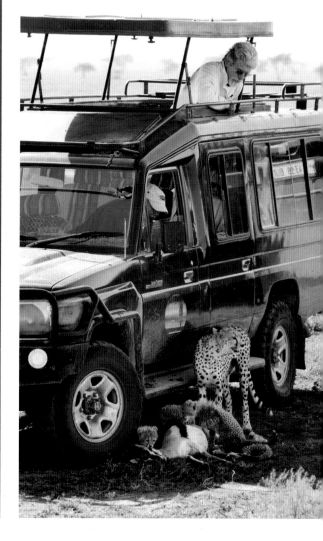

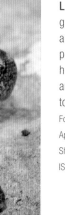

Left: I came across this sand boa on some disturbed ground on a building site in Greece and gently placed it on a rock to photograph it. When it adopted this inverted coiled posture with its blunt tail as a decoy uppermost where its head would normally be, I assumed that it must be stressed and perceiving me as an aggressor. So I gently returned it to some loose soil with plenty of cover in a safer place.

Focal length: 105mm (macro)

Aperture: f/16

Shutter speed: 1/125 sec.

ISO: 200

Above: Initially it appears as if this guide got his clients rather too close to the action! In fact, in the heat of the day the cheetah had dragged her fresh kill to the only shade in the vicinity, so in this case was benefiting from the retinue of tourists.

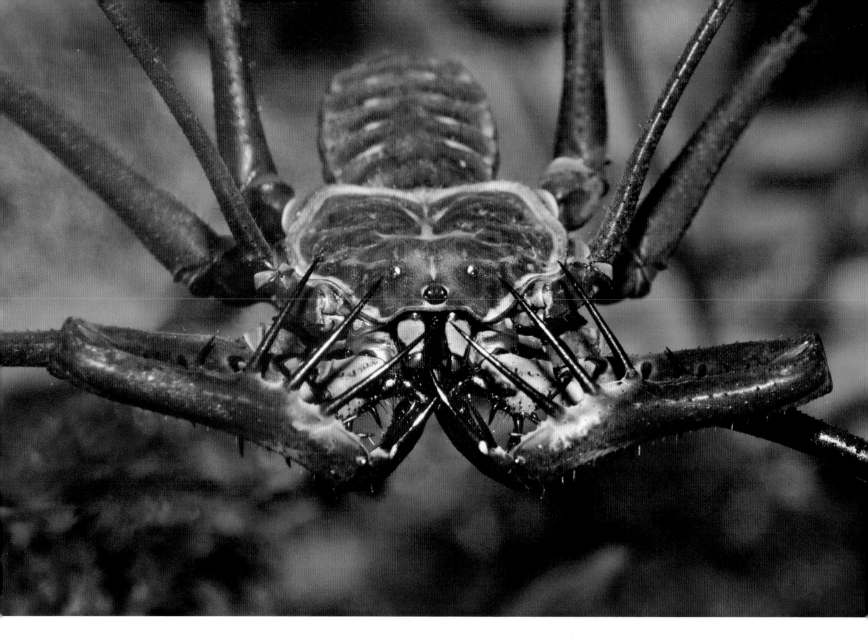

indigenous population that they have an asset, which if managed well, can provide jobs and natural resources.

Beyond financial and economic considerations, there are also potential benefits to both local people and the tourists through their interactions, expanding their awareness and tolerance of other beliefs and ways of living. So, when booking your trips, look closely at where your money ends up and how your visit will influence local communities.

Finally, a brief note on personal safety: Is it really worth risking your life for a single shot? Will your family and friends thank you for bequeathing

it to them in your will? Perhaps more importantly, in endangering yourself you are also putting the animal in a dangerous and stressful position.

So, take time to consider the potential risks and to research and study your proposed subject. Where possible take advantage of the services of an experienced guide. This enables you to focus on what is going on in your viewfinder secure in the knowledge that someone trustworthy is keeping an eye on what is going on around you.

Each species is different and it's important to be able to read any warning signs they offer. In general, wild animals are wary of us and will

Above: On a trek in the rainforest of Tobago, I was pleased to see that, having lured this whip scorpion out of its burrow to show it to me, my guide then gently coaxed it back and made sure it returned to its refuge.

Focal length: 168mm (macro)

Aperture: f/13

Shutter speed: 1/160 sec.

ISO: 250

run away rather than confront us, but there are situations where the risk of attack is raised. Surprising an animal by stumbling across it, is one such situation; another is finding yourself blocking an animal's potential escape route; while getting yourself between an animal and its young or being perceived as a threat to the young is also risky.

On a trek to see the mountain gorillas in Zaire, we were cautioned not to encourage any encounter with the inquisitive juveniles. If they approached us we were to turn and move slowly away. With their father (a 450lb silverback) looking on, this advice was easy to follow!

Above: Although they seem relatively placid when in the water, hippos have accounted for many deaths in Africa. These tend to have occurred when they are out of the water, grazing at night, and when people have unwittingly walked between them and the nearby water.

Focal length: 700mm

Aperture: f/5.6

Shutter speed: 1/320 sec.

ISO: 250

Chapter 1
General Principles

A good starting point for your wildlife photography is the question "what makes a great photograph?" I would suggest that four elements are usually evident:

1 A subject with impact—something that captures the viewer's mind for one reason or another.

2 A dynamic composition that supports the quality being expressed or the messages or stories that surround the subject being photographed.

3 Effective use of lighting, which is appropriate to the subject matter and the intended message and response.

4 A tendency to invoke an emotional response in the viewer.

Right: If you're looking to photograph an African cape buffalo, why not look for one with unusually long horns? This is actually a variant of the species found only in the Aberdares National Park in Kenya. The dense fog also helps make this shot unusual.

Focal length: 260mm

Aperture: f/5.6

Shutter speed: 1/25 sec.

ISO: 160

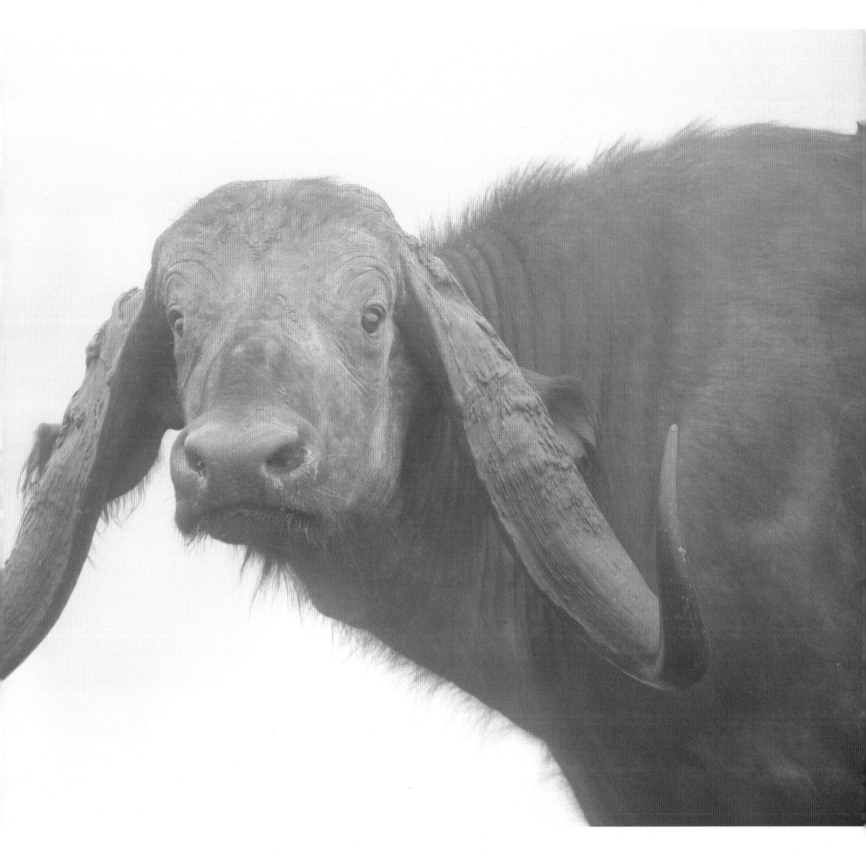

Subjects

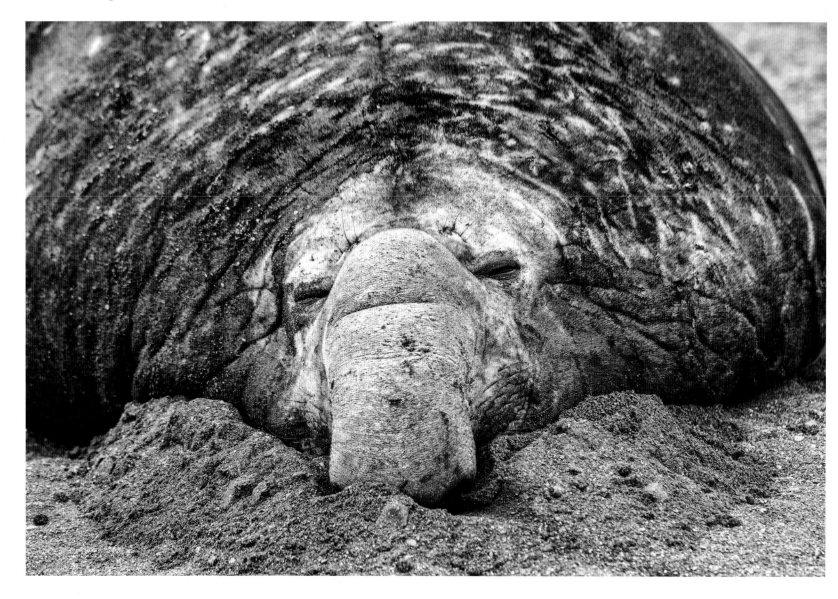

In this field of photography you have a wide range of subjects to consider and may be drawn to particular animals for a whole host of reasons. Occasionally, however, you will come across subjects that really grab your attention through their exquisite beauty, dramatic coloration, or perhaps even their extreme ugliness. It is these subjects that often provide the material for images with impact.

You can also see how each of the four elements mentioned on the opening page has a relationship with the others. We are often drawn to subject matter because it instigates in us a feeling of pleasure, shock, revulsion, or energy. If we convey the material well through our image making, it will hopefully go on to generate the same response in the viewer. Through good use of lighting and composition, you can augment

Above: This emotive image shows a battle-weary elephant seal on South Georgia. Soft light and a head-on view work well in this situation.

Focal length: 280mm

Aperture: f/6.3

Shutter speed: 1/250 sec.

ISO: 250

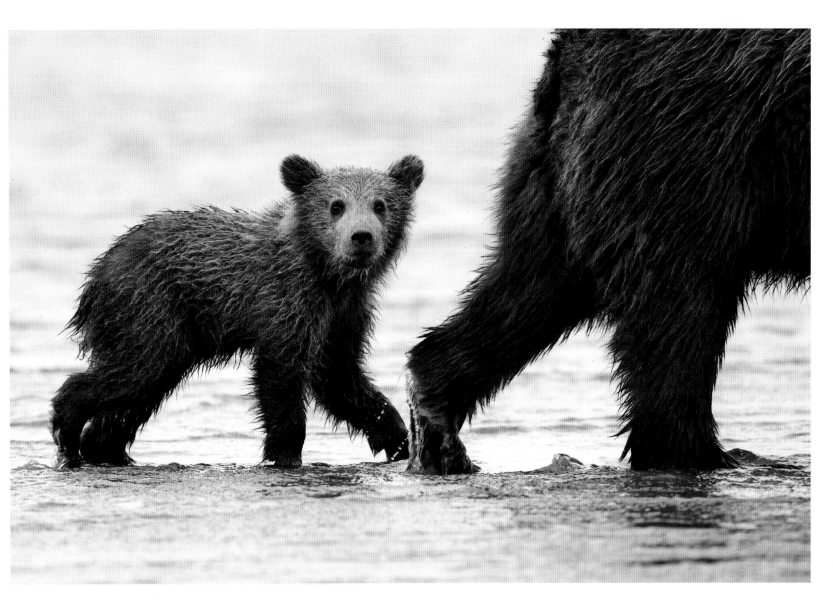

this effect by emphasizing or drawing attention to certain features or characteristics of the animal or to relationships between elements or individuals in the scene.

Lighting and composition are vast subjects in themselves, but let us now take a quick look at aspects of each in turn, as it is important to understand certain principles that we can harness in our quest to produce better images.

Above: Bear cubs are undoubtedly cute, and this image of a grizzly bear of about five months old works well for this reason. The phase of its gait gives a sense of movement, as it follows its mother. The cub is a little bedraggled and is looking directly at us with a look of inquisitiveness, tempered with fear.

Focal length: 500mm

Aperture: f/6.3

Shutter speed: 1/400 sec.

ISO: 400

Lighting

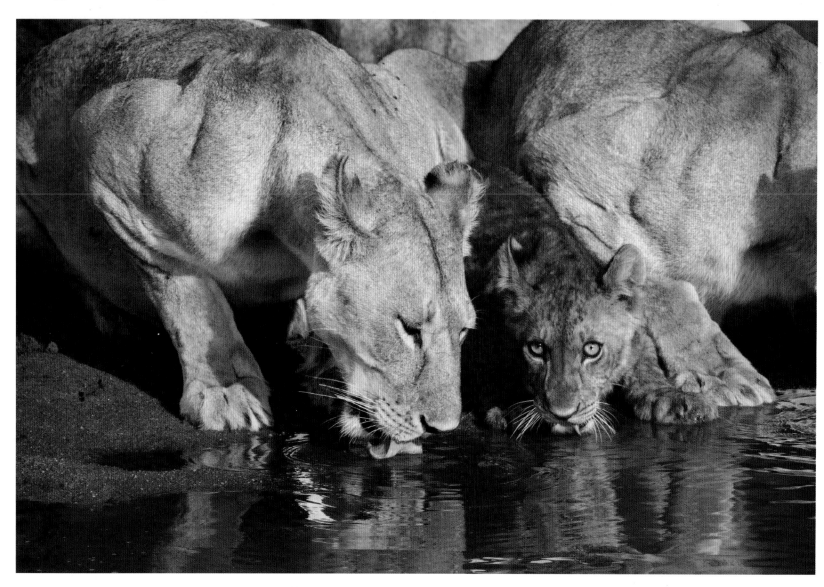

The direction and quality of light can be critical in determining how well certain characteristics of your subjects are revealed. The light falling on the subject profoundly affects colors and textures, and our perceptions and emotions are strongly influenced by the colors, contrasts, and tones that contribute to the overall mood of the image.

Color Temperature

In photography, we have the concept of the "Golden Hour" at the start and end of the day, during which time the vast majority of great outdoor images are captured. This is partly due to the "color temperature" of the light yielding a warmer tone to the scene at these times of day.

Above: The warm evening sunlight coming in obliquely to light the faces of these lions (particularly the eyes of the cub) is critical for the impact of this photograph.

Focal length: 800mm

Aperture: f/8

Shutter speed: 1/320 sec.

ISO: 200

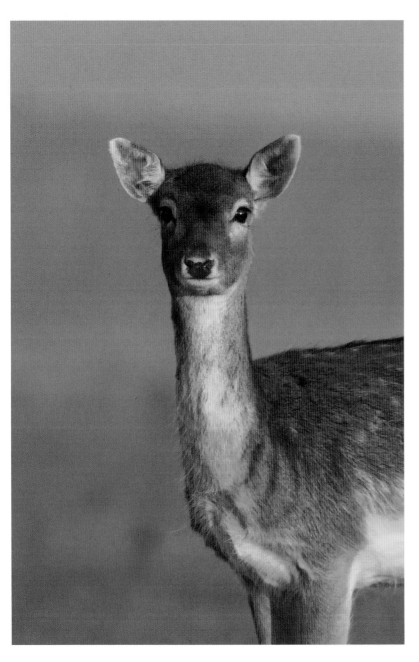
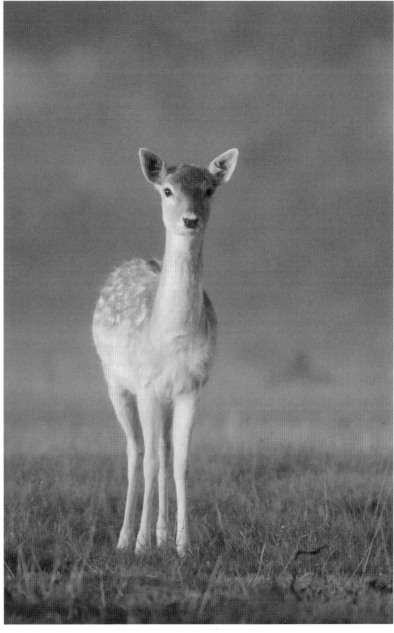

Color temperature is defined and measured in degrees Kelvin, where 5500K is the whitish color identical to the color of the sun at midday. Lower values of 2900–3400K are associated with the warmer light around sunrise and sunset where yellow, orange, and red predominate. At the other extreme, 12,000K is the bluish color of twilight or glacial ice where blue, purple, and green dominate.

Above Left & Above Right: These two images of captive fallow deer were taken at first light on a misty morning. They both benefit from the contrast of the warm tones created by the early morning sunlight falling on the subject with the much cooler background tones due to the filtering effect of the mist.

Above Left:
Focal length: 800mm
Aperture: f/5.6
Shutter speed: 1/640 sec.
ISO: 800

Above Right:
Focal length: 800mm
Aperture: f/5
Shutter speed: 1/500 sec.
ISO: 640

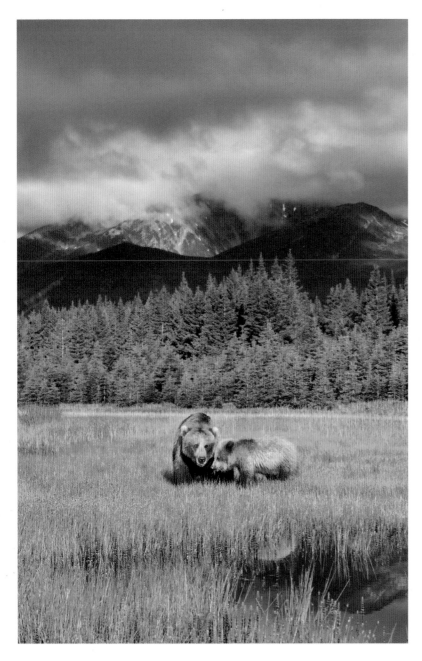

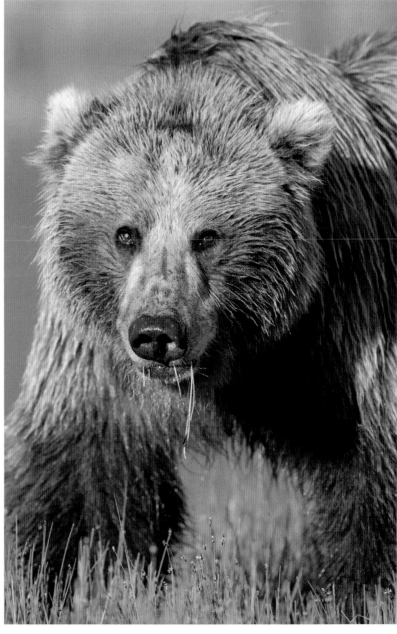

On a cloudy day, the water droplets in clouds absorb some of the red and yellow wavelengths, so the cooler, blue end of the visible spectrum passes through and is expressed disproportionately. This also happens to some degree in open shade.

You need to be aware of these concepts when making decisions regarding white balance settings, either in-camera or during postproduction, to ensure that your images look natural and show the light as it was—errors here will be perceived as unattractive color casts.

For now, though, you need to acknowledge that by using light intelligently you can add color—and emotion—to your images. Indeed, on occasion you may choose to deliberately bias the color temperature to further generate a certain mood.

Above Left & Above Right: For this encounter with a grizzly bear sow and her cub grazing on sedge grasses, the warmth of the early morning light was enhanced by dark clouds overhead.

Focal length: 500mm

Aperture: f/6.3

Shutter speed: 1/800 sec.

ISO: 150

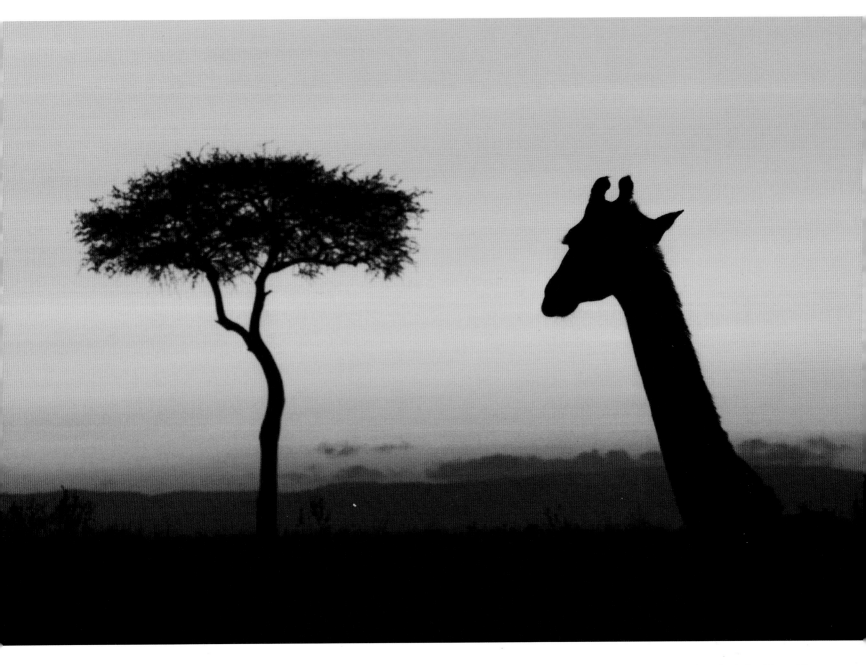

Above: Although it can be overdone (and often is), a subtle shift of color temperature toward warmer hues can enhance the mood generated by images taken at sunset and dusk. This photograph of a giraffe in the Mara Reserve relies on the balance between the two strong elements and the interest the giraffe appears to have in the acacia tree.

Focal length: 304mm

Aperture: f/11

Shutter speed: 1/40 sec.

ISO: 320

Direction

The second quality of light that we need to look at is its direction. Top light—where the light is coming from above the subject—is usually associated with midday, when the sun is high in the sky. Here there is often too much contrast between highlights and shadows due to the intensity of the light, and its direction tends to put stronger, darker shadows in the wrong places—in eye sockets, under noses, and so on.

Front light—where the light is coming from behind the photographer and hitting the subject from the front—tends to give no shadows, which means it can fail to give dimension and depth, leaving images looking a little flat. On the plus side, if the light is relatively soft, it can deliver even illumination for portraits with the eyes being well lit.

Side light (light that strikes your subject from the side) provides longer shadows, giving a scene dimension and better defining the form of objects. It is also very effective for revealing the texture of surfaces, such as the undulations of the thick hide of an elephant.

Finally, backlighting can be employed to give a glowing translucence to the margins of objects in the frame or even to silhouette them to help make a statement about their shape. It also accentuates haze, mist, and dust in the atmosphere, which can add dimension and mood.

However, because light will be hitting the front elements of the lens directly, you need to beware of "lens flare"—when the light reflects off the lens elements resulting in altered tones and colors, and a detrimental loss of contrast. Flare can also cause starburst effects or shafts of light (which can be used creatively).

Depending on the position of the light source, a lens hood may not extend far enough to offer sufficient protection, so you may need to find something else to shield the lens from stray light if it is problematic.

Each direction of lighting clearly has its place in our work. Side lighting and backlighting often give the most pleasing results due to the emphasis on form and shape, and the fact that they introduce shadows as further compositional elements. The opportunity to employ these is optimal at the beginning or end of the day when the sun is low in the sky.

Tips

Some photography is suited to the top light created by a high sun. For example, midday is good for photographing life on vertical surfaces, such as steep banks and gorges.

Spotlighting can be a great creative aid as it focuses the viewer's interest on a specific part of the image. The general rule here is to expose for the spotlit area.

Above: Bold side lighting helps to emphasize the contours of the elephant and the textures of its skin and crust of dried mud.

Focal length: 800mm

Aperture: f/4.5

Shutter speed: 1/2000 sec.

ISO: 160

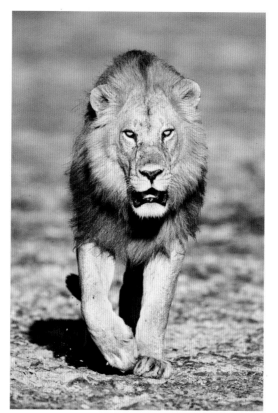

Right: Backlighting can give a lovely rim-lighting effect, creating a "halo" around your subject. This works particularly well with furry animals, such as this grizzly bear, as the rim-light helps draw attention to the shape and coat of the subject. In general, you would bias the exposure toward the shadow areas to accentuate this effect.

Focal length: 256mm

Aperture: f/7.1

Shutter speed: 1/800 sec.

ISO: 250

Left: A classic portrait of a male lion looking and walking straight toward the camera. Its impact comes from the warm morning light striking the lion's eyes from the front.

Focal length: 700mm

Aperture: f/6.3

Shutter speed: 1/640 sec.

ISO: 125

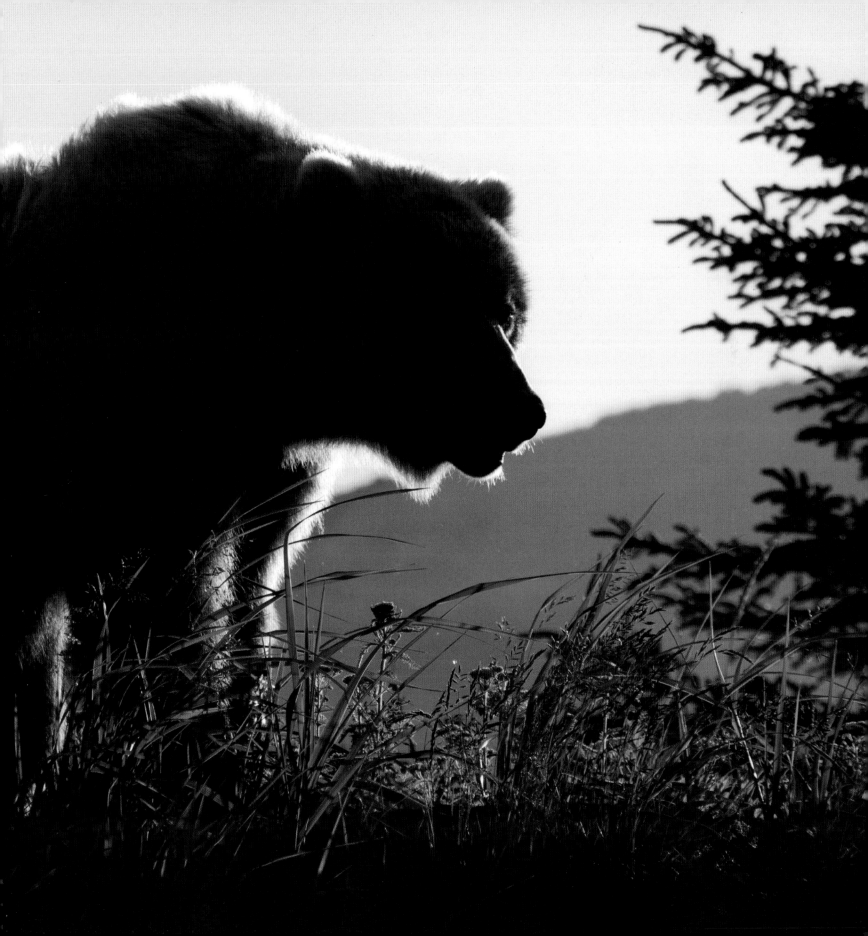

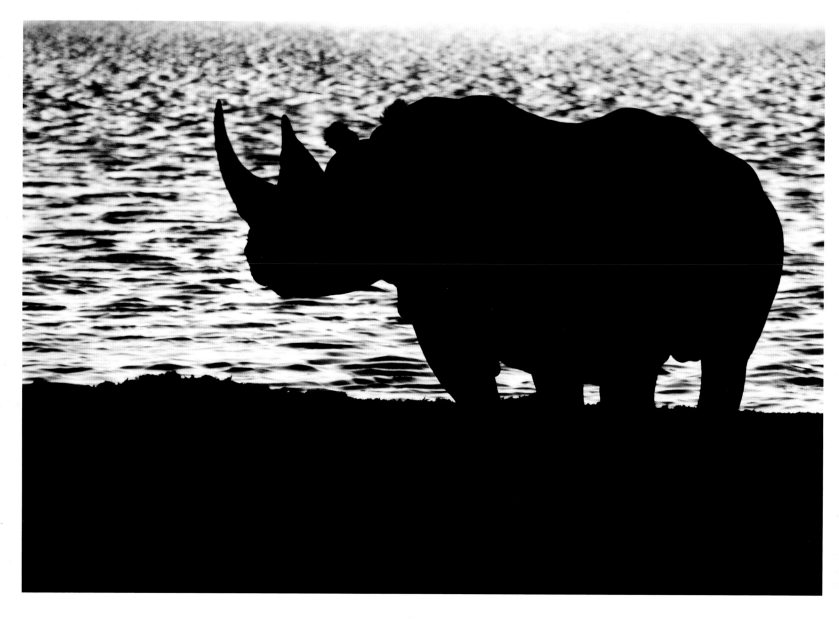

Above: An example of shooting into the light to emphasize shape. In this case a lone black rhino is defined against the rippled surface of a waterhole in Namibia.

Focal length: 456mm

Aperture: f/5.6

Shutter speed: 1/40 sec.

ISO: 1600

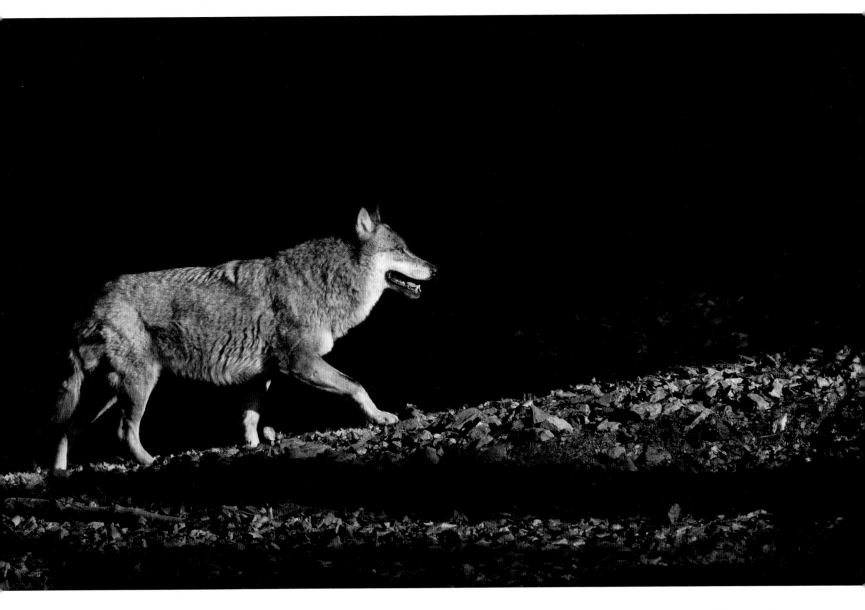

Above: Shafts of early morning sunlight penetrating woodland highlight the contours and features of this captive gray wolf.

Focal length: 800mm

Aperture: f/6.3

Shutter speed: 1/320 sec.

ISO: 250

Intensity

The third quality of light to mention is its intensity. Specular or direct light—as on a bright, sunny day, or through the use of flash—gives bright highlights and deep shadows, and a large tonal contrast. It tends to reduce color saturation, but is good for defining textures and creating drama. It is regarded as being more bold and aggressive.

Diffuse light, on the other hand, is the type of light we get on a cloudy day or in shade, or at either end of the day when the sun's rays are softened as they pass through haze and particles in the atmosphere. This type of light is good for close-ups and portraits where the more even illumination can better reveal the delicate details of a flower or face, for example.

It is also good for conveying subtleties of color, as the blue and ultraviolet wavelengths are filtered out allowing other colors to appear more saturated. Emotionally, it is regarded as being non-assertive and calming. So don't give up and put your camera away once the sun has set, or on those overcast days—try to make use of the more even lighting by targeting your subject matter.

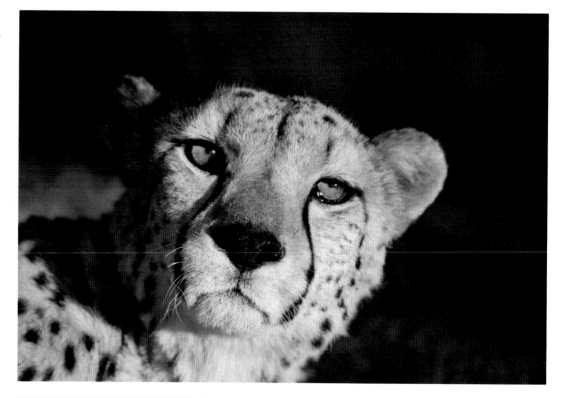

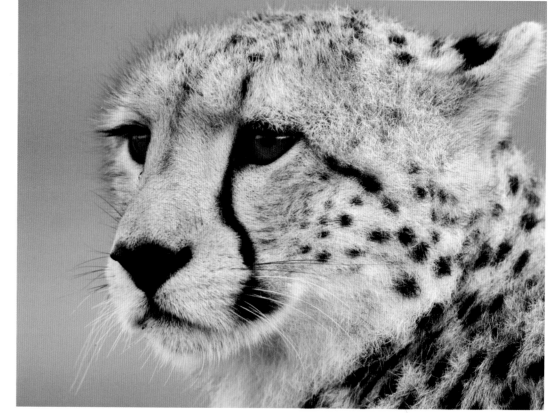

Right Top & Right Bottom: Compare these two portraits of cheetahs. The first (top) was taken with direct light and the second (bottom) with diffuse light. Both have merit, but you can see how the diffuse light reveals the finer details across the whole face.

Right Top:	Right Bottom:
Focal length: 275mm	Focal length: 800mm
Aperture: f/5.6	Aperture: f/5.6
Shutter speed: 1/1000 sec.	Shutter speed: 1/50 sec.
ISO: 200	ISO: 400

Supplementary Lighting

With the latest generation of digital SLRs providing quality images even using relatively high ISOs, there is less call for the use of flash. However, for low-light conditions, nighttime photography, freezing fast-moving subjects, and various other creative enterprises, flash or strobe lights still have a place.

There are various options for providing additional lighting. For night drives in many game reserves, the vehicles are equipped with powerful flashlights that can provide adequate light levels in many situations. However, for most of our photographic endeavors standard flashes are the norm. They generally offer good power output and are relatively portable—tripods or lightweight stands can be used to support and position them.

Many dedicated flashes can be synchronized wirelessly and even the output can be adjusted from a remote position using control triggers. This can be a significant advantage in the field with nervous subjects.

The most common mistake with supplementary lighting is to over do it. With wildlife photographs, you will generally want things to look natural, so any artificial lighting needs to be applied sensitively. Work with the natural light rather than simply replacing it.

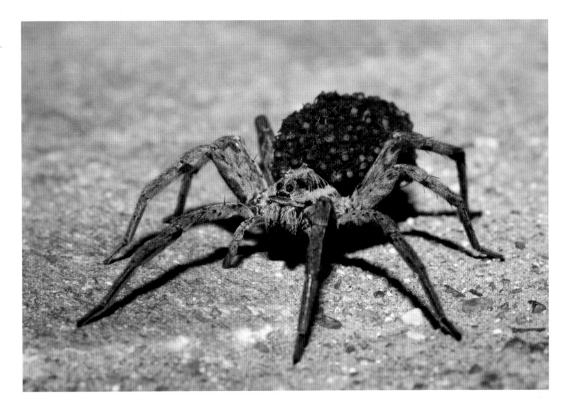

Above: I had to react quickly when I spotted this wolf spider carrying her spiderlings across a terrace in Greece. I only had one flash with me and no time to set up any reflectors. Nevertheless, the angle shows her amazing face and the mass of spiderlings hitching a ride.

Focal length: 105mm (macro)

Aperture: f/16

Shutter speed: 1/160 sec.

ISO: 100

Tips

If you want softer, more diffused light, you may need to use a diffuser or bounce the flash off something.

You can use a single flash as a fill-in light to brighten parts of the subject matter that would otherwise be in deep shade. As a starting point, try reducing the power of the flash by setting the flash exposure compensation to -1 stop.

Decide whether you want shadows to appear as a result of the flash. If not, you may need to use additional flashes to provide light from different directions and fill in the shadows.

Due to the fall-off of the light's intensity with distance from its source, backgrounds will tend to be darker than the subject and even black if there is quite some separation between them. To avoid this, make sure the background is also lit or insert an artificial backdrop closer to your subject.

Flash can improve separation between subject and background when shooting in woodland areas. This is partly due to the fall-off effect, but if the flash illumination is coming in obliquely, it will also help to define the form of the subject against the backdrop.

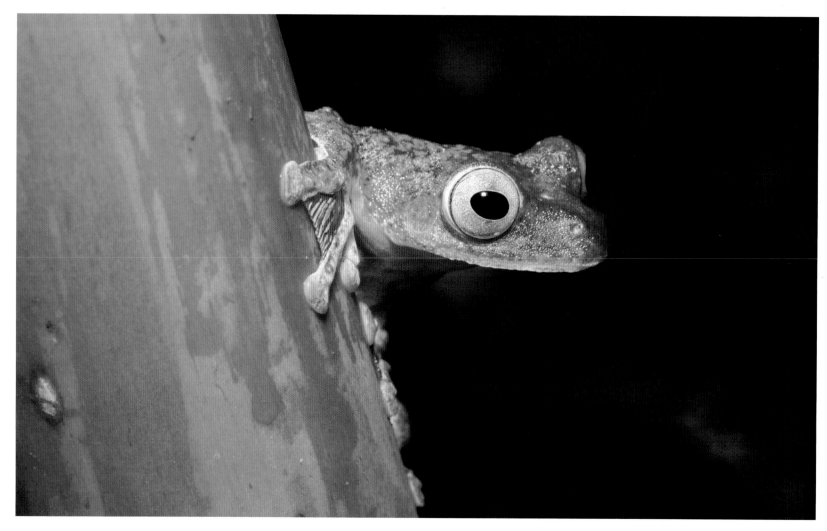

Freezing Motion

The duration of light emitted by a flash is incredibly short (from as little as 1/1000 sec. at full power to 1/10,000 sec. at 1/16 power). This makes it ideal for extreme high-speed photography, especially if multiple flashes are used and they are close enough to the subject to allow lower power outputs to be set. Using this approach with a lot of planning and staging we can freeze even the fastest of movements in the animal kingdom.

When you want to use shutter speeds faster than 1/250 sec. (which is the typical flash synchronization speed on most cameras), remember to activate the "high-speed sync" setting to avoid overexposure.

Above: This photograph of a harlequin tree frog was taken at night, deep in the rainforests of Borneo, using two flash units. One flash was on the camera and fitted with a diffuser, while the other was held by my guide who directed it from above and from behind the leaf. The latter was to prevent the leaf shading the subject from the on-camera flash and also to cast a little light onto the background to avoid it being rendered completely black.

Focal length: 105mm (macro)

Aperture: f/20

Shutter speed: 1/100 sec.

ISO: 200

Right: A single flash has helped freeze the movement of this female ruby topaz hummingbird, although the speed of movement of the flapping wings would have been lower at this phase of the wing beat anyway. There is a little ghosting of the furthermost wing, probably due to the fact that the shutter speed was slower than the flash duration.

Focal length: 416mm

Aperture: f/5.6

Shutter speed: 1/250 sec.

ISO: 400

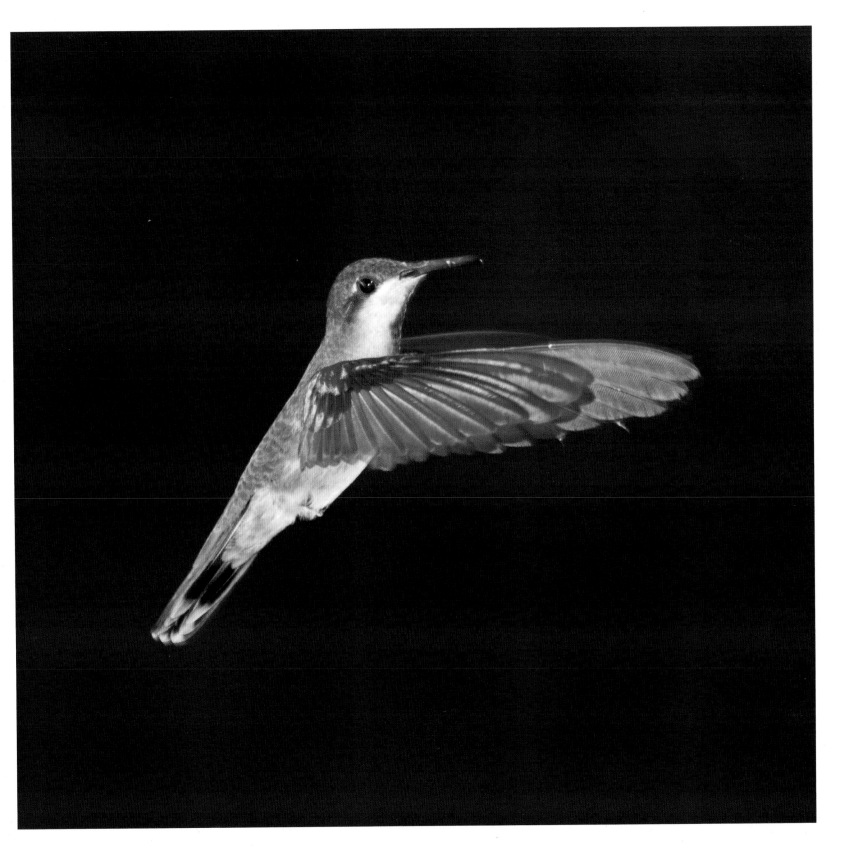

Weather

Bad weather can offer opportunities for some unusual or unique takes on things. There have been many striking images taken of animals huddled against rain lashing down or being caught as they shake the water droplets from their bodies.

Streaks of falling snow can add a sense of the environment and reflections in puddles can add graphic interest to an image. Even strong winds can add another level of texture, as foliage or grasses buffeted by the wind are rendered blurred. If this is around a relatively static animal it can lead to a rather surreal effect.

When you are featuring the wildlife in a broader environmental setting, majestic or brooding storm clouds can add to the drama and mood of the image, while fog and snow can simplify scenes by concealing much of the "clutter." Mist and rain can help provide a sense of depth in a scene, while rainbows and lightning strikes can add an extra element that can spice up your compositions. So make a point of getting out there in all conditions, not just when it's dry and bright.

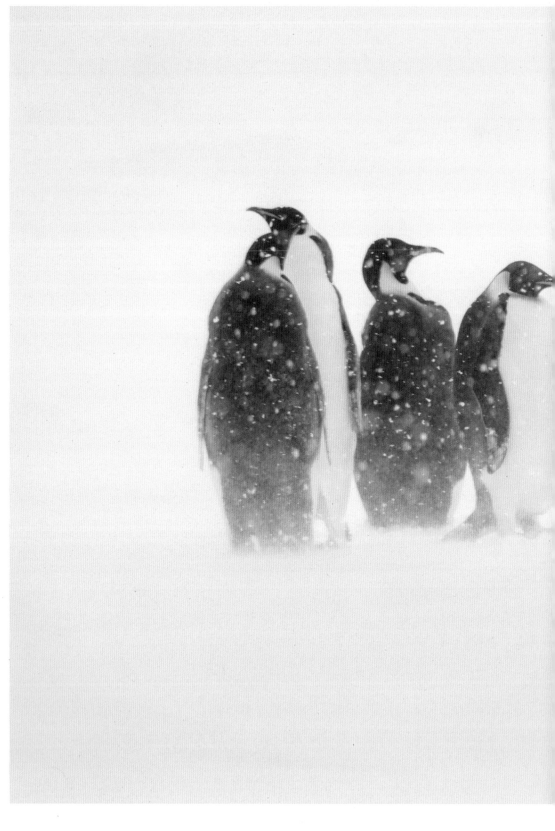

Right: A graphic image of Emperor Penguins standing up to a snow storm in Antarctica. The visible flakes of falling snow add dimension and reveal the extreme conditions.

Focal length: 400mm

Aperture: f/9

Shutter speed: 1/1600 sec.

ISO: 160

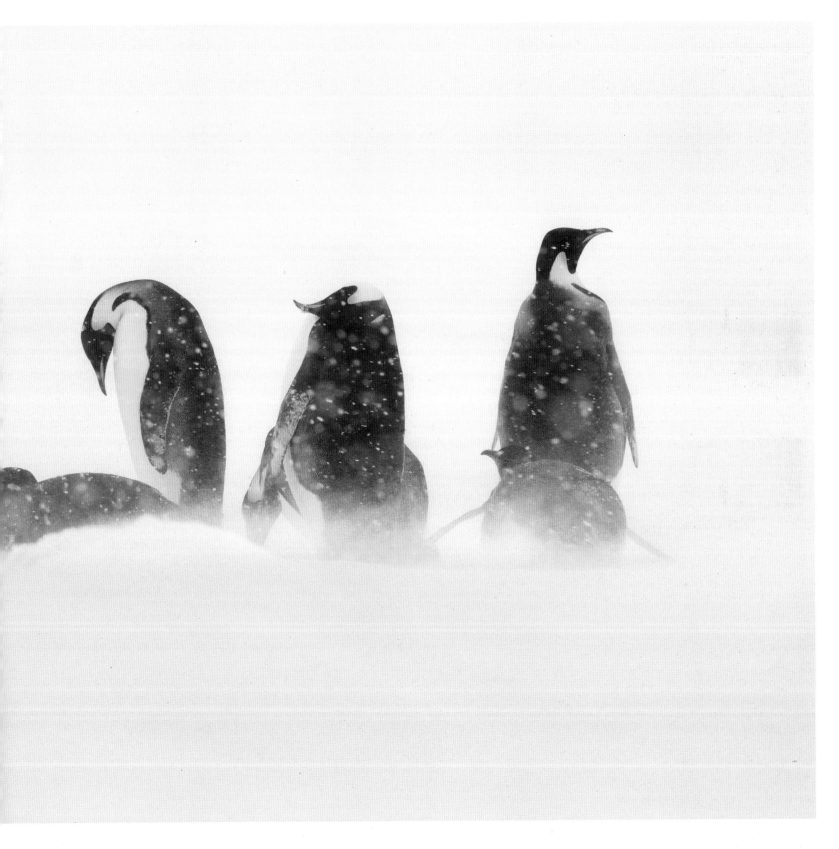

Composition

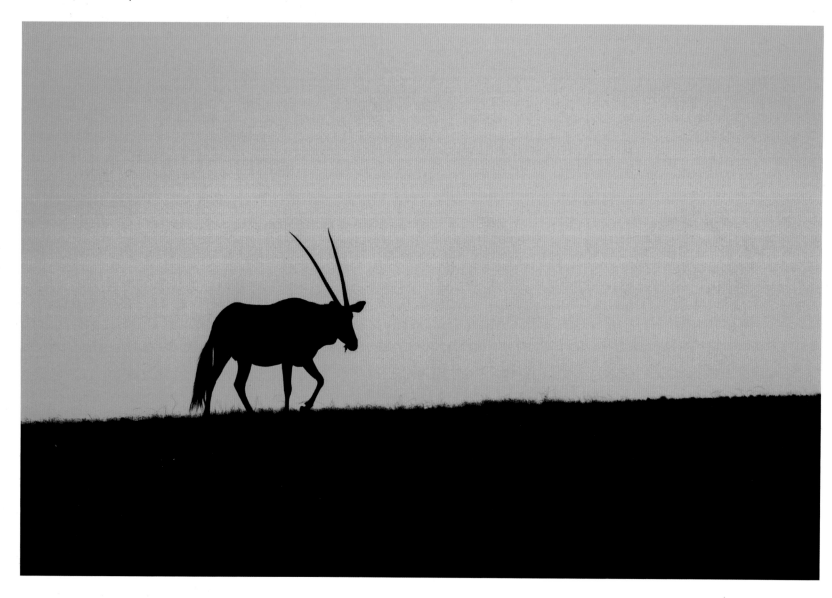

How you compose your images is an important part of your quest to produce wildlife imagery with impact. There are countless ways in which you can arrange elements within the frame, and various "rules" have been espoused that you might use (or abuse) to your advantage.

Firstly, as wildlife photographers we often feel driven to fill the frame with our subjects, making the most of those expensive long lenses. However,

filling the frame often gives the sense of the subject being confined and this can also leave the viewer feeling a little claustrophobic. Backing off a little, to give more space around the animal, can give a sense of freedom. It also enables the viewer's eye to wander and explore other parts of the image.

We are often looking to convey the beauty in what is before us, and the perception of beauty is generally aided by our detecting a measure of

Above: Allowing plenty of space around this oryx lets the viewer enjoy the beautiful orange hue. I have also allowed room for it to move into to give a sense that it is marching purposefully along the brow of this hill in Namibia.

Focal length: 640mm

Aperture: f/7.1

Shutter speed: 1/640 sec.

ISO: 500

harmony and balance in an image. Therefore, it is worth thinking about how the arrangement of the various elements can be improved.

The center of gravity for an entire composition is generally at the center, so the obvious way to create balance in an image is to place the subject in the middle of the frame. In doing this, the viewer's eye will travel directly to the heart of the image and stop there. This can be an effective ploy, particularly in portraiture or when perfect symmetry is the message you wish to convey.

In practice, however, we usually place the subject off-center to encourage the eye to wander and take in other parts of the image that are also part of the story or to perceive relationships between the subject and other elements within the frame. Juxtapositions of two elements, for example, can say a lot about the size of an animal.

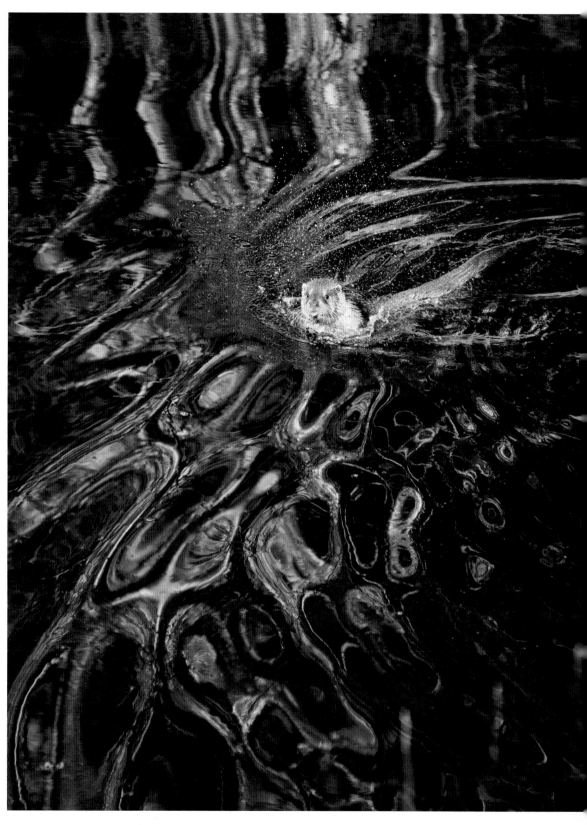

Right: The space around this captive European otter allows the wonderful pattern of ripples and light on the water surrounding it to be included in the photograph. An elevated viewpoint provided the ideal angle of view.

Focal length: 220mm

Aperture: f/6.3

Shutter speed: 1/320 sec.

ISO: 400

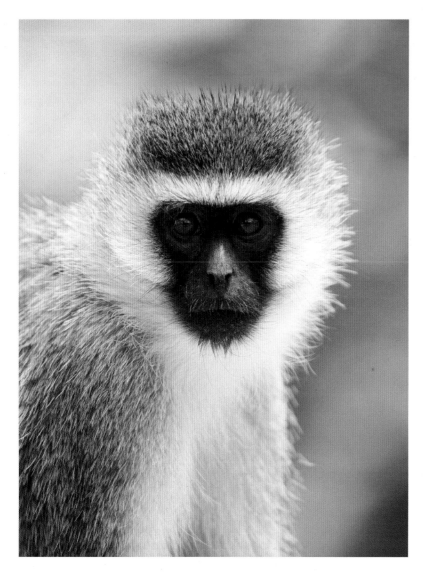

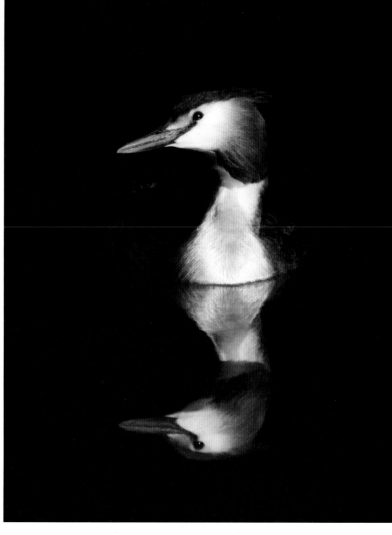

Above: Centering the face of this vervet monkey was appropriate here, as the photograph's strength is the piercing gaze of the monkey directly into the camera.

Focal length: 390mm

Aperture: f/6.3

Shutter speed: 1/200 sec.

ISO: 200

Above & Right: These images of a great crested grebe and an oryx are about their reflections. Off-setting the subject so that it precisely balances its reflection is an appropriate strategy to emphasize this point.

Above:

Focal length: 560mm

Aperture: f/8

Shutter speed: 1/250 sec.

ISO: 250

Right:

Focal length: 700mm

Aperture: f/5.6

Shutter speed: 1/800 sec.

ISO: 400

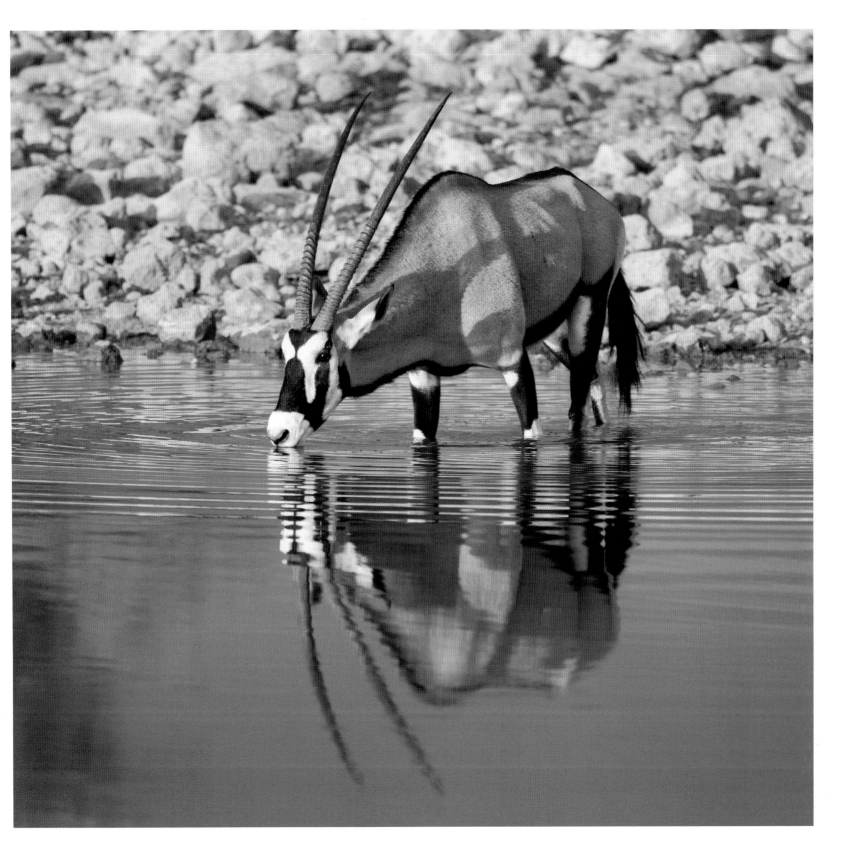

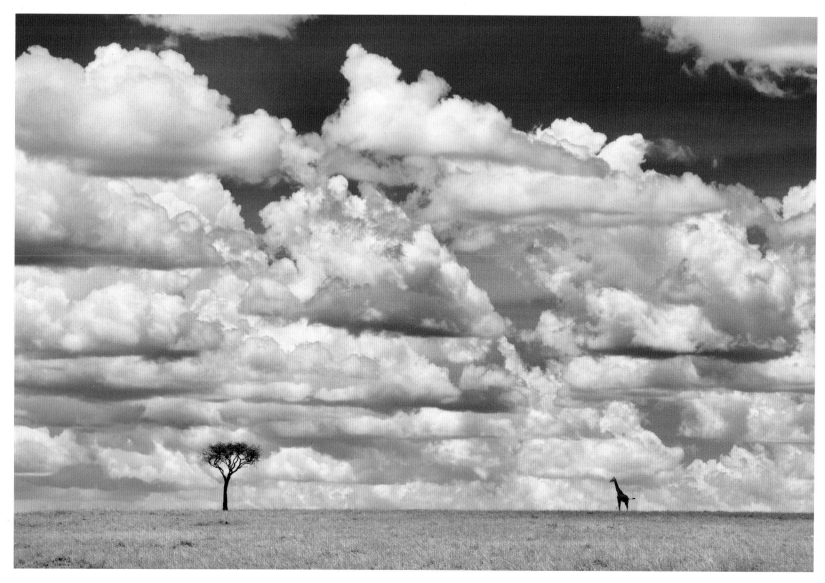

Visual Weight

When multiple elements are included in the frame it is important to consider the overall sense of balance. Since we experience gravity, we tend to look at a picture with the subconscious assumption that the elements in it could have a tendency to fall to the ground—even clouds carry an element of this "visual weight."

An element's weight depends on its size, shape, location, and color. Because of this, a small object can be balanced by a larger one; a light one by a dark one; and a negative space by a visually full space. Therefore, when you elect to position the key element away from the center, you need to remember that the farther away from the center it is, the more the viewer is likely to look for some justification for this positioning.

This will often come from the relationship of the subject to other elements within the frame. Usually it's enough simply to ask yourself whether the image seems balanced around its central point or whether you get a sense of it wanting to rotate one way or the other due to more weight on one side.

Above: A simple illustration of "visual weight." The giraffe and tree are two elements of similar weight that balance each other by being similar distances from the center of the frame. The inclusion of the dramatic sky helps give a sense of space.

Focal length: 168mm

Aperture: f/7.1

Shutter speed: 1/400 sec.

ISO: 200

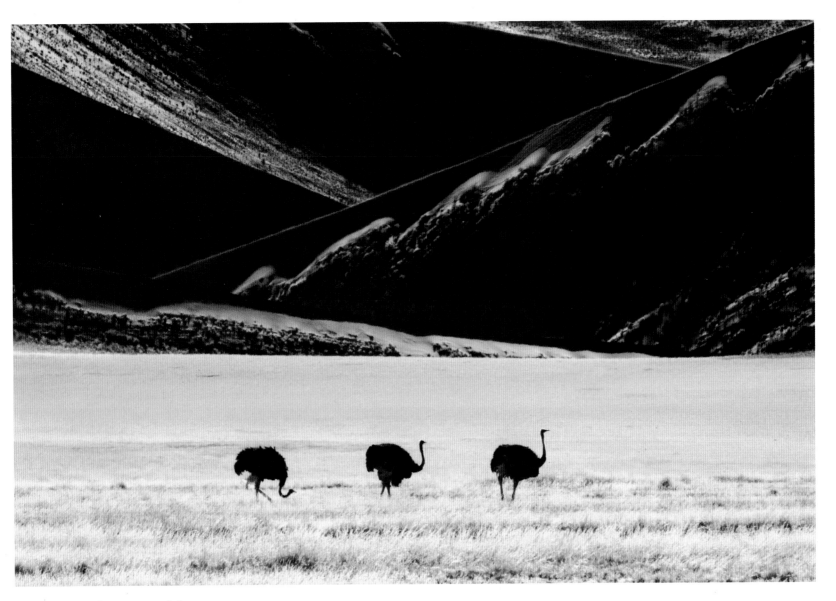

Rules of Composition

There are various rules that have been proclaimed to help us with positioning our subject matter in the frame in a pleasing way.

The Rule of Odds is related to the concept of visual weight. It states that odd numbers of animals in a group photograph often work better than even numbers. This is because the central one can act as a sort of fulcrum with the others balancing each other on either side. This isn't to say that images with two or four individuals never work, but simply that including three or five individuals in the frame often seems to give a pleasing sense of balance in itself.

The Rule of Thirds is perhaps the best-known compositional rule. Here, you avoid the center of the frame for points of interest and instead try putting them at one of the points where lines meet if you use imaginary lines to split the frame into three both horizontally and vertically.

This rule should certainly not be used in a prescriptive, routine way, though—it is better to use your built-in balance meter (aka "gut feeling")

Above: An example of how three individuals is often pleasing. The three equally spaced ostriches balance one another and, as each has a different posture, they act almost like a timelapse sequence of one individual.

Focal length: 480mm

Aperture: f/16

Shutter speed: 1/100 sec.

ISO: 250

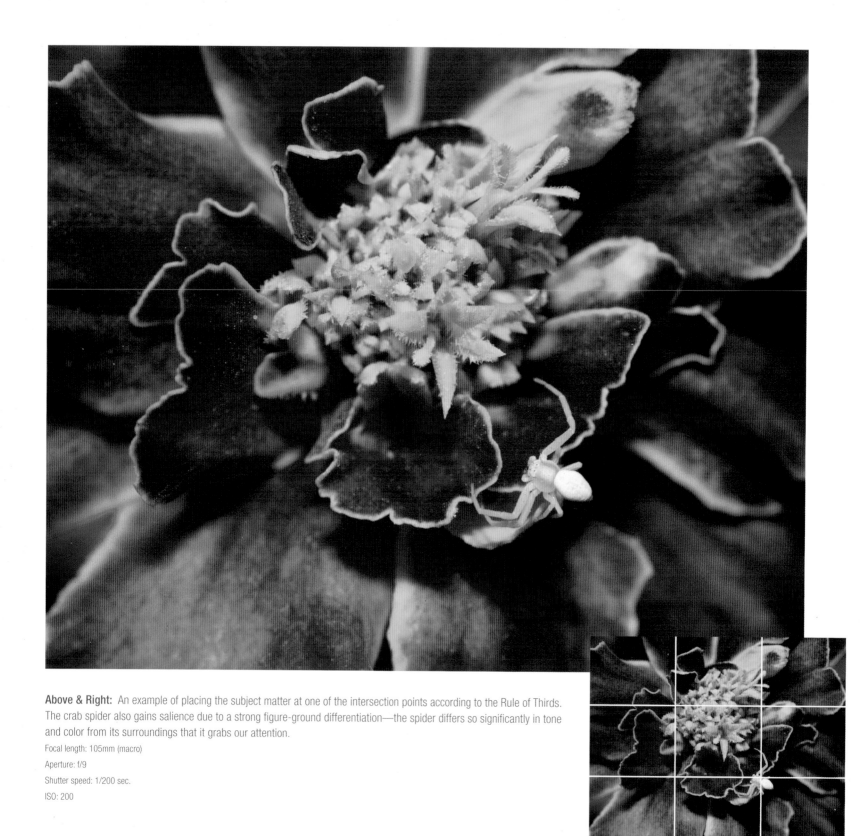

Above & Right: An example of placing the subject matter at one of the intersection points according to the Rule of Thirds. The crab spider also gains salience due to a strong figure-ground differentiation—the spider differs so significantly in tone and color from its surroundings that it grabs our attention.

Focal length: 105mm (macro)

Aperture: f/9

Shutter speed: 1/200 sec.

ISO: 200

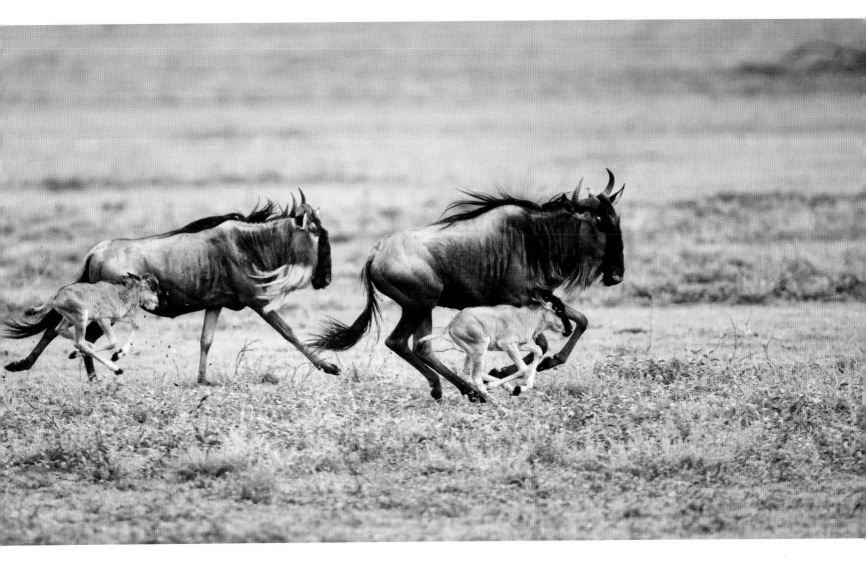

to give a sense of balance. There are likely to be other compositional considerations related to other objects or animals in the scene that will cause you to opt for a modified position that is actually slightly away from that proposed by the rule of thirds.

Another rule related to the positioning of your subjects away from the center is that of "nose room" or "leading space," which states that a subject should have space to move into in the direction in which it is facing or moving. This is because the viewer's eye will tend to follow the direction of gaze or orientation of the subject to investigate what it is looking at or relating to. If it is moving, we also have a tendency to follow the projected course of the animal to see where it is

heading. Even if the destination is not within frame, we feel freer to explore these possibilities with our imaginations if there is some space for our eyes to wander and explore in the appropriate direction.

Above: A simple example of allowing some "leading space" for the wildebeest and calves to gallop into. How much you choose to leave will depend no doubt on a host of factors, including the perceived speed of movement of the subjects.

Focal length: 700mm

Aperture: f/5.6

Shutter speed: 1/640 sec.

ISO: 125

Frames, Lines, Shapes & Patterns

As you look to include other elements in your images to support your messages, there are various tools you can use to help direct the viewer's attention to where in the scene you want them to look or to certain attributes of our subject matter. Using a frame within the frame is one such way. Here, you would look for elements in the environment that could be used as a natural frame to surround the important features. In the natural world opportunities for this abound with trees, branches, rocky overhangs, or even parts of other animals providing the frame. Chosen well, they will also say a lot about their environment and help complete the story.

You can also make use of lines within the scene. Lines form channels for our eyes to follow,

Below: This "frame within a frame" does more than simply focus attention on the subject—it helps infer the close relationship between egrets and browsing mammals.

Focal length: 1120mm

Aperture: f/10

Shutter speed: 1/320 sec.

ISO: 200

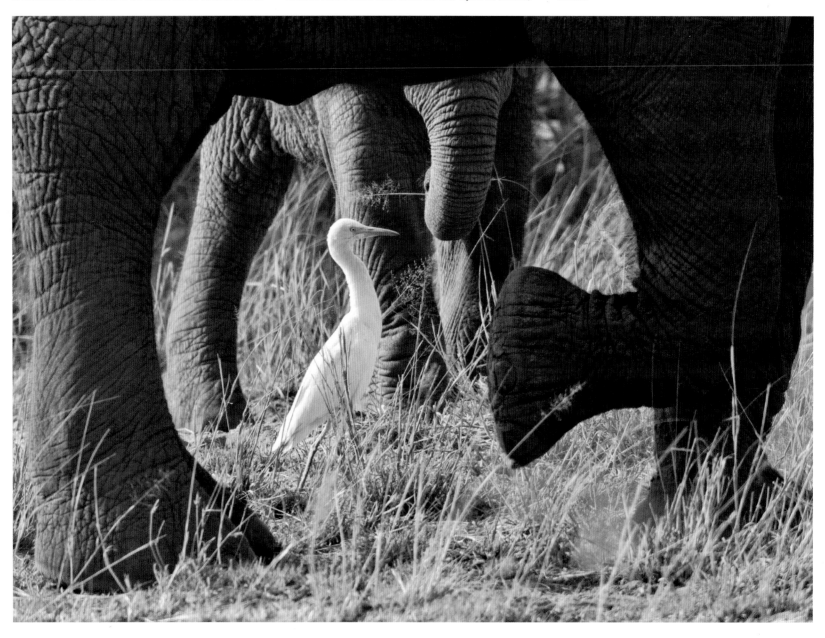

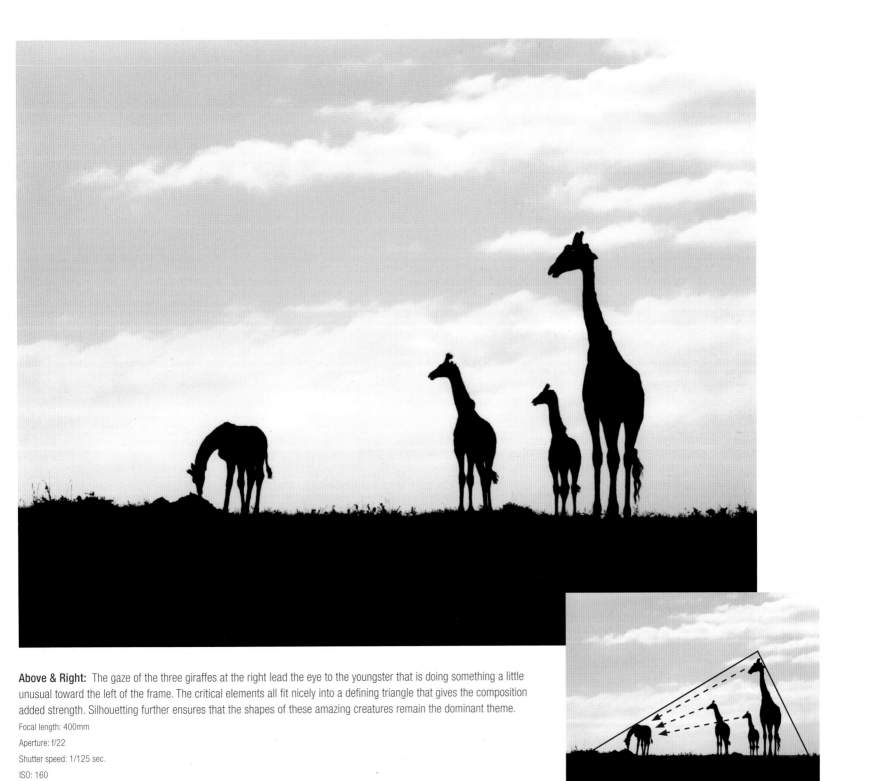

Above & Right: The gaze of the three giraffes at the right lead the eye to the youngster that is doing something a little unusual toward the left of the frame. The critical elements all fit nicely into a defining triangle that gives the composition added strength. Silhouetting further ensures that the shapes of these amazing creatures remain the dominant theme.

Focal length: 400mm

Aperture: f/22

Shutter speed: 1/125 sec.

ISO: 160

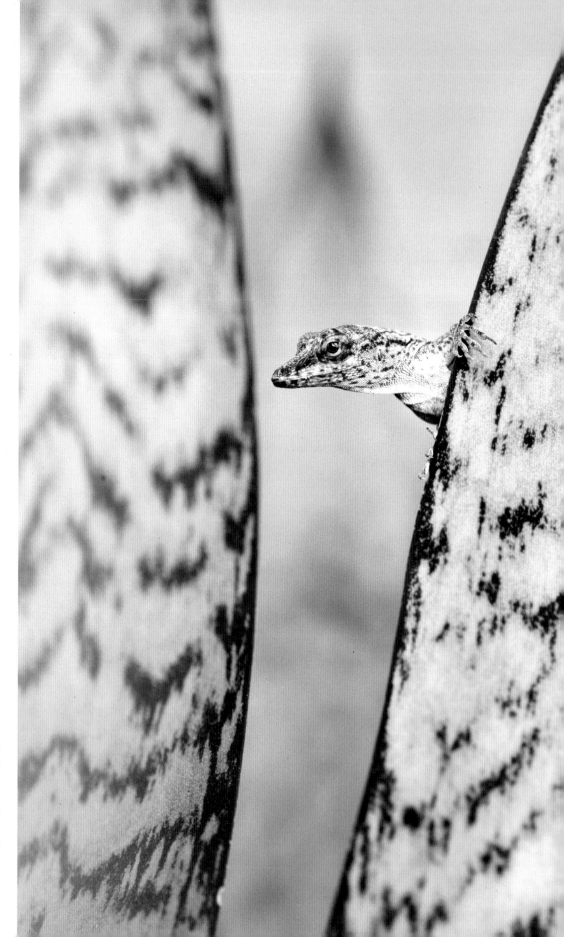

so can be a good way of leading the viewer to notice what you want them to. However, the lines don't have to be actual lines—they can also be implied. For example, we tend to follow the gaze of an animal to see what they are looking at, so the line of their gaze can be seen as a virtual line.

The orientations of lines within a composition (both physical and implied) have different connotations. Horizontal lines convey a sense of calm and often a sense of breadth or width, so an expansive horizon will give a real sense of the vast space occupied by your subject.

Vertical lines are more assertive and create a sense of height. They can gain emphasis from being used in conjunction with a portrait/vertical frame orientation, but again, try to compose with them off-center to avoid splitting the perceived image in two.

Diagonal lines tend to give an illusion of motion. This partly arises from the sense of imbalance that the diagonal gives. View it like a tree trunk—if it's diagonal it is neither standing nor fallen, but falling. Try composing relatively linear subjects diagonally across the frame for added dynamism. Sweeping curves if positioned well can help convey a sense of balance and harmony, and wavy, sinuous lines give a sense of fluidity and sensuality.

Wonderful shapes abound in the natural world. Their inclusion can create more graphically appealing images. Perfect circles, rectangles, and triangles are rare, but many creatures have fascinating outlines and shapes.

Right: Animals peering out from behind or between things often make for endearing photographs, as in the case of this lizard, Anolis richardii, in Tobago.

Focal length: 168mm (macro)

Aperture: f/4

Shutter speed: 1/400 sec.

ISO: 320

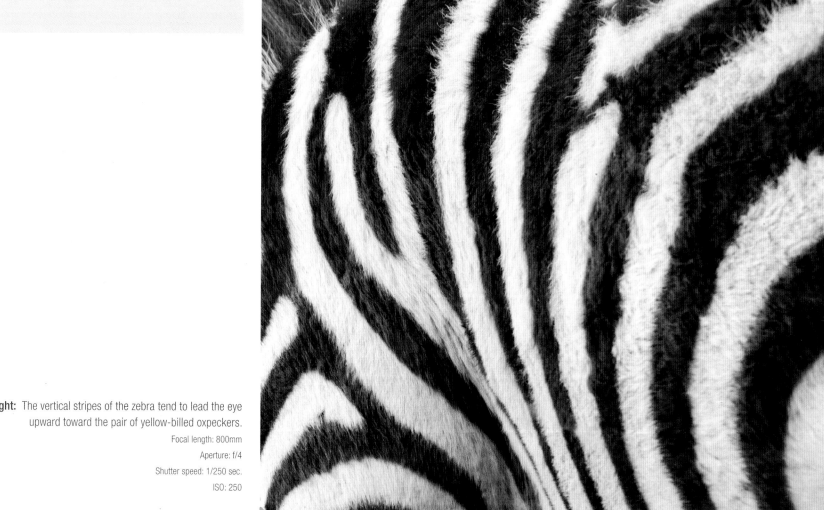

Tips

Look for shapes within your subject's make-up, such as the space between an elephant's legs as it walks and shapes formed by its shadow.

There may be shapes in the environment or the background that can add interest and support your compositions—pyramidal-shaped mountains, for example.

Silhouetting your subject is a strong way of eliminating detail and focusing attention on outlines and shapes. If it's the entire animal that you wish to silhouette, you may need to seek out a low viewpoint so you can get them high on the horizon relative to the light source beyond.

Right: The vertical stripes of the zebra tend to lead the eye upward toward the pair of yellow-billed oxpeckers.

Focal length: 800mm

Aperture: f/4

Shutter speed: 1/250 sec.

ISO: 250

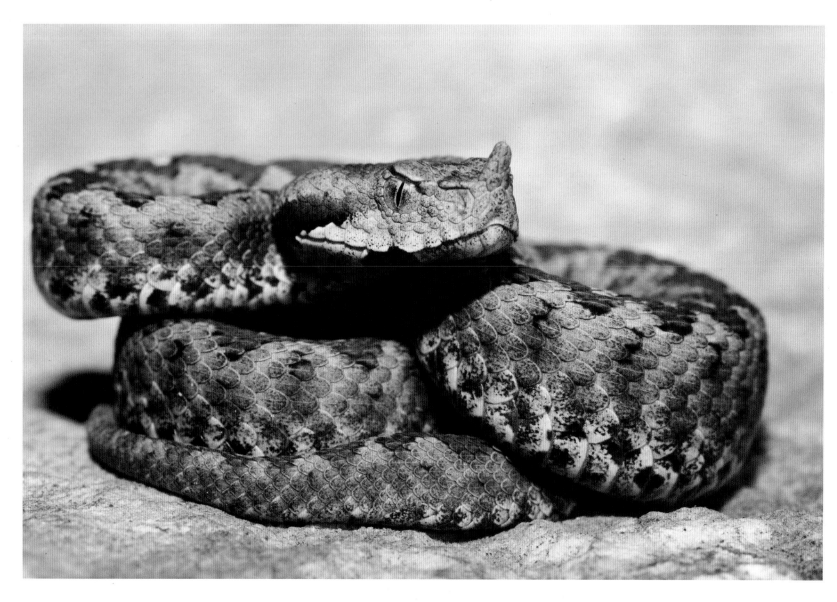

We also find pleasure in patterns, and these are also prevalent in the natural world. Ensuring that the pattern fills the frame completely often works well. If the pattern reaches right up to the edges on all sides it will give the impression that it continues indefinitely. Breaking the pattern is also a useful ploy serving both to emphasize the pattern and draw attention strongly to the element that breaks it.

It is worth reiterating that you shouldn't get too obsessed with applying the rules and guidelines that have been proposed. It is worth experimenting with them to gain a better understanding of

their effect, but to avoid your work becoming predictable you should also experiment with breaking them.

How you arrange things in your viewfinder will ultimately depend on what you are trying to say or what feeling or response you are attempting to engender in the viewer. Your intention may not be to convey a sense of beauty and harmony, for example, and doing the opposite to what a rule suggests may be the best way of doing this. In general, if you are going to break the rules, do it boldly so that it looks like this was your intention.

Above: The curves of a coiled snake, such as this nose-horned viper ready to strike, will generally make a more pleasing composition than one stretched out straight across the picture frame.

Focal length: 105mm (macro)

Aperture: f/16

Shutter speed: 1/125 sec.

ISO: 125

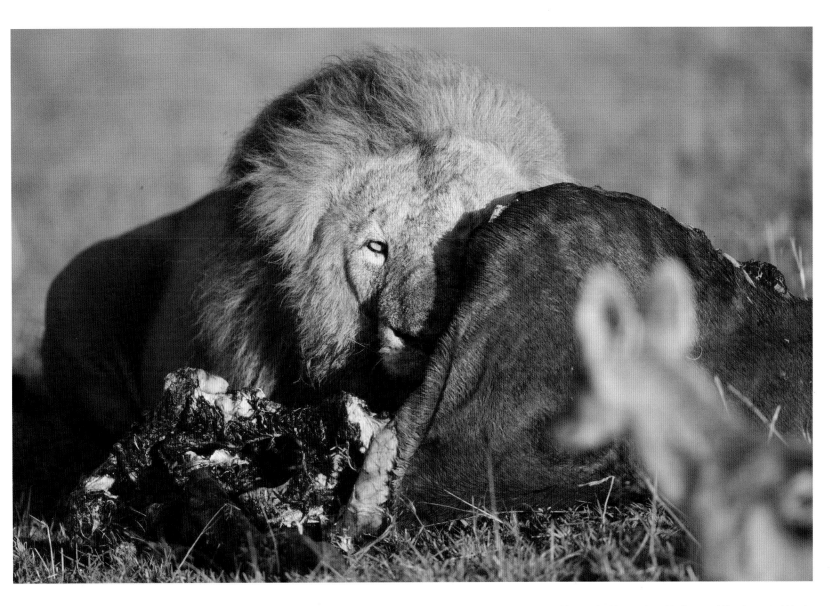

Above: As I focused on this lion at a kill, a frustrated black-backed jackal was wandering to and fro in the foreground awaiting his opportunity. I decided to try to catch him in frame, but decided against going for a greater depth of field, as I wanted him to appear as a sort of ghost that is constantly following and tormenting the lion. Hopefully, the jackal is sufficiently out of focus to do this, but also to make it clear that this was intended!

Focal length: 500mm

Aperture: f/4.5

Shutter speed: 1/1000 sec.

ISO: 400

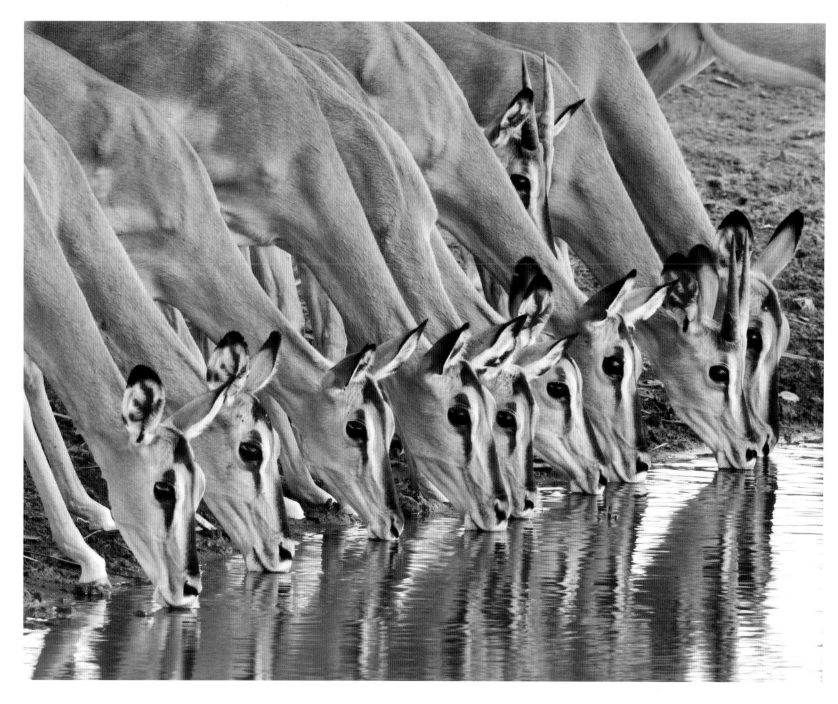

Above: The individual reluctant to lower its head to drink breaks the pattern nicely in this row of black-faced impala at a waterhole in Namibia.

Focal length: 800mm

Aperture: f/10

Shutter speed: 1/40 sec.

ISO: 160

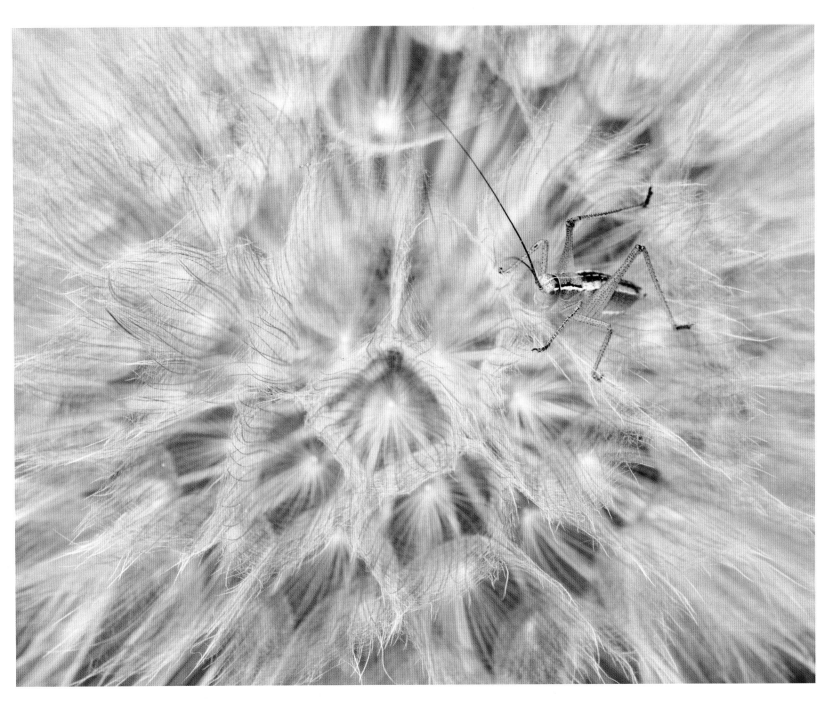

Above: Another example of the subject breaking a pattern. In this case, a bush cricket breaks the pattern formed by a salsify seed head.

Focal length: 168mm (macro)

Aperture: f/5.6

Shutter speed: 1/200 sec.

ISO: 160

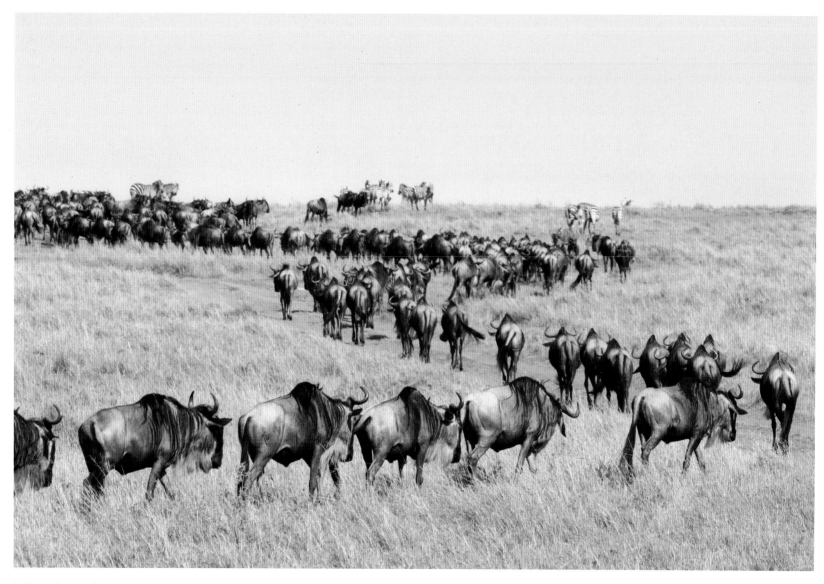

Viewing Angle

You can profoundly adjust your compositions and fine tune them by altering your position or by changing the focal length that you are using. We are all familiar with seeing the world from eye level, but getting higher or lower will produce less familiar angles, allowing you to gain impact through altered perspectives and relationships of the pictorial elements.

We are also usually looking down at most of our wildlife subjects, but the sense of connection and relationship will usually be much stronger if you get the camera down to their level. Faces are then viewed front-on and there is a greater sense of intimacy. With small animals, it can involve some extreme contortions, but the results are generally worthwhile. Using right-angle viewers or Live View mode and a tilting LCD screen can make things easier for the less flexible.

The angle of view you choose will depend on many things, including the features of the subject that you wish to emphasize. There will be times when you may strive to view them from above,

Above: The angle of view on the meandering route of these migrating blue wildebeest reveals a wonderful zigzag line.

Focal length: 304mm

Aperture: f/10

Shutter speed: 1/200 sec.

ISO: 320

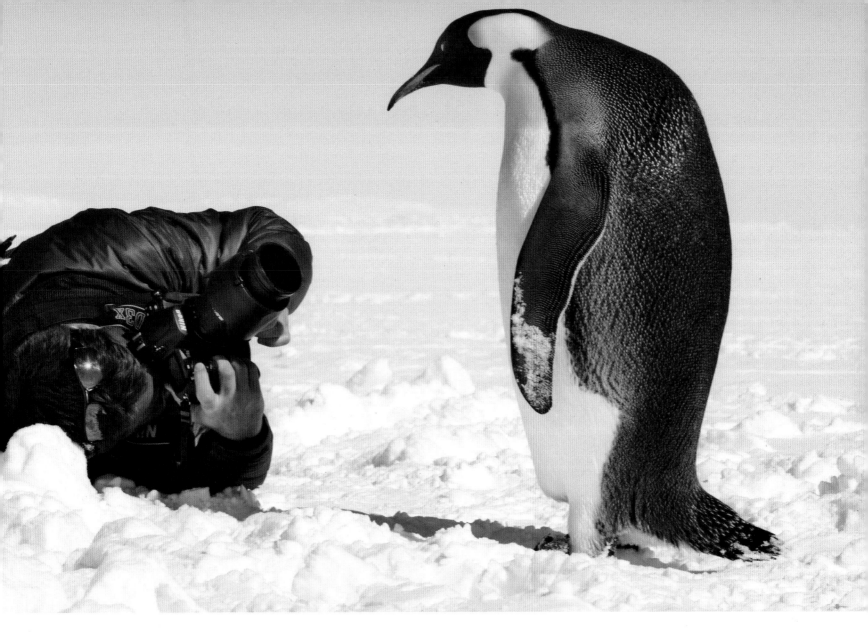

as with a butterfly with its wings spread, for example. Aerial photography is one way of getting less conventional views of larger animals in their environment. On the other hand the features that strike you may even require that you find some way of getting directly underneath.

Using different focal lengths can radically alter the size and position of the elements in a scene in relation to each other. Timing is also often critical, as it is often necessary to wait until the animals move into the right place. If they are moving quickly, continuous shooting mode may help ensure you get them in just the right position.

Before releasing that shutter, you need to consider how you could better position or balance things and note whether there are any undesired or superfluous elements that you could remove by changing your focal length or position, or by waiting for the animals to move a little. The general rule here is to simplify your image, getting rid of all distractions and non-essential elements.

Above: Good photography often involves some contortions and a willing subject like this bemused emperor penguin!

Focal length: 250mm

Aperture: f/22

Shutter speed: 1/250 sec.

ISO: 200

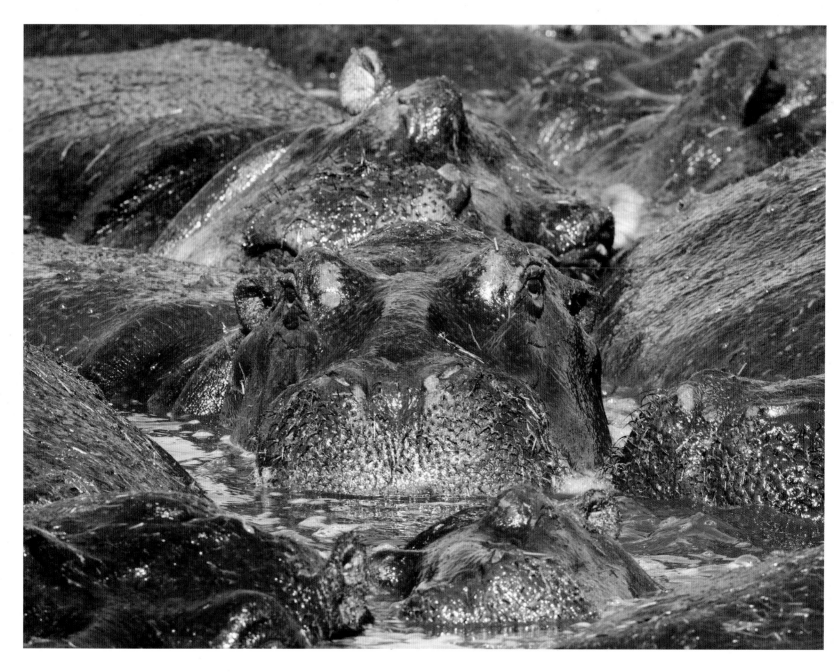

Above: Using a longer lens on a more distant subject obviates the need to get down so low, as with this hippo photographed from a riverbank in Tanzania. Longer lenses also give a sense of reduced distance between near and far elements in a scene, emphasizing the close packing of the hippos in this case.

Focal length: 800mm

Aperture: f/11

Shutter speed: 1/125 sec.

ISO: 200

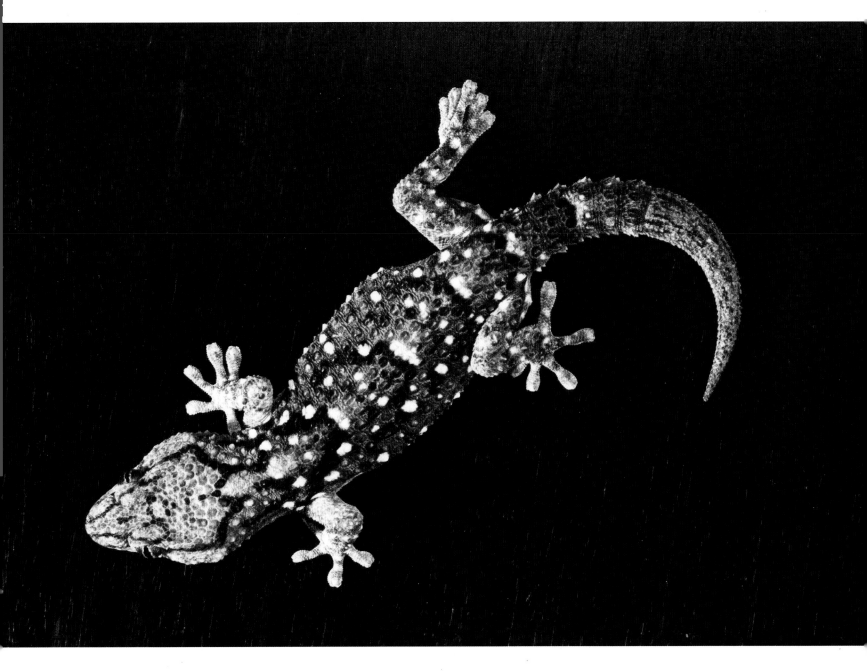

Above: I was struck by the shape and skin texture of this gecko on the door to my hotel room in Namibia. This angle seemed to best convey its shape and a mono conversion helped emphasize the relevant qualities.

Focal length: 117mm

Aperture: f/16

Shutter speed: 1/125 sec.

ISO: 250

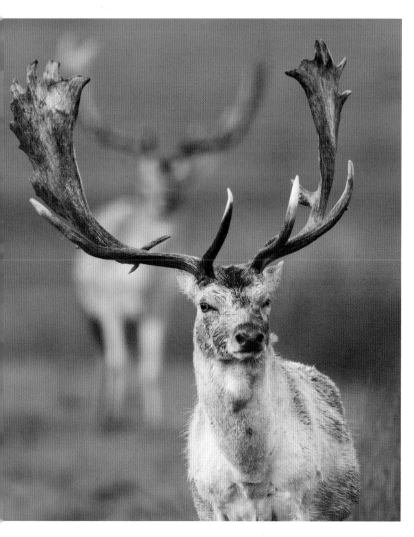

Backgrounds

The background has ruined many potentially great photographs, yet at the same time a lot of successful photographs depend on the nature and content of the background.

If you want all the attention to fall on the subject, you should generally look for a bland background of a complementary color that is free of distracting details, tones, and colors. Your choice of viewpoint and a wide aperture for minimal depth of field are the usual course of action here.

Above Left: An example of a background element being a critical part of the story—the distant fallow deer stag is seeing off his injured rival.

Focal length: 1120mm

Aperture: f/5.6

Shutter speed: 1/500 sec.

ISO: 320

Above: The head and horns of the buffalo in the background provide more context for this photograph of the yellow-billed oxpecker. They also provide a darker background, which helps the bird stand out.

Focal length: 800mm

Aperture: f/4

Shutter speed: 1/400 sec.

ISO: 320

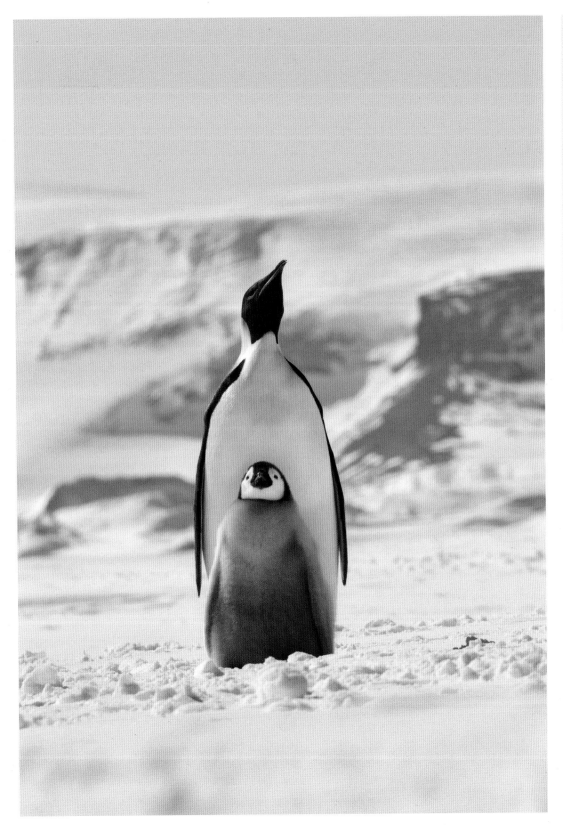

Make the subject fill the frame, so there is little competition for the viewer's attention.

If the background is distracting, consider changing your viewpoint. Sometimes a small adjustment to your shooting position can make a big difference to your photograph.

Use a larger aperture to blur background and foreground elements. Use your camera's depth of field preview button to check on this.

Compose the scene so that other elements support or take the eye to the main subject.

Make the subject brighter than its surroundings. Adjust your exposure accordingly, so the subject is exposed correctly.

Motion blur is an effective treatment for moving subjects: critical parts of the subject will be in focus while everything else is thrown into a pleasing directional blur.

A frame within the frame will focus attention more actively on what is contained within it.

Left: The background can give a sense of location. Here, the snow-covered rock face rendered slightly out of focus provides a pleasing tapestry supporting the emperor penguin and chick.

Focal length: 400mm

Aperture: f/16

Shutter speed: 1/1600 sec.

ISO: 400

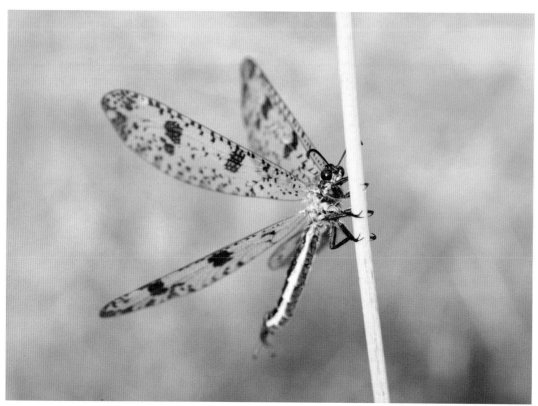

Left Top & Bottom: An example of how a 1-stop difference in aperture can affect the background markedly. The top photograph of this ant lion was taken at f/8 and the bottom shot was taken at f/11. In this sort of close-up work, your choice is often a compromise—the increased depth of field in the lower image at least renders the entire insect in focus.

Left Top:

Focal length: 105mm (macro)

Aperture: f/8

Shutter speed: 1/40 sec.

ISO: 100

Left Bottom:

Focal length: 105mm (macro)

Aperture: f/11

Shutter speed: 1/40 sec.

ISO: 100

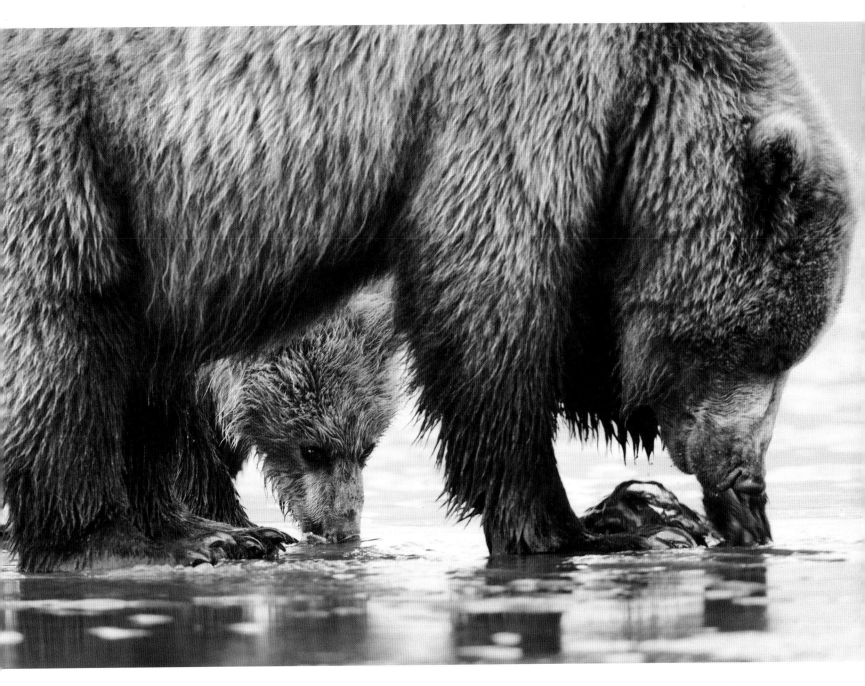

Above: This grizzly bear cub searching for razor clams strongly becomes the subject of this image by being framed between its mother's legs.

Focal length: 500mm

Aperture: f/7.1

Shutter speed: 1/125 sec.

ISO: 320

Color

Strong colors abound in the natural world and are often a key part of the fauna and flora that we wish to include in our photographs. Many creatures are attired in bold colors to advertise their presence: it can be a warning to potential predators that they pack a punch, or are not a tasty meal, or it can be a courtship statement. At the other extreme are creatures that prefer not to be seen and often their subtle coloration contributes to some remarkable camouflage. All this is worthy of representation in your imagery.

Color also acts as a potent element in our compositions, so needs to be introduced with care: it not only has a direct link to our emotions, but also has its own connotations:

- Yellow, the brightest color, is associated with warmth and friendliness, and can convey cheerfulness. However, at the other extreme, it can also suggest aggression.
- Red is also bold and energetic, and conveys vitality, power, love, danger, fear, and heat.
- Orange is the other warm color conveying a sense of heat and energy.
- Blue is a less active color and conveys coolness, tranquility, mood, and loneliness.
- Green says "growth, hope, youthfulness."
- Purple can suggest mystery and spirituality.

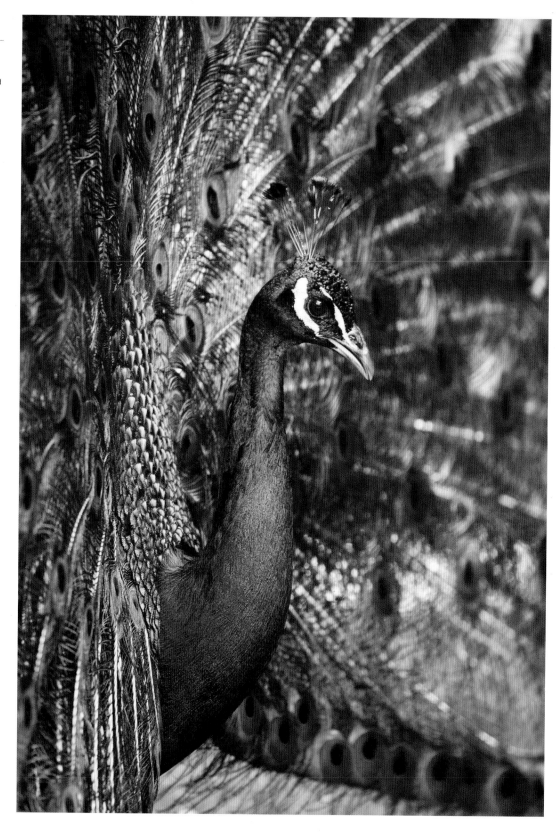

Right: The iridescent blues and greens of the peacock are certainly a bold statement, with display mechanisms used to support and accentuate them. I chose a slightly unusual angle here, with a degree of selective focus to draw attention to the areas of particularly vibrant plumage.

Focal length: 400mm

Aperture: f/6.3

Shutter speed: 1/60 sec.

ISO: 320

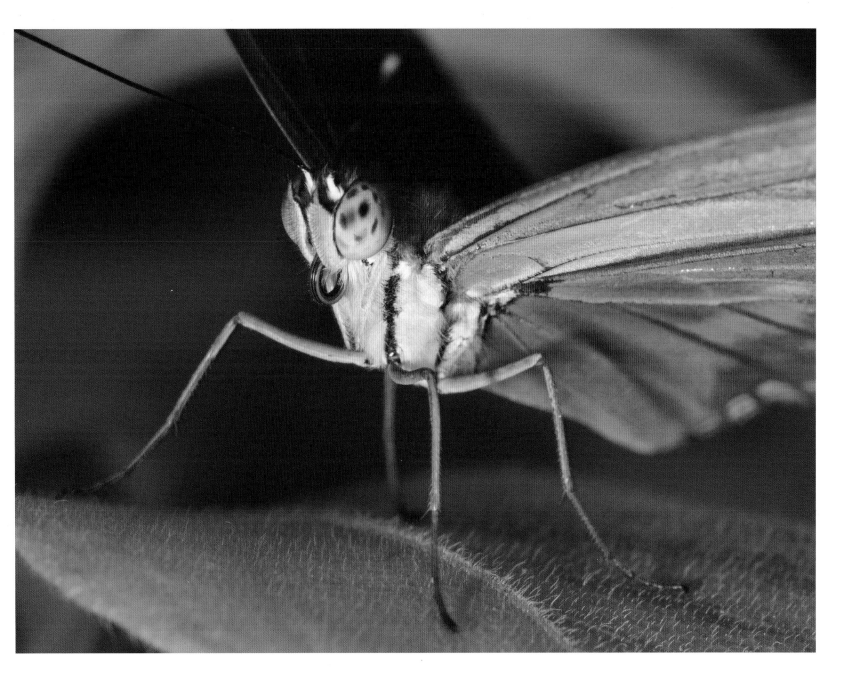

Above: The orange underside and reddish topside of the wings of this captive Flambeau butterfly are complemented nicely by the green background; the blurred arc of lighter tones forms a pleasing frame. Diffused flash helped to provide a more subtle variation of tone and colors.

Focal length: 168mm (macro)

Aperture: f/13

Shutter speed: 1/160 sec.

ISO: 160

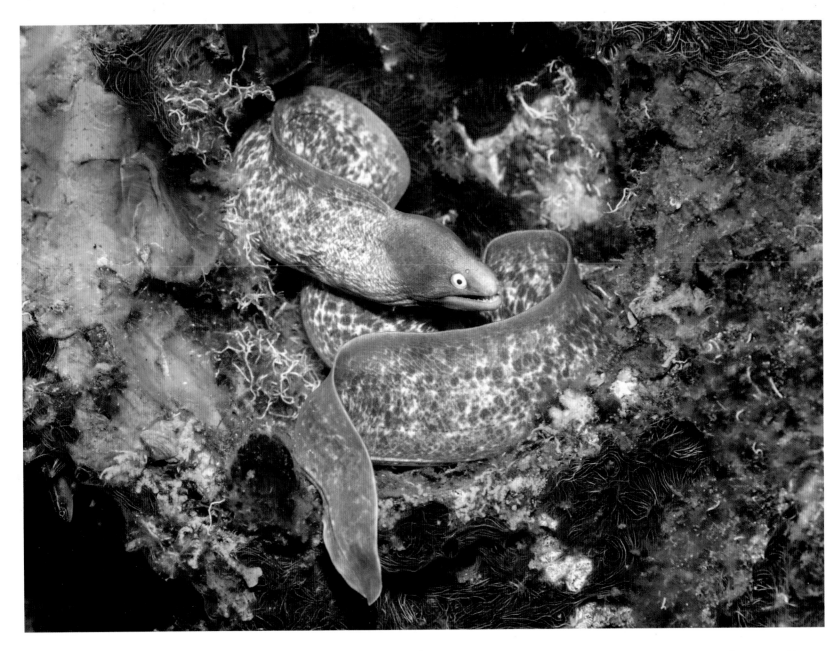

Bright colors and tones can also be a hazard, particularly when they act as distractions. So look out for these in the background and foreground— even when blurred they can still ruin a shot. Red and yellow in particular tend to catch our attention, so may need to be used with caution.

A common mistake in wildlife photography is oversaturation of colors. This often comes from trying to give an image that doesn't quite make the grade that extra boost. It can also arise as a byproduct of overcooking the contrast. Your audience is generally a little more sensitive in this regard too—most people love the animals for how they are and believe that nature has already perfected the hues and color patterns in your subject matter.

Above: An example of purple and yellow tones working well together. In this case a white-eyed moray eel nestles in a bed of purple sponge.

Focal length: 60mm

Aperture: f/8

Shutter speed: 1/200 sec.

ISO: 160

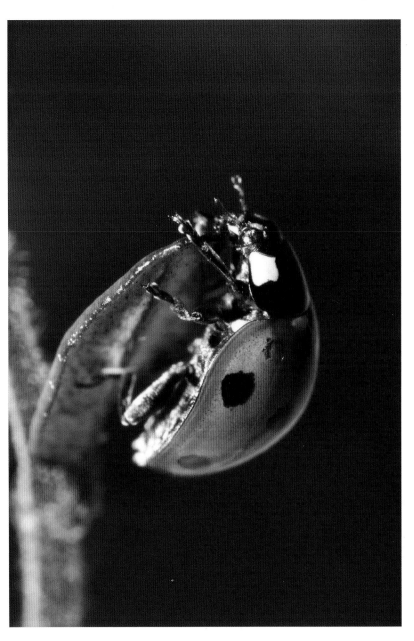

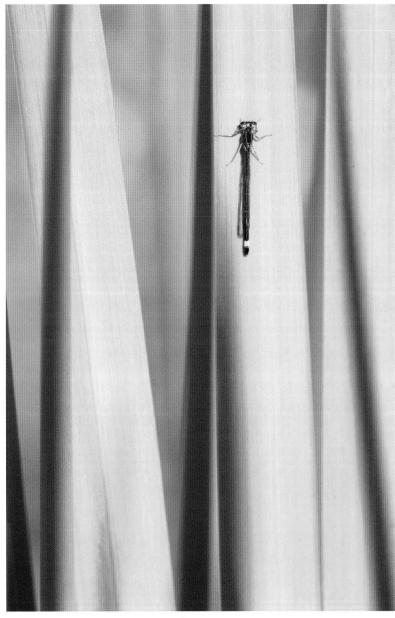

Above: The color of the background can change the whole mood of a picture. This shot of a ladybird was taken in the field, with distant foliage producing the purple backdrop.

Focal length: 168mm macro

Aperture: f/10

Shutter speed: 1/160 sec.

ISO: 320

Above: An image that is all about colors and lines. There is a pleasing pattern of soft vertical lines, but you can't miss the damselfly, which stands out due to its contrasting tones, color, and degree of focus.

Focal length: 168mm

Aperture: f/2.8

Shutter speed: 1/1000 sec.

ISO: 100

Capturing the Moment

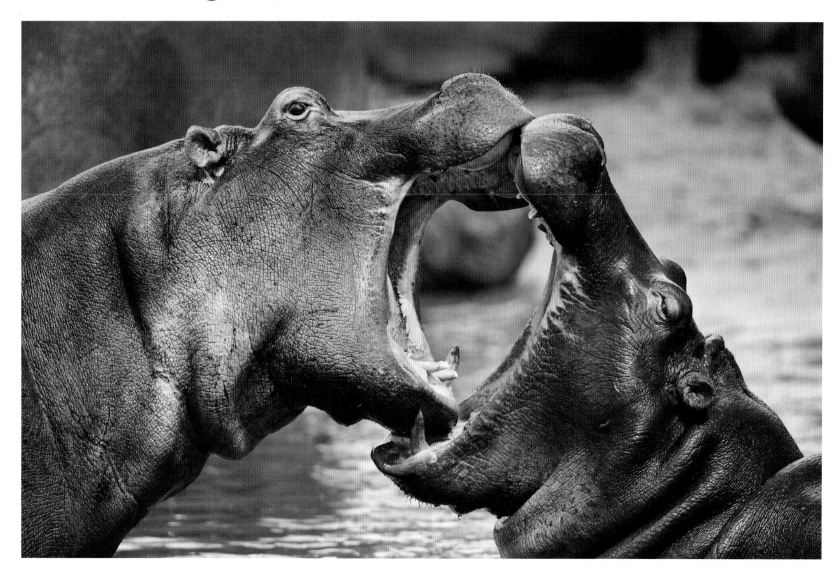

Many of the best wildlife photographs capture something special that occurs in a split second. This might be a posture, an expression, an interaction between individuals, or some unusual behavior. It might be a fleeting expression of emotion or a transient coming together of many factors, including lighting, to produce something special. It is your ability to capture and reveal these fleeting interactions and expressions that will enable the viewer to relate to and identify with what happened in that moment. Interactions between a mother and her young, courtship displays, territorial disputes, feeding, and hunting often provide these moments of high drama.

These images are not arrived at by chance alone (although this can help). Knowing your subject matter and its behavioral traits is going to be to your advantage, as will having a vision of what it is that you hope to capture. You are then more likely to be in the right place at the right time

Above: Hippos spend a lot of time during the day semi-submerged and not doing much. However, due to their enforced proximity to each other, disputes are bound to arise. They can be over in a second or two, so you need to be ready.

Focal length: 700mm

Aperture: f/7.1

Shutter speed: 1/320 sec.

ISO: 200

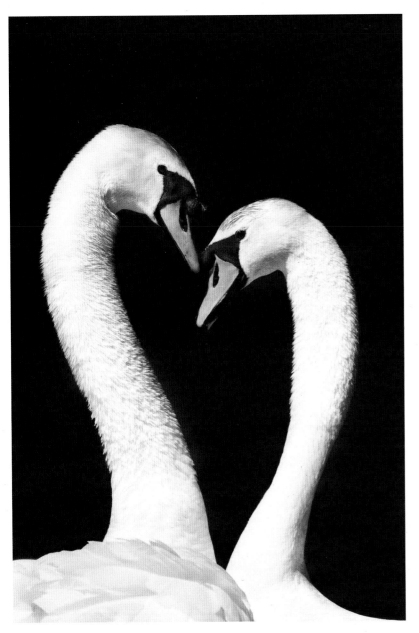

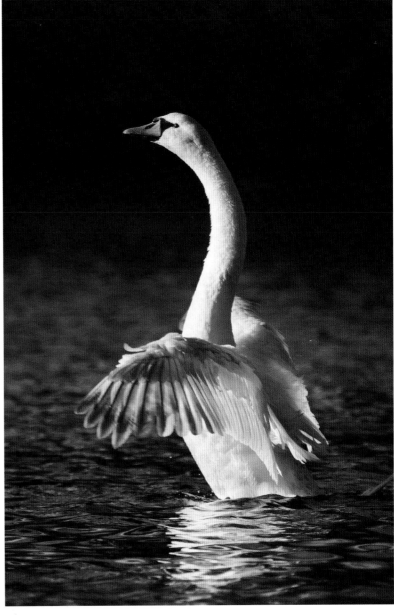

and you can better compose and prepare the scene through your viewfinder in anticipation of something that you know might happen.

You can also ensure that you have the right settings selected on your camera and lens. If you are expecting fast movement, you may need a faster shutter speed and therefore possibly a higher ISO. If it is an interaction between two individuals, you may opt to select a smaller aperture to ensure a large enough depth of field.

Above Left & Right: These two images of mute swans depended on me capturing a moment. In the first (above left), the necks and heads of the pair form a heart shape, which is quite symbolic, as the tendency of this species is to form lasting partnerships. In the second photograph (above right), the lighting and transient posture come together to make an image with impact.

Above Left:

Focal length: 240mm

Aperture: f/5.6

Shutter speed: 1/2000 sec.

ISO: 160

Above Right:

Focal length: 390mm

Aperture: f/5.6

Shutter speed: 1/1600 sec.

ISO: 200

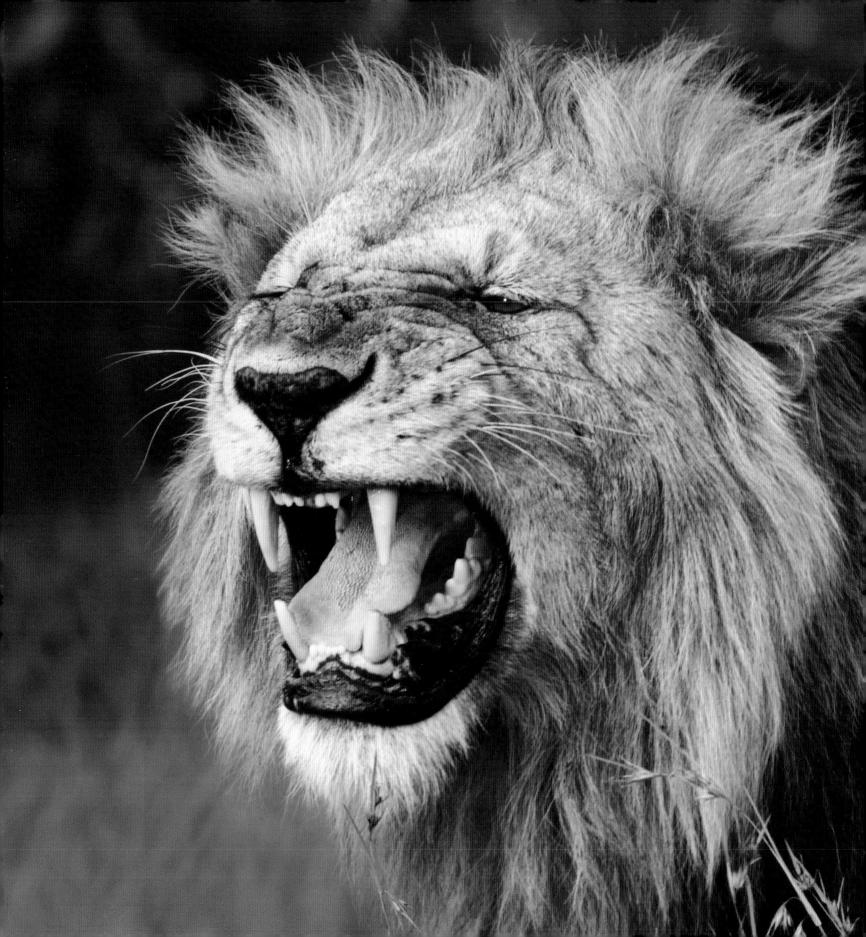

Right: I followed these two zebra stallions through the viewfinder for quite some time as they intermittently chased each other around the periphery of their herd. I was then ready to catch the moment as they both reared up.

Focal length: 480mm

Aperture: f/8

Shutter speed: 1/500 sec.

ISO: 200

Good field craft may be necessary to help you get into the right place. When selecting a viewpoint, you will also need to bear in mind the direction of the light, as well as the background, foreground, and position of any other elements that you may wish to include in the scene to support your intended message.

Once in the desired place, a great deal of patience may then be required. When there is a chance of something special happening you may need to concentrate for a long time with your eye tight to the viewfinder, following the movements of the animals, keeping the focus locked on your subject, and with your finger poised over the shutter-release button.

You also have to be prepared for the disappointments. More often than not, the anticipated event, posture, or expression will not occur, or if it does, it will be in that split second when you take your eye from the viewfinder to check your watch. As a wildlife photographer you often need a measure of optimism to drive you, and a sense of humor to help you overcome the inevitable frustrations.

Left: You need to be ready to catch fleeting expressions, as was the case with this lion appearing to snarl. In fact, it is what is known as the "flehmen grimace," where the lips are curled back, allowing the lion to sample the air for pheromones.

Focal length: 800mm

Aperture: f/6.3

Shutter speed: 1/30 sec.

ISO: 400

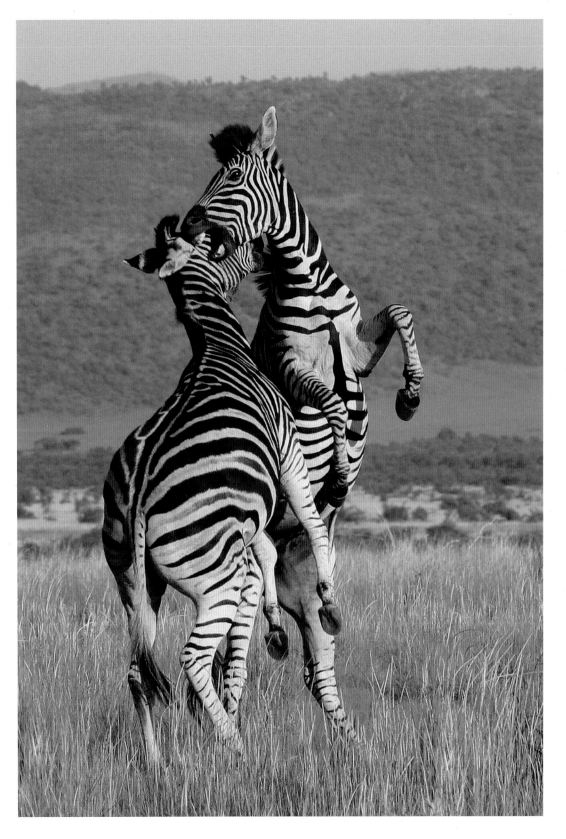

Exposure & Settings

Raw or JPEG?

Raw is the preferred file type for serious photographers, as it enables you to maximize image quality. This is because no in-camera processing is performed on a Raw file; instead, images are processed using Raw conversion software on your computer.

Having adjusted your Raw images, they are then usually saved as TIFF files, which can be worked on repeatedly, and re-saved without loss of data due to compression of the file. To maximize image quality, it is generally best to work on the TIFF files as 16-bit or 32-bit files, rather than 8-bit files. This way, adjustments will have less impact on image quality. Once you are confident that the image is ready for output, you can usually reduce it to an 8-bit version without a significant loss in quality of the printed image.

The universal JPEG format is a compressed file form that discards image data to enable the size of the file to be reduced. This reduces quality every time you re-save the file—a loss that is not only cumulative, but also permanent.

If you opt to shoot JPEGs (because you have limited storage space on your memory cards, need to shoot a long series in continuous shooting mode, or simply don't have the time to edit shots individually), it is important that you get the white balance and exposure settings correct in-camera, as this is where the image is processed.

Your choice of picture style setting also becomes more critical. These are in-camera processing options such as Portrait, Landscape, and Standard that can affect sharpness, contrast, color saturation, and color tone. If you get this wrong and need to make adjustments to the image on the computer it will be a more degrading process when you shoot JPEG.

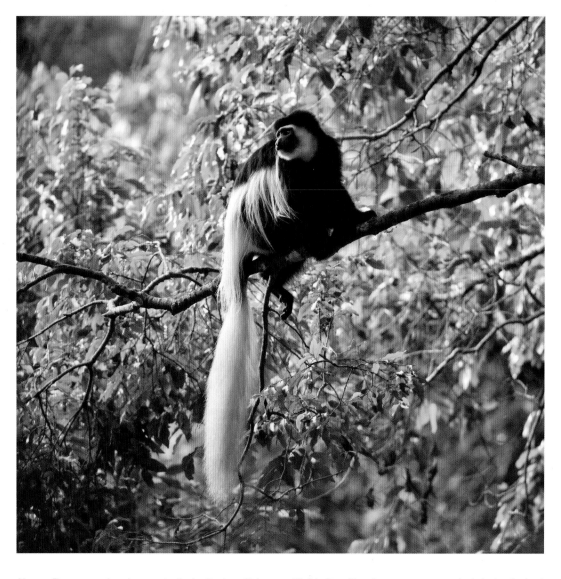

Above: The pose and angle serve to display the beautiful coat and tail of the black-and-white colobus monkey. Any black-and-white animal can be a challenge in terms of exposure: shooting in Raw can give you a little more leeway in terms of retaining detail.

Focal length: 700mm

Aperture: f/5.6

Shutter speed: 1/640 sec.

ISO: 100

Right: Raw files give you more scope for bringing the best out in an image, as with these emperor penguins appearing to have some fun in Antarctica. Here it was essential to retain detail throughout the extreme range of tones represented in the image.

Focal length: 400mm

Aperture: f/25

Shutter speed: 1/200 sec.

ISO: 200

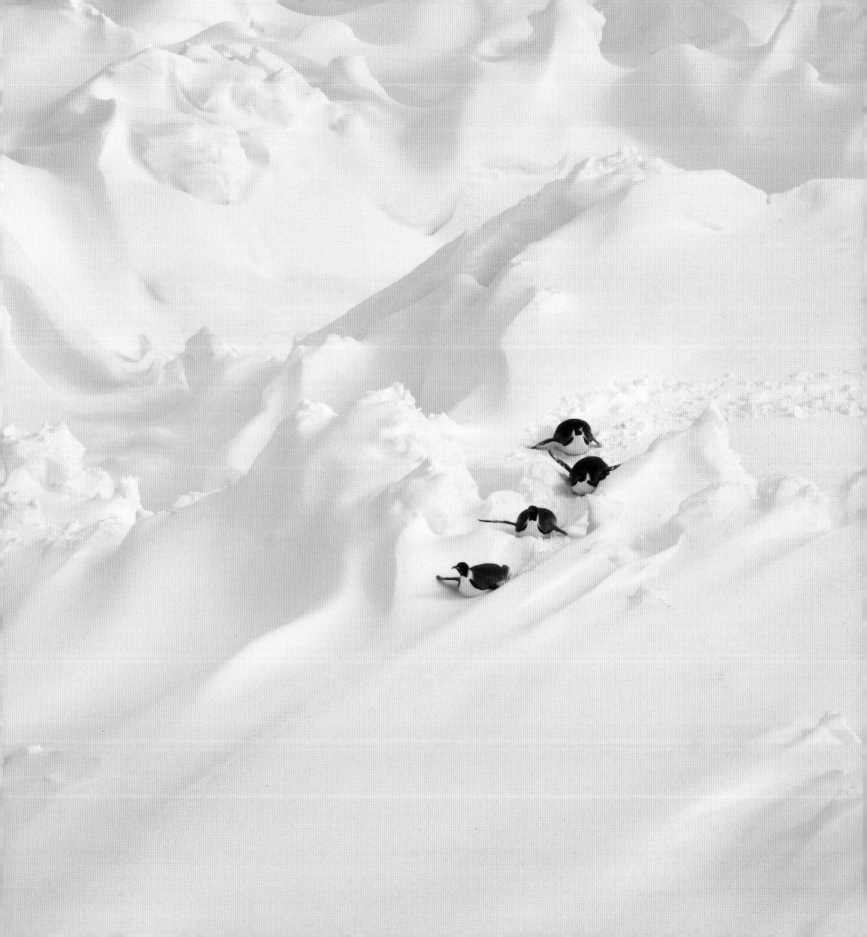

Exposure Essentials

Exposure settings are based on EV (Exposure Value), which relates to aperture, shutter speed, or ISO settings. ISO ratings are a measure of a sensor's sensitivity to light. At higher settings the signals generated on the sensor by light hitting it are amplified. Unfortunately, in addition to the "good" image-forming signal being heightened, any non-image-forming signal ("interference") is also magnified, resulting in "noise."

At higher ISO settings you will see more chroma noise (colored speckles) and luminosity noise (an overall textured speckling), which is particularly apparent in the darker parts of the image. For this reason it is a good idea to retain control over the ISO setting, rather than relying on your camera's Auto ISO option.

Having said that, there have been marked improvements in controlling noise at higher ISO settings. This gives you more options. You can often handhold the camera where before you would have needed a tripod, for example; you might get away with ambient lighting when light levels are low whereas before you would have needed to use flash; you can use faster shutter speeds to guarantee freezing action; and you can use smaller apertures to ensure adequate depth of field.

In addition to the sensitivity of the sensor, the exposure is a product of aperture and shutter speed. Photographers tend to speak in terms

Right: A few years ago I would have kept my ISO down to 200–400 in a situation like this, to ensure a noise-free image. With modern cameras, however, I would rather raise the ISO to 1000 and use a shutter speed that guarantees any movement is frozen.

Focal length: 700mm

Aperture: f/8

Shutter speed: 1/640 sec.

ISO: 1000

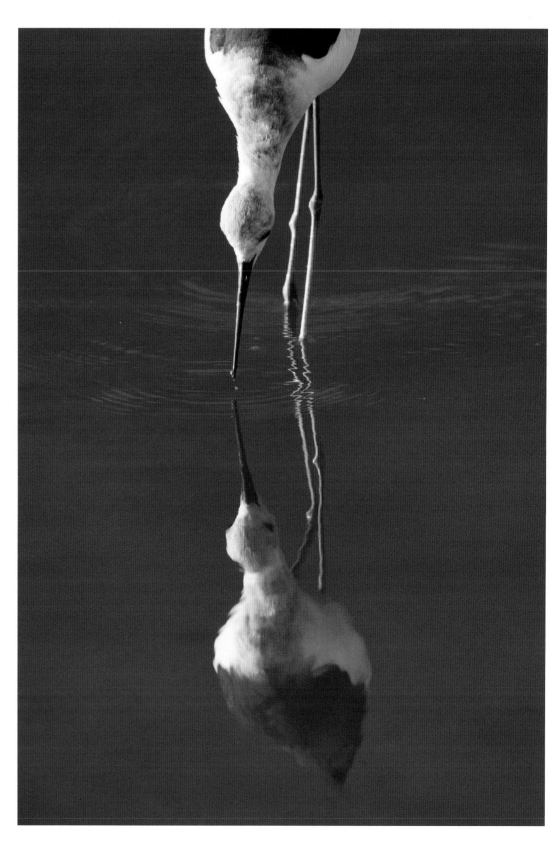

of "stops," where each increase in aperture f-number results in half the amount of light passing through the lens, necessitating a halving of the shutter speed (a doubling of the exposure time) to provide the same exposure.

For wildlife photography, sharp images are generally critical and so a shutter speed that is fast enough to freeze any movement of the animal and/or of the camera is essential. The usual rule of thumb is to select a shutter speed equal to the effective focal length to counter any movement caused by "camera shake." So, for example, with a 300mm focal length you'd use a shutter speed of at least 1/300 sec.

However, with image stabilization technology and a beanbag, you can usually reduce this significantly. Image stabilizing systems in lenses or cameras will often buy you an extra 2–3 stops, although for maximum benefit you usually need to allow about one second after half pressing the shutter-release button before the stabilization reaches optimal performance.

Your main concern when determining the aperture you select will be the depth of field you require. Also bear in mind that lenses have a "sweet spot"—an aperture at which they produce their best image quality in terms of sharpness. The general rule regarding this is to close the aperture down by 2–3 stops from its maximum setting to ensure the sharpest images. Quality decreases again at very small apertures due to light diffraction.

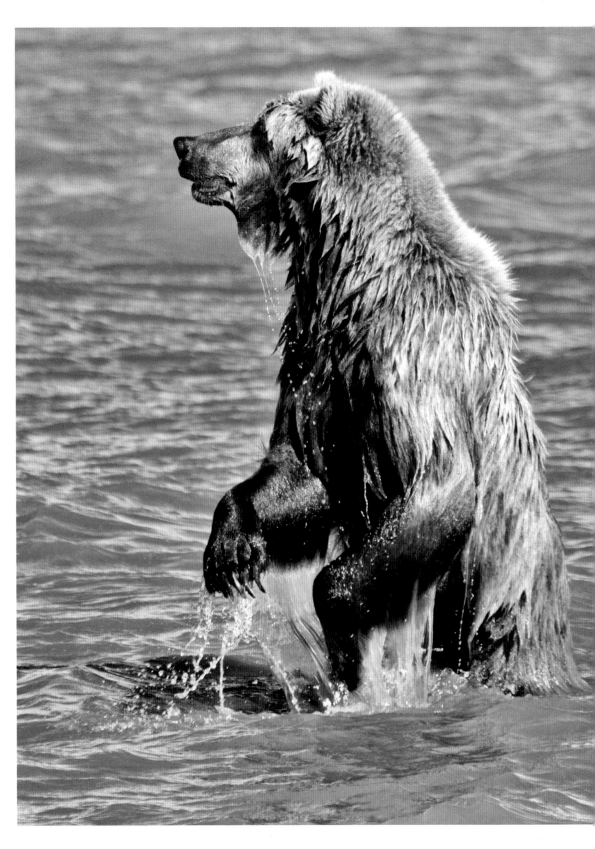

Right: A shutter speed of 1/400 sec. proved sufficient to freeze the movement of the brown bear emerging from the seawater, while also minimizing the risk of camera shake from handholding a 400mm effective focal length.

Focal length: 400mm

Aperture: f/6.3

Shutter speed: 1/400 sec.

ISO: 400

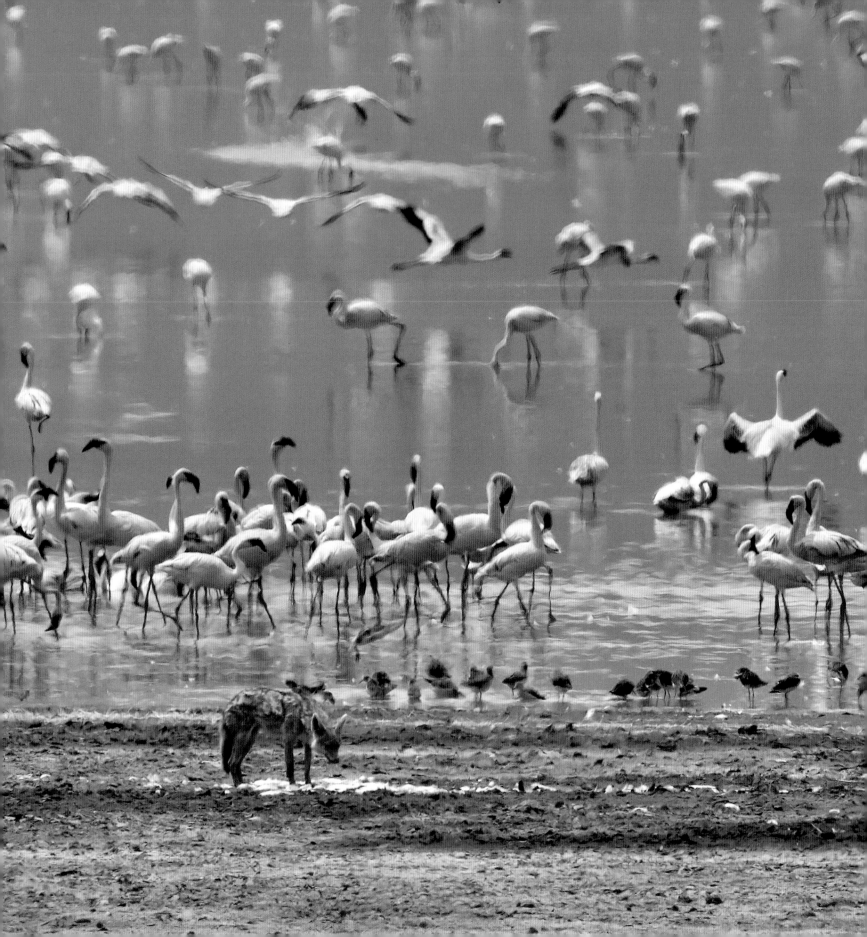

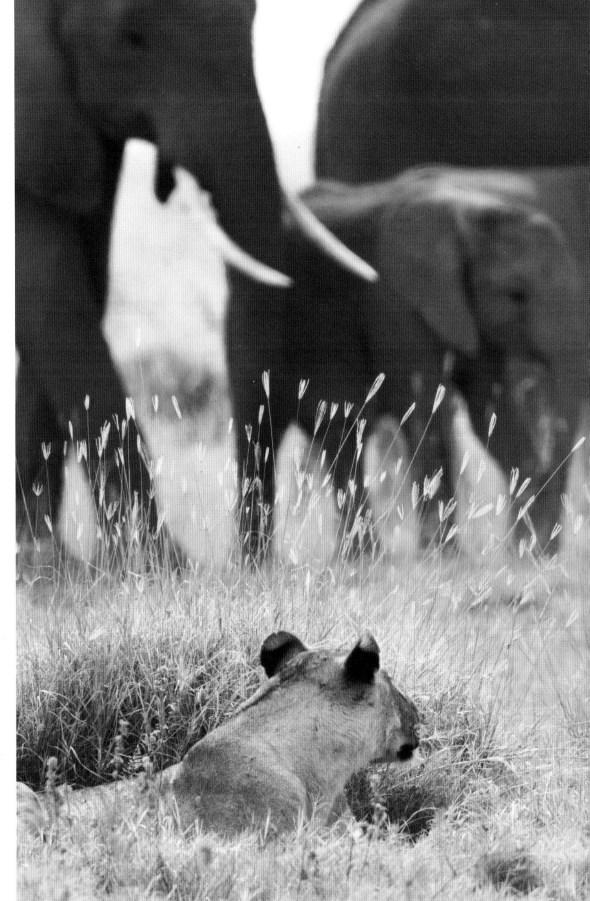

Left: An aperture of f/14 was used to keep the scavenging common jackal and the nearer flamingoes in focus in this scene on the salt lake in Ngorongoro Crater, Tanzania.

Focal length: 700mm

Aperture: f/14

Shutter speed: 1/400 sec.

ISO: 200

Right: Elephants will often chase lions away and here I wanted to show this lioness hiding rather nervously behind a clump of grass as the herd passed her by. An aperture of f/13 was selected to provide an appropriate level of detail in the passing elephants.

Focal length: 1120mm

Aperture: f/13

Shutter speed: 1/125 sec.

ISO: 160

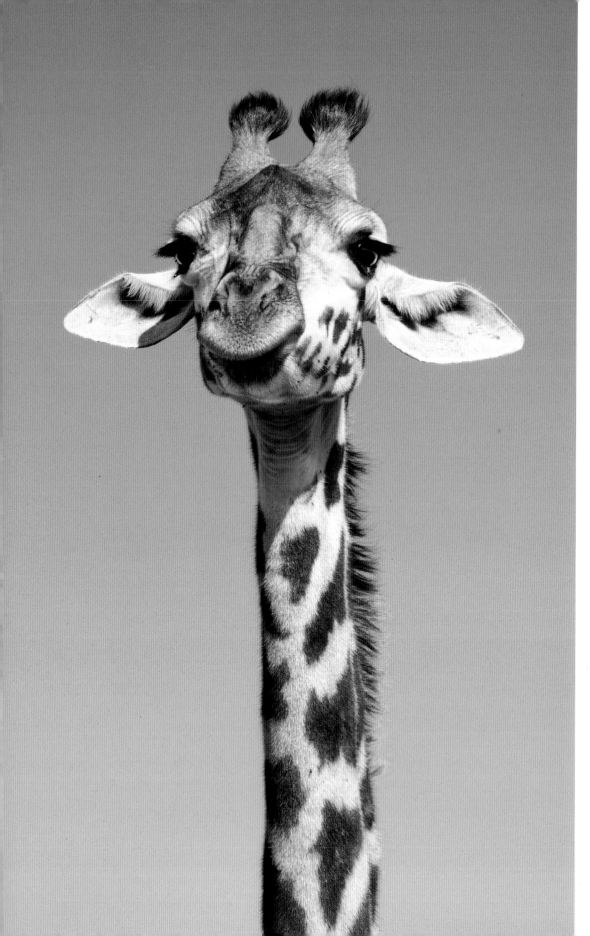

Exposure Meter

Before turning to the issue of the camera's exposure metering options and auto-exposure settings, it is worth reminding ourselves that the exposure meter in your camera is simply calculating the exposure that will provide a medium gray tone.

However, to get the correct exposure for a given subject, you will need to take into consideration the subject's reflectance. For example, you wouldn't want a white, sandy beach, snow scene, or polar bear to appear gray. You would therefore need to dial in some exposure compensation, "opening up" to make the exposure brighter.

Snow typically requires +2 stops, for example, so for an animal in a snowy scene you may elect to dial in +1 to +1½ stops above the exposure suggested by the camera's meter. The exact amount will depend on the portion of the scene taken up by the snow relative to the darker tones of the animal, but this would ensure that the snow appears reasonably white and that some detail is revealed in the darker tones of the animal.

For a foggy scene, you might also use +1 to +1½ stops of compensation, while for a flowing waterfall, you could meter off the white water and add +2 stops.

For a dark or black subject you may choose to reduce the exposure, "stopping down" a little to underexpose and keep the tones more natural.

Left: This portrait of a giraffe, taken against a relatively bright blue sky, needed +1 stop of exposure compensation.
Focal length: 160mm
Aperture: f/5.6
Shutter speed: 1/320 sec.
ISO: 250

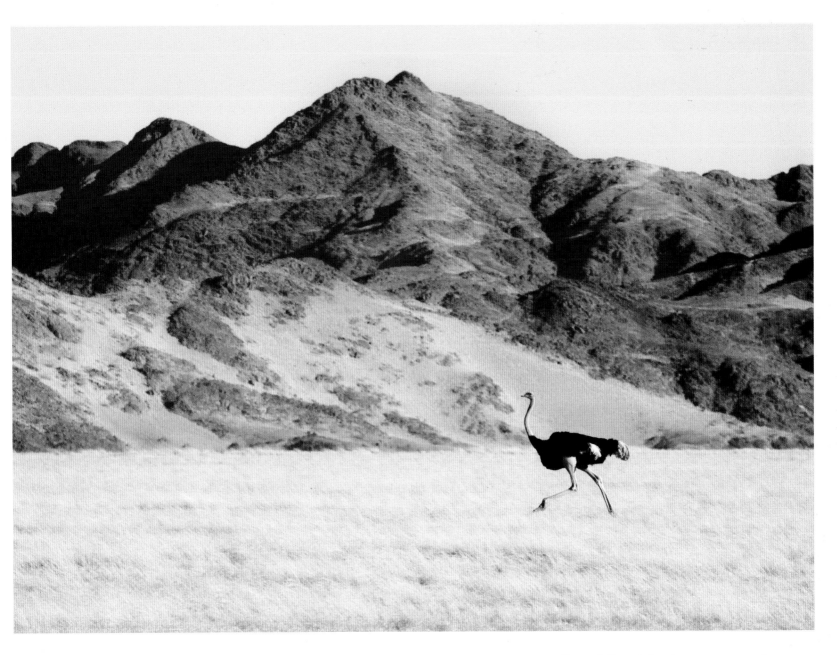

Above: Setting +1 stop of exposure compensation was appropriate for this Namibian scene being crossed by the running ostrich. A large part of the vista is the bleached grass and this would otherwise have caused the camera to underexpose the image.

Focal length: 376mm

Aperture: f/9

Shutter speed: 1/640 sec.

ISO: 320

Metering Modes

Different camera manufacturers have adopted various terms for the light metering modes offered by their cameras, but they are all variations of four standard options:

- Evaluative/Matrix/Multi-zone/Multi-segment: The light reading is taken from all over the image field.
- Center-weighted/Average: The light reading is taken from all over, but is biased toward the central portion.
- Partial: The light reading is taken from the central 8% of the image field.
- Spot: The light reading is typically taken from a spot at the center of the image field.

Which metering mode you choose will depend on the situation. Multi-segment tends to be a good fallback for general use, and with experience you can easily dial in a little negative or positive exposure compensation to fit the scene and subject matter before you shoot.

Center-weighted is also useful for wildlife photography, especially when you are using long lenses and have your subject matter at the center of the frame. In particular, portraits suit this mode as the exposure generally must be correct on the animal's face and eyes. It is worth noting here that many digital SLRs lock the exposure setting after a light press on the shutter-release button, at the same time that autofocus is achieved. It may be necessary to take this into account when you choose to focus on part of a scene and then reframe before taking the shot.

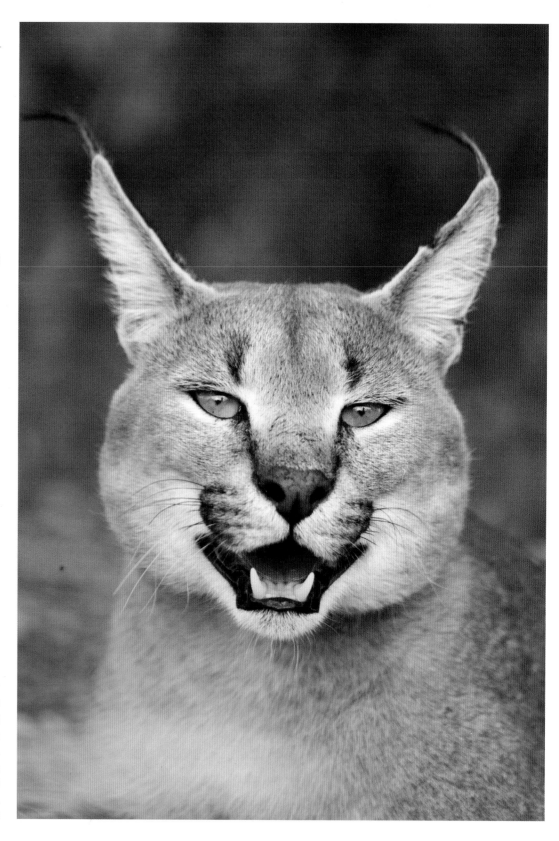

Right: Center-weighted exposure metering works well for this sort of situation, where the captive caracal's face fills a large part of the center of the frame. Evaluative metering would be influenced by the darker background, resulting in an overexposed face.

Focal length: 360mm

Aperture: f/5.6

Shutter speed: 1/50 sec.

ISO: 400

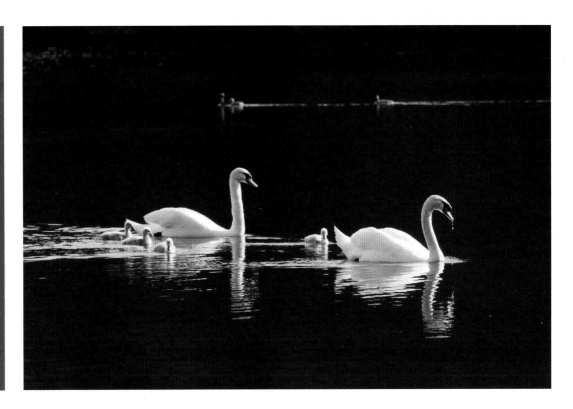

Spot metering (and partial metering) is useful when there is a critical but small part of the scene that must be exposed correctly. It is usually used in conjunction with the Manual exposure mode. This can be particularly effective when photographing and trying to retain detail in subjects that are at either end of the tonal range, particularly when the lighting is producing extremes of contrast.

It is often worthwhile checking your camera's histogram after taking the first shot, particularly in bright light, as it's often difficult to determine whether you've got the exposure right simply by looking at the image on the LCD screen. Set your camera so that when you review an image the histogram is also visible in the screen.

With experience you soon learn what shape you would expect your histogram to be for a given scene, but don't always expect the histogram to be centered. For example, in a high-key shot the image has more light tones, so the histogram would be shifted to the highlight (right) end of the range. Conversely, a low-key image has more dark tones, so the curve will be shifted to the darker (left) end of the range.

The main thing initially is to notice when part of the curve is lost off the end of the histogram—particularly at the right side, which would indicate that detail in part of the image has been lost due to overexposure ("burnt out" or "blown highlights" are other terms describing this phenomenon). The "clipped highlights" warning facility is a useful function to activate—when an image is viewed any areas with blown highlights will flash on and off.

Above: The contrast in this scene is as high as you are likely to get. You would want to retain the detail in the family of mute swans, but render them white rather than a duller gray. Losing detail in the specular highlights of the water is acceptable and also in the darker background.

Focal length: 304mm

Aperture: f/7.1

Shutter speed: 1/200 sec.

ISO: 250

Exposing to the Right

In your quest for images of optimal quality it is worth considering exposing to the right, or "ETTR." Here, the camera is set to Raw and the exposure is biased so that the histogram is shifted toward the right (the highlights end of the spectrum), as far as possible without highlight detail being lost. The exposure is then brought back to appropriate levels when you convert the Raw file and process the image.

Files treated in this way will contain more tonal information and suffer less from noise, particularly in the darker areas. The reason for this is that digital sensors are linear devices so each stop records half the light of the previous one. Therefore, half the tonal levels available are found within the brightest stop, half the remainder within the next one down, and so on. So, if you try to lighten an underexposed image, the tonal transitions will not be as smooth and there will be more risk of posterization (abrupt changes in shading/tone). The ETTR method does, however, involve longer exposures (or wider apertures) and the risk of clipping highlights, so may not always be a risk worth taking.

When you have a range of tones in the scene that exceeds the range that a digital sensor is typically able to handle, you could consider exposure blending if the camera is on a tripod and the subject matter is static. However, opportunities for this with most wildlife photography are limited.

Graduated filters also have a place in our kit—particularly for taking broader views of animals in their environment, where they can help balance a bright sky with the darker land and subject.

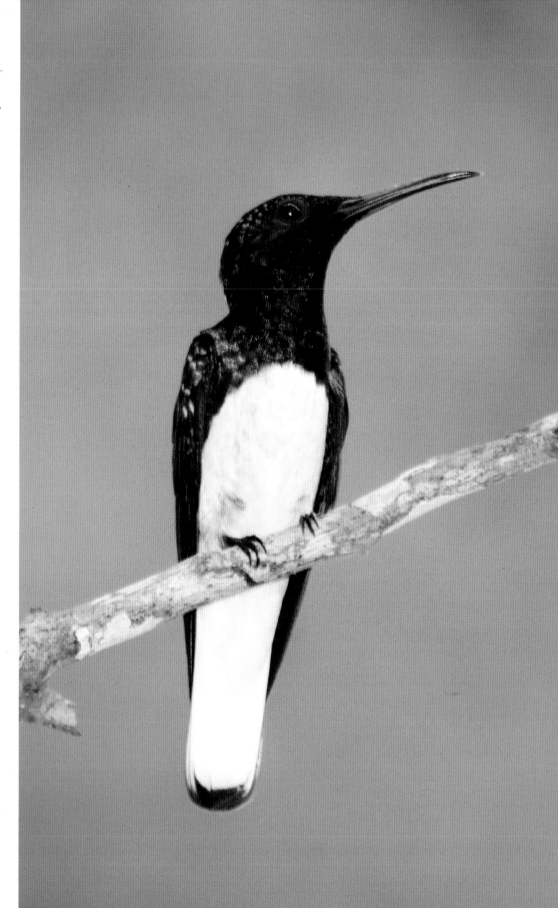

Left: When taking photographs of dark subjects with white patches, such as this white-necked jacobin, it is often worth reviewing the image and histogram immediately to check that detail is not lost in the white zone.

Focal length: 640mm

Aperture: f/5.6

Shutter speed: 1/320 sec.

ISO: 320

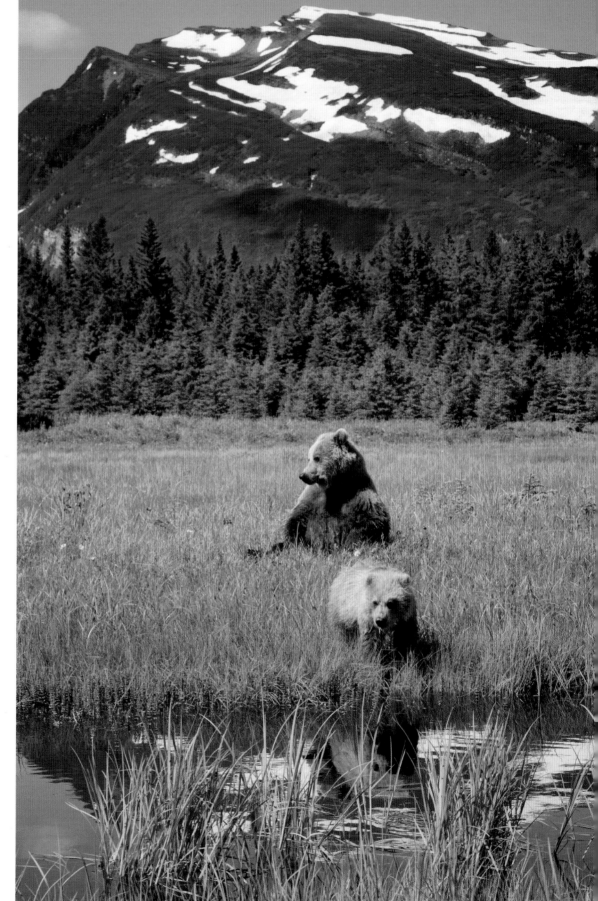

Right: An example of a broader view where a neutral density gradient filter came in handy to balance the tones of the snow-capped mountains with the rest of the scene.

Focal length: 75mm

Aperture: f/13

Shutter speed: 1/100 sec.

ISO: 400

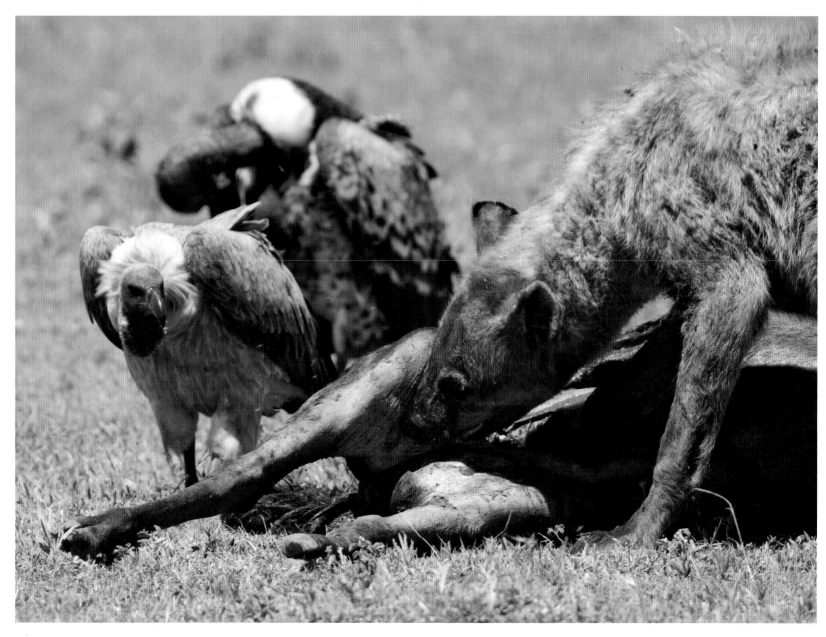

Exposure Modes

As well as a choice of metering modes, you also have a range of exposure modes, including Programmed Auto (P), Shutter Priority (S or Tv), Aperture Priority (A or Av), and Manual (M). In Programmed Auto mode you select the ISO, but the camera chooses the shutter speed and aperture. In Shutter Priority you select the ISO and shutter speed, and allow the camera to choose the appropriate aperture—you might opt for this to ensure that a moving subject is rendered sharp. In Aperture Priority you decide the aperture leaving the shutter speed to the camera—this might be a good choice where the depth of field is critical. Finally, in Manual mode, you control the ISO, shutter speed, and aperture.

Above: Where there is a number of moving elements potentially forming your compositions, Aperture Priority mode enables you to rapidly adjust the aperture to control depth of field. For this photograph of a hyena feeding on a wildebeest carcass, while being closely watched by a white-backed vulture, f/7.1 proved appropriate.

Focal length: 1120mm

Aperture: f/7.1

Shutter speed: 1/200 sec.

ISO: 100

Right: An example of a situation where you might focus at the hyperfocal distance to maximize depth of field, rather than focusing on the point of most interest.

Focal length: 220mm

Aperture: f/18

Shutter speed: 1/40 sec.

ISO: 250

Depth of Field

When you need to be confident that two or more elements at different distances are in focus, it can be helpful to calculate the hyperfocal distance. For any effective focal length and aperture combination there is an optimum distance at which you focus to maximize depth of field. If you focus at this distance, then everything from half that distance to infinity will be acceptably sharp.

On many prime lenses you can use the depth of field scale on the lens barrel to estimate this. Alternatively you can use tables, charts, or apps to determine the hyperfocal distance for your focal length and your camera type.

Drive Mode

Things often happen quickly in wildlife photography and to improve your chances of capturing the moment it's generally a good idea to set your camera's drive mode to Continuous, rather than Single shot so that you can fire off a sequence of shots. Firing off three or four shots in quick succession will give you a good chance of capturing a definitive moment.

Overleaf: When the action hots up, your camera's Continuous drive mode can enable you to catch the one frame that really works. This image of stampeding blue wildebeest gets its sense of disturbance from the head orientations of the animals on the right. The one with its head tilted back is crucial, catching the viewer's eye as it drifts from left to right.

Focal length: 1120mm

Aperture: f/7.1

Shutter speed: 1/200 sec.

ISO: 100

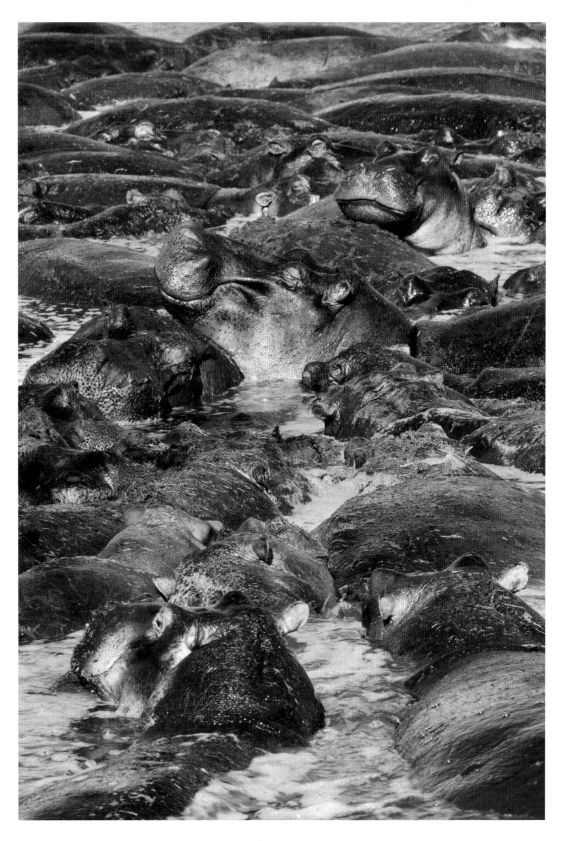

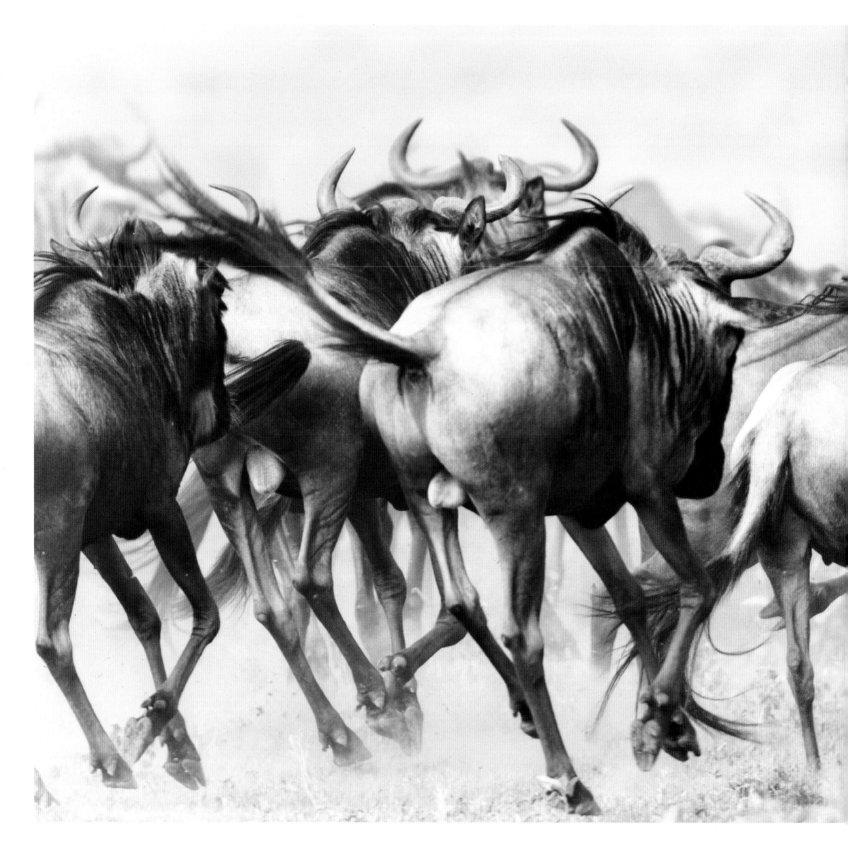

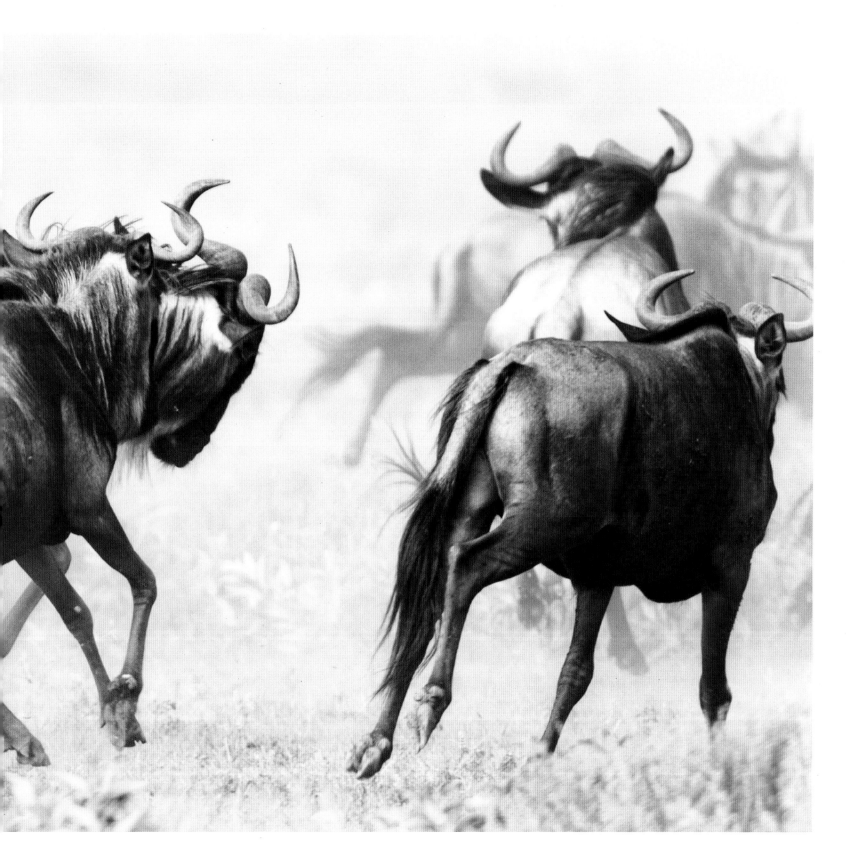

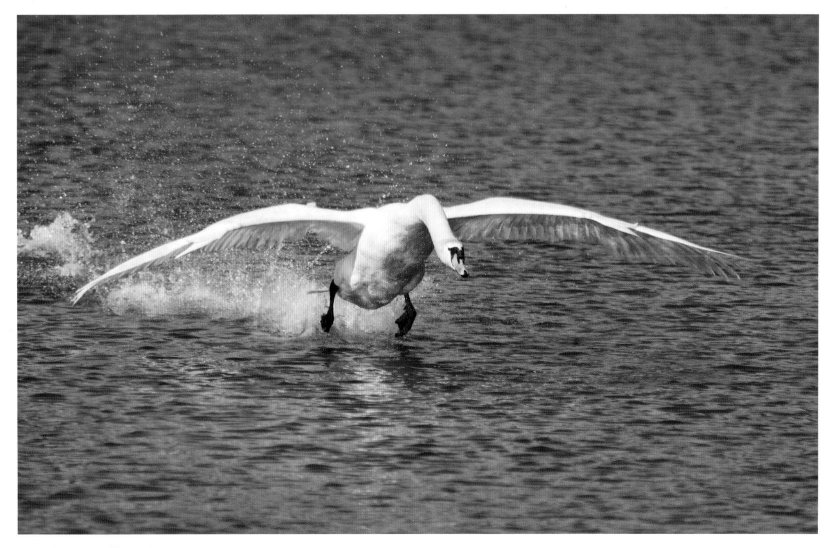

Autofocus Settings

The terms used for the various autofocus (AF) modes differ between manufacturers, but typically they all provide the following options:

- A single focusing action initiated by half pressing the shutter-release button. This can be useful for portraits when you can focus precisely on the eye and then reframe before taking the shot. Canon calls this mode One-Shot or Single Servo AF; Nikon calls it Single-Servo AF (AF-S).
- Predictive Autofocus (called AI Servo by Canon and Continuous-Servo/AF-C by Nikon), means the focus can follow a moving object, continually refocusing on the selected focus point. This, of course, is appropriate for moving wildlife. This form of focusing is also "predictive" on most modern cameras—the camera predicts continued movement and adjusts focus during the delay between you pressing the shutter-release button and the exposure being made.
- Some manufacturers offer an option for the camera to automatically switch from one to the other if the subject starts to move. This feature is referred to as Auto-Select AF (AF-A) by Nikon and AI Focus by Canon.

Above: Predictive AF enables you to capture a series of focused shots in this sort of situation. You can then choose the one in which the elements come together to make the most compelling image.

Focal length: 544mm

Aperture: f/5.6

Shutter speed: 1/800 sec.

ISO: 160

Right: When employing a degree of motion blur, as in the case of this galloping zebra, the slower shutter speeds required together with the fact that the background will tend to be nicely blurred by the motion enable you to use a smaller aperture. This tends to mean that the point of focus is less critical, due to the greater depth of field. However, it is still important to get your auto focus tracking locked on to the head of your subject, particularly with long lenses.

Focal length: 320mm

Aperture: f/16

Shutter speed: 1/25 sec.

ISO: 125

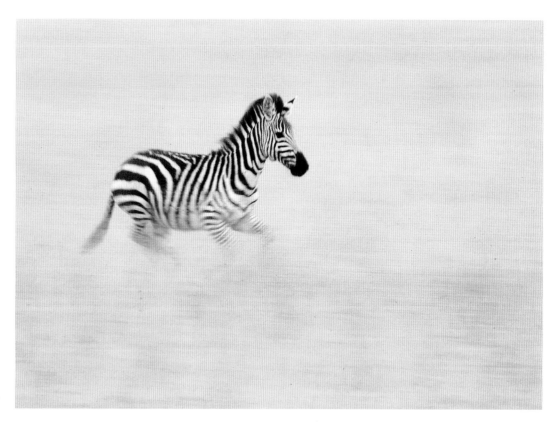

NOTES

AF systems will have to work harder the closer the subject is and the longer the focal length of the lens you're using.

Generally, larger apertures allow the autofocusing mechanisms to operate more effectively. Apertures smaller than f/8 can sometimes cause problems when following the action. A teleconverter will also reduce the "speed" of your lens and need to be taken into account.

On many long lenses there is a "focus limiter" switch. This enables you to define the range within which the AF will search to focus on the subject. This can help prevent the lens from "hunting" over too large a range and can speed up the recovery of focus if it is lost whilst following a moving subject.

Right: Predictive autofocus should certainly help you retain focus in situations like this. These grizzly bears were out in the open, with little else that the focus could accidentally lock onto—the challenge here was following the erratic movement.

Focal length: 500mm

Aperture: f/7.1

Shutter speed: 1/1000 sec.

ISO: 400

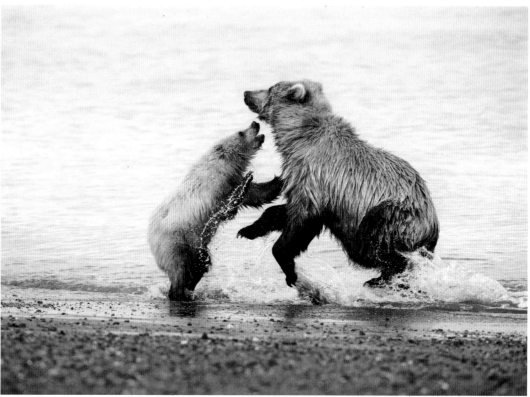

Preparation & Research

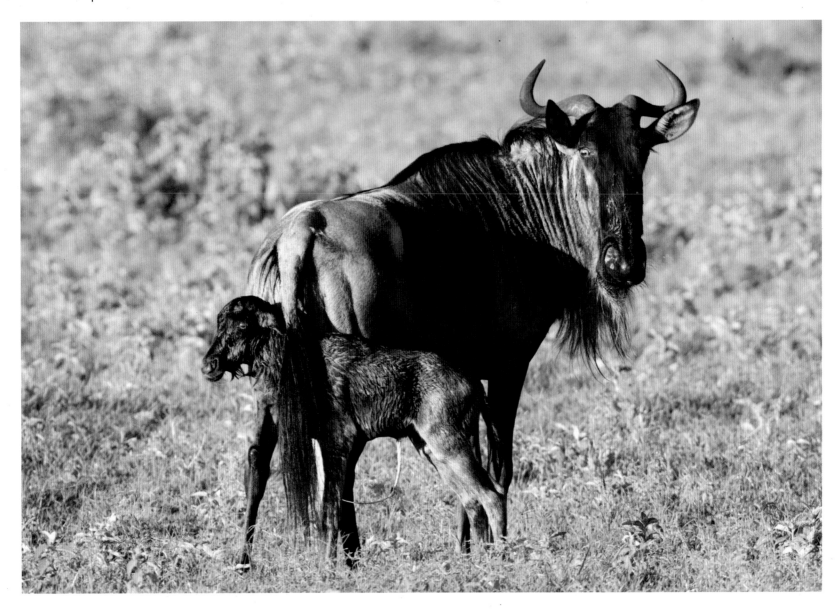

Producing great imagery requires a great deal of behind-the-scenes work. Having established a clear vision of what it is you want, you can research where you have to be to achieve it and when you have to be there. This will also help with decisions regarding what equipment to take.

A very "driven" photographer may choose to focus on one endangered animal species and single-mindedly try to engineer things so that they are in the right place at the right time to capture a particular event or activity involving that animal. This targeting can put a lot of pressure on the photographer and their guides, but can also lead to great rewards.

However, in the natural world you can't control your subjects and ensure any outcomes, so a lot will remain down to chance. Consequently, it helps to temper your ambitions with a measure of flexibility and acceptance. If things don't quite work out as you had hoped, you are then freer mentally to make the most of other opportunities that may present on the side.

Left: In East Africa, 80–90% of blue wildebeest calves are born within a three-week time period. The calves can follow their mothers within 15 minutes, but to improve their chances most births occur toward the middle of the day when predators are less active. So, if this picture was your aim, you would have to do a little research.

Focal length: 1120mm

Aperture: f/8

Shutter speed: 1/250 sec.

ISO: 160

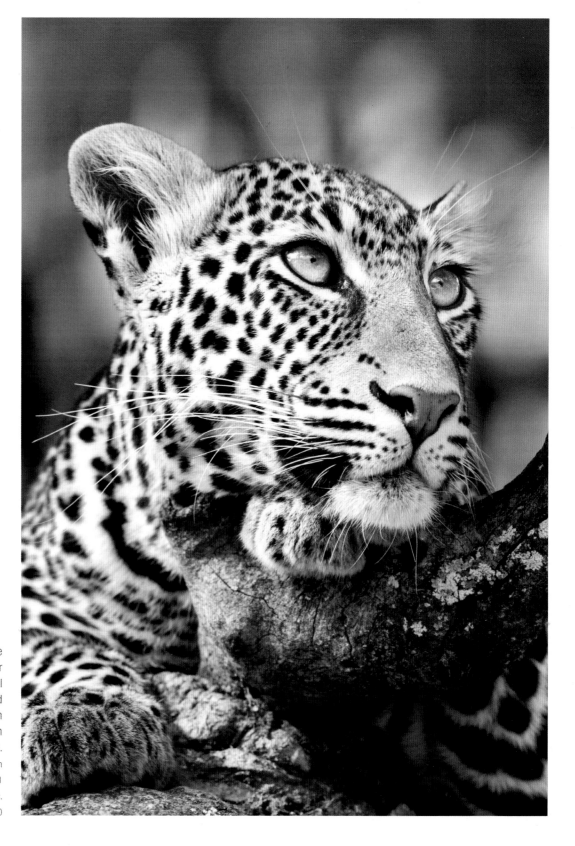

Right: Leopards are certainly not easy to find and a guide who is familiar with the reserve will vastly improve your chances. This was the most beautiful leopard I had seen. I wanted to reveal this beauty in the photograph, so I zoomed in closely on her face. It was then a case of waiting for an appropriate pose, which came when she rested her chin on her paw, gazing nonchalantly to one side.

Focal length: 800mm

Aperture: f/7.1

Shutter speed: 1/200 sec.

ISO: 200

Locations

Knowledge of, and familiarity with, a location and its wildlife is a great advantage, and the best work of many wildlife photographers is derived from their own "backyards." If, however, you choose to work in new environments—including other countries—do your research and use travel agents with local knowledge to establish your itinerary.

Once there, take time to explore and familiarize yourself with the surroundings and the habits of its wildlife. A local guide with an understanding of the needs of photographers can be an invaluable service that is worth paying extra for—on safari in Africa I have found this essential.

A good guide will have had training as a ranger/guide and experience leads them to having an uncanny knack of spotting animals that you would have driven past if on your own. They also often share information with each other regarding the whereabouts of various animals, particularly the rarer predators.

Remember that your guide is likely to know everything there is to know about the locality and the animals, but will need your guidance with regard to getting in the right position for the photograph. So, it's important to brief your guide clearly on your requirements and to establish a good system of communication to use in the field. Your guide is also responsible for your safety and their knowledge and experience needs to be respected in this regard. They will know from the animals' body language when there is a risk, so listen out for their directions and warnings.

The Internet provides a terrific resource for researching and planning your trips. You can easily establish sunset and sunrise times, and even the direction of the lighting that will be falling on your chosen terrain. Weather forecasts and high/low tide times are readily available worldwide, and routes can easily be planned and mapped out. You can also access details of the wildlife you might encounter and establish the best times of year for observing specific events. You can even search for photographs of a particular animal in that location to see what has already been done.

If traveling, it can, of course, be more economical to go with a group. If you go with a mixed group including non-photographers, there can be conflicts of interest. Non-photographers might not always be as keen to set out very early in the morning, for example, or to spend ages waiting for a leopard to wake from his afternoon siesta. So, I would recommend joining a tour designed specifically for photographers and lead by an experienced professional.

If you are anticipating being away from base for a long time and taking thousands of photographs, plan and rehearse your system for downloading and backing-up images. Schedule adequate time into your itinerary for this (as well as for cleaning equipment) and ensure that your accommodation will have facilities for recharging batteries. If you check your images as you download them, particularly at 100%, you may spot errors that can be rectified quickly and easily while you're still at that location.

If you're traveling to relatively remote locations, it is also important to consider what you would do if equipment fails—a back-up camera is often a lifesaver.

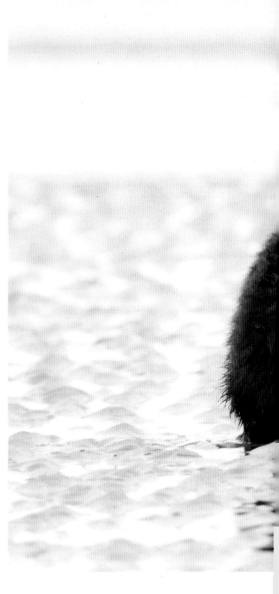

Right: On my quest for images of wild bears out in the open with their cubs, my research led me to undertake a trip to Lake Clark National Park in Alaska. In June, the grizzly bears bring their cubs out onto the mudflats at low tide to dig for shellfish.

Focal length: 500mm

Aperture: f/9

Shutter speed: 1/50 sec.

ISO: 250

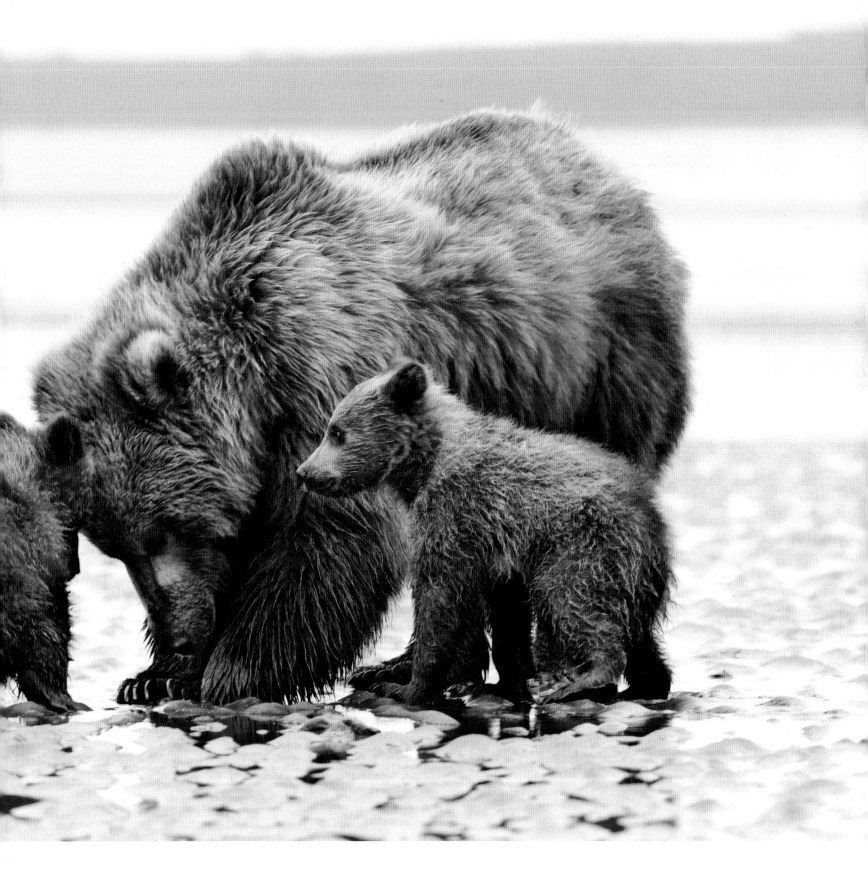

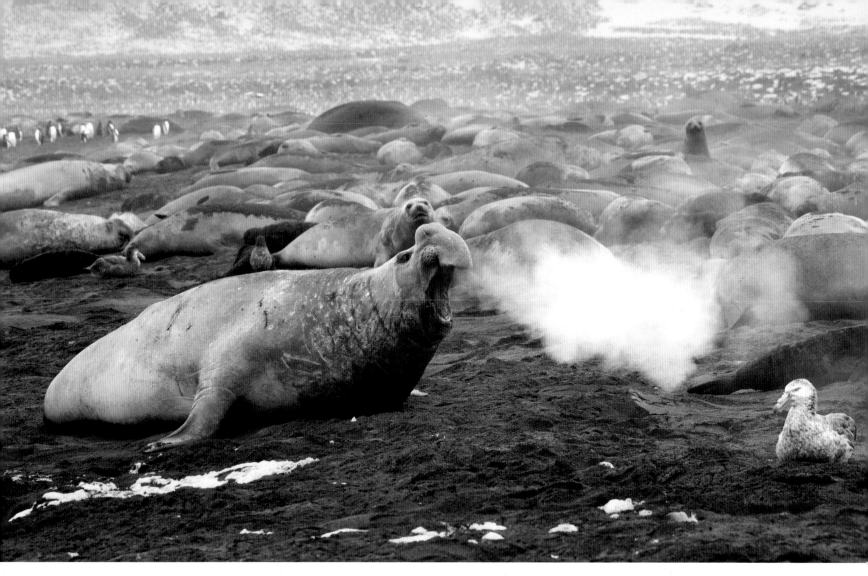

Seasons

The different seasons in temperate climates all have their merits. In general, spring is the season for courtship, nest building, and breeding. There is plenty of color in the environment to utilize in your compositions and this continues into the summer months. This is also a great time for plant and flower photography.

Fall is another active period for much wildlife as they try to build their reserves to see themselves through the coming winter. It can also be a time for claiming territories and control over resources, as seen in the annual deer ruts. The turning leaves can add lovely orange, gold, and brown hues to your backgrounds.

Winter, of course, offers frost and snow in many countries and many of the animals active during these months tend to have thicker coats making them more photogenic. They are also often bolder as food sources are scarce.

Different seasons and environments also have their accompanying hazards. In colder climates, batteries don't retain their charge for long, so it's a good idea to carry spares with you and keep them in inside pockets to keep them warm. Preserve battery life by avoiding live view mode and unnecessarily viewing images.

Obviously, wind and rain can be a hazard in many regions, while salty spray on coastal shoots

Above: During winter, or in colder climates, the visible breath of an animal might add that essential ingredient. Here an enormous elephant seal appears to be blasting a great southern petrel with hot air!

Focal length: 135mm

Aperture: f/7.1

Shutter speed: 1/160 sec.

ISO: 640

Right: A stink bug on great mullein, which flowers through the summer months in Greece.

Focal length: 105mm (macro)

Aperture: f/14

Shutter speed: 1/160 sec.

ISO: 125

has the potential to be particularly damaging to your camera equipment.

In more arid locations you have the hazards of heat haze and dust. The extremely fine particles of dust not only pose a problem by forming a film over the front element of your lens, but can also get into gaps and openings, potentially interfering with mechanical and electrical connections.

When you don't anticipate photo opportunities, it is a good idea to put all your equipment away in your bag and zip it up. If you need to have your equipment to hand in dusty environments, it is a good idea to have a cover for your lens and camera—a plastic bag with a hole at either end may prove adequate.

On returning to base each day, it is important to clean everything. A small, soft paintbrush is good for removing dust from bags and less sensitive equipment, but a specialist lens brush should be used on more sensitive parts of the camera and lenses. A "blower" and specialist lens cleaning tissues or cloths and fluid are also essential. However, do not use the cloths and fluid without having first blown the dry dust off, otherwise you risk scratching the lens coatings by dragging the dust particles across the surface.

Regular sensor checks are also wise, particularly if you are changing lenses fairly regularly. If the sensor needs cleaning, then ideally do this back at base using a manual blower (not pressurized) and special sensor-cleaning swabs and fluid or any other specialist sensor cleaning equipment that you should have packed.

Of course, it goes without saying that it is important to try not to change lenses when you are enveloped in a cloud of dust. Also, when changing lenses, turn the camera off first to reduce any static charge that might pull dust in, and aim the camera downward.

With heat haze, there are no real tricks for reducing its softening effect on your images. The only answer is to avoid shooting during the hotter parts of the day and to get as close to your subject as possible. Haze can, of course, add to a photograph on occasion, conveying a sense of the heat in your location.

Technique & Practice

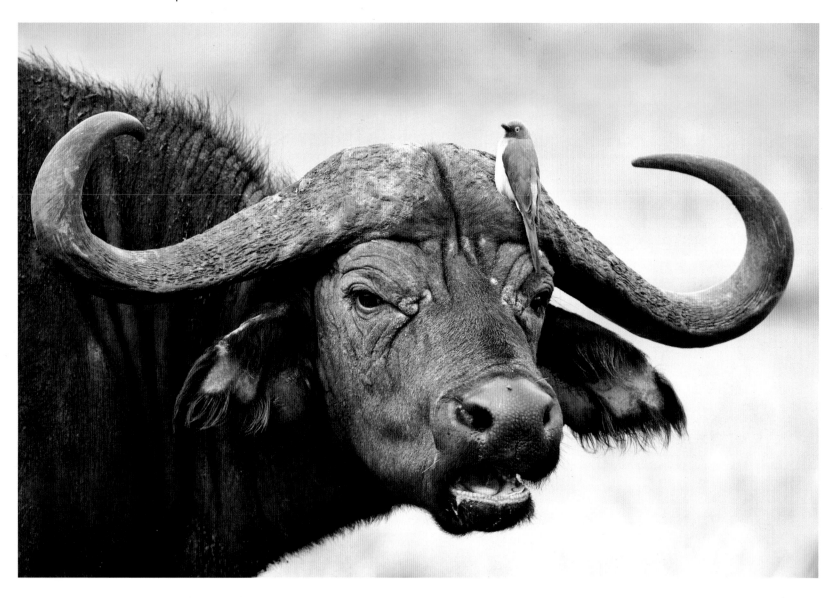

Routines and good habits ensure that you can respond quickly and appropriately to whatever presents itself. These are usually acquired and established through experience and practice.

As you move through habitats you should be constantly anticipating what is likely to pop up, changing lenses and camera settings to suit the conditions. Then, when the time comes to respond quickly, you will be able to simply raise your camera, compose, focus, and shoot. The best shots are often the first you get with each encounter—the animal lifts its head and stares inquisitively straight at you.

It can be devastating when the message "Card full" pops up on your camera's LCD screen at a critical moment, especially as this could easily have been anticipated. Once you've rummaged around in your bag, found a replacement card, inserted it,

Above: A quick response enabled me to catch this cape buffalo and red-billed oxpecker staring back at me as I arrived on the scene.

Focal length: 700mm

Aperture: f/5.6

Shutter speed: 1/100 sec.

ISO: 200

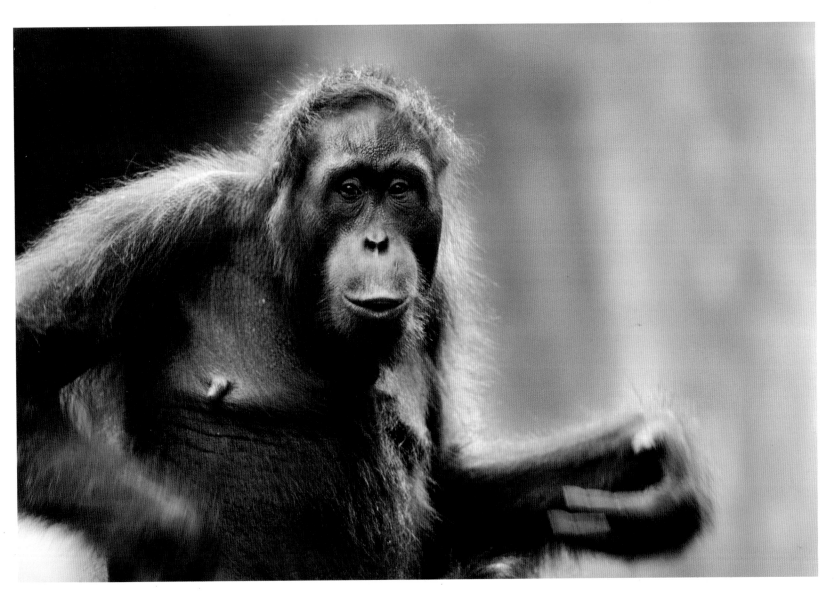

and had to re-format it (because you forgot to do it the previous night), the moment will have passed.

It is also important to know where various accessories, such as filters, memory cards, and spare batteries are in your bag, so they are readily to hand.

Practice makes perfect and the more you get out with your camera, the more familiar you will become with its operation and the requirements of diverse situations. Be sure to know how to change your ISO quickly, dial in exposure compensation, change autofocus mode, and select your autofocus point, all without taking your eye from the viewfinder.

Above: Low light levels in the Borneo rainforest made me take a few risks with slow shutter speeds. This was taken at 1/40 sec., with an effective focal length of 800mm supported only by a monopod. However, experience and practice had taught me that with care I would get the features sharp.

Focal length: 800mm

Aperture: f/4

Shutter speed: 1/40 sec.

ISO: 320

Chapter 2
Equipment

When starting out in photography it's often more important that you concentrate on developing your vision and understanding of the fundamentals of lighting, composition, and technique, rather than getting too obsessed with the quality of your camera and lenses. After all, the best camera in the world linked to the best lens won't take good pictures in the wrong hands. However, once you are starting to take better photographs, better quality equipment will often improve both the quality of your images and your chances of realizing your ambitions and expressing your vision.

Right: To get closer to this diminutive crab spider on an early purple orchid, I used a 25mm extension tube.

Focal length: 168mm (macro) with 25mm extension tube

Aperture: f/7.1

Shutter speed: 1/4 sec.

ISO: 100

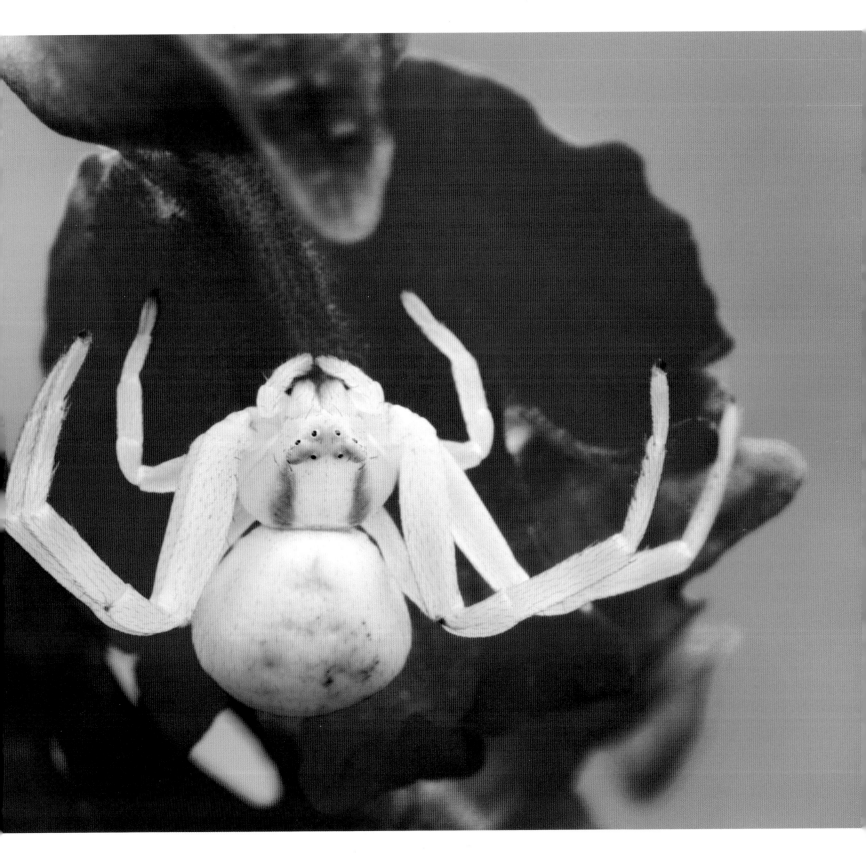

Cameras

Digital SLRs are the preferred camera for wildlife photography. Large, bright viewfinders are helpful and they allow you to attach a variety of lenses. The size, weight, and design of this camera type is also ideal in terms of portability and handling, with high-end models offering very robust construction and a good degree of weather-proofing.

In general, the latest models ensure good high ISO performance and fast, responsive autofocus, both of which enable photography in low light conditions or of fast-moving subjects.

When choosing a camera, a decision has to be made about the type of sensor you require: the standard sizes used in digital SLRs are Micro Four Thirds, APS-C, and full-frame.

Full-frame cameras employ sensors that are the same size as a 35mm film frame (36 x 24mm). This enables the use of larger light-sensitive receptors, which can capture more light. The signal produced therefore require less amplification so the signal-to-noise ratio is higher, so they produce less image noise for a given light level and therefore tend to offer better high ISO performance. This can be advantageous in low-light conditions or when very faster shutter speeds are required.

Cameras with APS-C-sized sensors employ a smaller sensor (typically around 23 x 16mm). Compared to a full-frame sensor, the image projected by the lens is cropped, which narrows the angle of view and makes the lens appear longer (in terms of focal length) than it actually is. This creates what is known as a "magnification factor." The magnification factor varies a little from manufacturer to manufacturer, but tends to be 1.5x or 1.6x, so a 200mm lens gives an angle of view closer to a 300mm or 320mm focal length on a full-frame camera. This can, of course, be a great advantage to wildlife photographers when it is difficult to get close to your subject matter.

The choice between full-frame or APS-C will often come down to your budget and need for portability. To achieve the same reach with full-

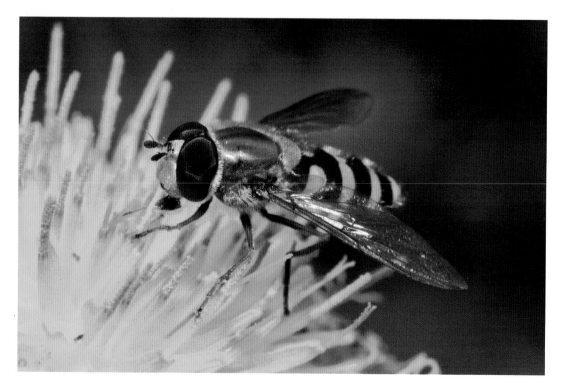

Above: The use of a 105mm macro lens on a camera with an APS-C sensor offered two advantages in capturing the detail in this hoverfly. Firstly, it meant I didn't have to get too close and risk disturbing my subject, and secondly it offered a relatively greater depth of field for a given aperture, meaning I could get away with f/16 rather than risk the softening effect that could come with smaller apertures.

Focal length: 105mm (macro)

Aperture: f/16

Shutter speed: 1/160 sec.

ISO: 250

Left: There are countless full-frame and APS-C-format cameras available, such as Nikon's full-frame D810 and Canon's APS-C-format EOS 7D Mark II. Each format has its advantages and disadvantages for wildlife photography, but both are capable of producing stunning imagery.

frame cameras you will need longer, heavier, and more expensive lenses, although the superior image quality may allow for a little more cropping of the resulting images.

Another point to bear in mind is that for lens/camera combinations offering the same effective focal length on the two types of camera, the full-frame camera will offer shallower depths of field. This is because the APS-C camera is actually taking the photograph using a shorter focal length, and at a given aperture shorter focal lengths offer a greater depth of field. This can work to your advantage in either way: smaller depths of field blur out backgrounds, but there are times you'll want a greater depth of field, particularly with macro work.

Micro Four Thirds sensors are 30–40% smaller than APS-C sensors and therefore provide a 2x multiplication or crop factor. They also give slightly different image dimensions, producing an aspect ratio of 4:3.

The quality of your images also depends largely on the lenses used, so when choosing a camera look at the selection of lenses that can be used with the make and model you are considering.

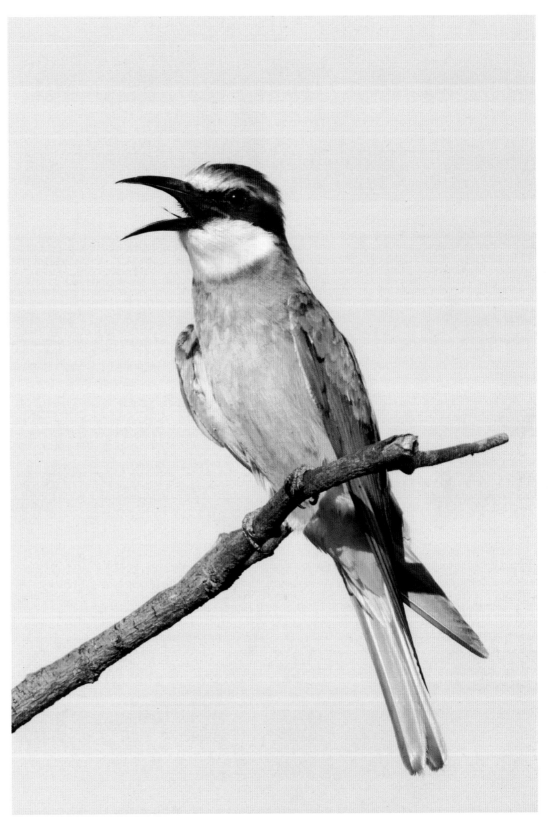

Right: For bird photography, I have found that an APS-C sensor has often enabled me to get frame-filling shots, as with this blue-cheeked bee-eater in Namibia. Using a 500mm lens with a 1.4x extender gives a 700mm focal length, but the camera's 1.6x magnification factor extends the effective reach to 1120mm.

Focal length: 1120mm

Aperture: f/9

Shutter speed: 1/500 sec.

ISO: 250

Remote Releases

When light levels are low and very slow shutter speeds are being employed with static subjects, being able to release the shutter without touching and potentially moving the camera can be an advantage. A cable release may be adequate for this purpose, although wireless remote releases are also available. The latter is particularly useful when you want to trigger your camera from a remote position, so as not to disturb your subject.

Motion Sensors

The term "stealth cam" is often used for specially designed cameras with weather-proof cases that are triggered by a motion sensor to shoot stills or video. They are now routinely employed for research purposes to monitor nocturnal and shy animals. There are various ways of triggering the camera and flashes, including contact switches, where the animal physically instigates the process, light beams, and motion sensors.

Generally, the image quality is not up to that of a good SLR, so if quality is critical it may be worth thinking about improvising—a simple plastic bag may be enough to provide the weather-proofing for a digital SLR, for example.

Various contraptions can also be employed to enable you to get a camera where you can't personally go or wouldn't choose to go. Will Burrard-Lucas is a photographer producing innovative designs in this regard, such as the BeetleCam for remote photography.

Above: When your attention is drawn to something, look at it from all angles—there may be another take on it, as with this leaf beetle shadow.

Focal length: 168mm (macro)

Aperture: f/13

Shutter speed: 1/40 sec.

ISO: 250

Lenses & Lens Accessories

There are two types of lens: zoom and prime. The main reason for selecting a prime (fixed focal length) lens in preference to a zoom comes down to image quality. This is because prime lenses tend to give sharper images and are less prone to aberrations including color problems and vignetting. Prime lenses are also less prone to "pincushion" distortion (found in telephoto focal lengths) and "barrel" distortion (typically found in wide-angle lenses).

However, the best zoom lenses can now rival the image quality and speed of prime lenses, while also offering greater compositional flexibility.

In either case, fast lenses (those with larger maximum apertures) are ideal for wildlife photography. The larger aperture enables faster shutter speeds when light levels are low, and can also exaggerate the blurring of the background, helping to isolate a subject and make it stand out.

Where possible, choose a lens/camera combination that offers image stabilization. Much of what you do will be shot handheld, and this will reduce the need for you to use higher ISOs.

In terms of the focal lengths most suited to wildlife photography, this really depends on the creatures you are likely to be photographing and how much cropping of your images you are prepared to do. Obviously, telephoto lenses are essential for a lot of wildlife work, but for flexibility I would suggest you aim to cover as much of the focal length range from 150–400mm as possible. For birds and shy mammals even longer focal lengths are an asset—ideally a prime lens that can be matched to a teleconverter for even more reach.

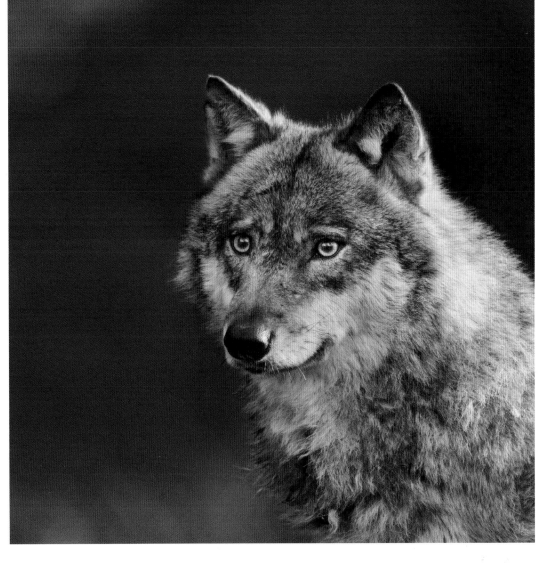

Above: For this portrait of a gray wolf in an enclosure in the Bavarian Forest National Park, Germany, the use of a 500mm prime lens at f/4 has rendered the background as a pleasing tapestry of color.

Focal length: 500mm

Aperture: f/4

Shutter speed: 1/320 sec.

ISO: 400

Left: Fast prime telephoto lenses, such as this 500mm f/4 lens from Sony, are ideal for filling the frame with dangerous or timid subjects, but such lenses are usually very expensive.

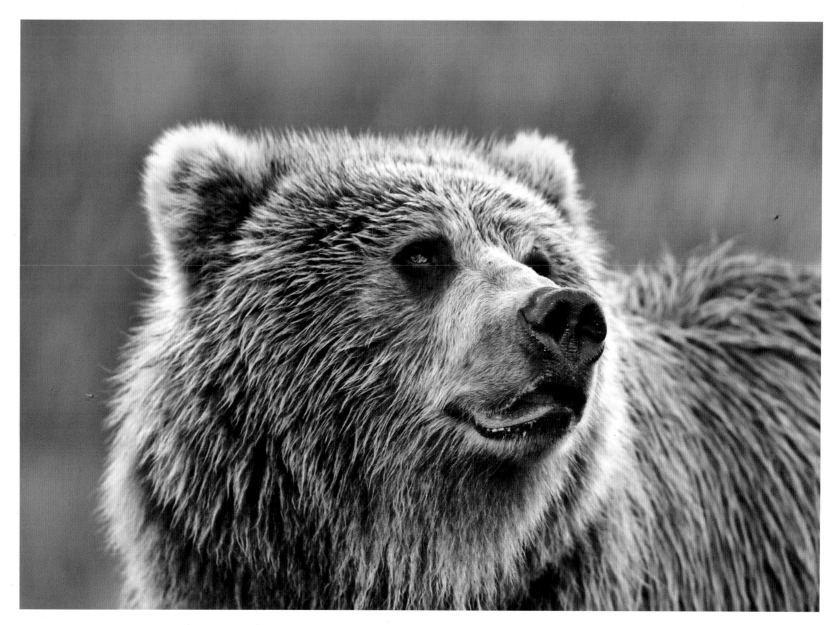

Teleconverters

A teleconverter (or "extender") increases the focal length of a lens by a fixed amount—the most popular ones do this by a factor of 1.4x or 2x. This is a great way of extending the reach of your lenses, without making a big investment, but a teleconverter is only as good as the lens it is attached to—any imperfections will be magnified. Teleconverters also affect image quality due to the extra glass and reduce the maximum aperture of

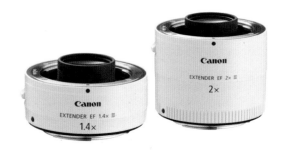

Above: The longer reach provided by a teleconverter enabled me to get a frame-filling portrait of this grizzly bear, without jeopardizing my safety!

Focal length: 700mm

Aperture: f/6.3

Shutter speed: 1/250 sec.

ISO: 400

Left: Teleconverters are an affordable way of extending your focal length range without investing in expensive new lenses.

the lens—a 500mm f/4 lens will become a 700mm f/5.6 lens with a 1.4x converter attached, or a 1000mm f/8 lens with a 2x converter.

Remember also that some variable aperture zooms may not allow a teleconverter to be attached, and if you're not using a fast lens, auto-focus may be lost or affected due to the reduction in maximum aperture. It is therefore worth doing your research before you buy.

Extension Tubes & Bellows

Extension tubes fit between the camera and lens, reducing the minimum focusing distance. The tubes come in various lengths, with 12mm, 25mm, and 36mm being the standard (they can also be combined to increase the effect).

Non-automatic extension tubes are cheapest, but you'll lose the camera's control of the aperture and focusing. They also reduce the light entering the camera, although your camera's TTL metering will compensate for this automatically.

Extension tubes are often used in conjunction with a macro lens to get an even more detailed view of small subjects, but they can be used with longer lenses as well—to provide frame-filling shots of butterflies with a medium telephoto lens, for example.

Bellows, which are accordion-like contraptions that fit between the lens and camera, fulfill a similar function to extension tubes, but are adjustable, rather than one fixed length. This provides you with greater control over the level of magnification, but is offset by added bulk and complexity—extension tubes are far easier to use in the field.

Right: The lines and symmetry of the various appendages of this crane fly, which had settled on a window, struck me. I used a 25mm extension tube to enable a frame-filling shot of the relevant parts.

Focal length: 168mm (macro) with 25mm extension tube

Aperture: f/20

Shutter speed: 1/200 sec.

ISO: 200

Reversing Rings

Reversing rings are another option for close-up photography, allowing you to attach a lens to your camera in reverse (so the front lens element is closest to the camera). You will typically lose any automation (focus, aperture, and possibly exposure metering), but will be able to focus very closely on your subject. A high quality 50mm prime lens with a manual aperture is a good choice if you are going to do this.

Filters

There are numerous filters available, but few that continue to be useful for digital photography: most photographers now use postproduction to manipulate the hues and tones of their images and the effects of various filters can be mimicked digitally using software. However, there are filters that still have a purpose.

Skylight (1B) filters provide a subtle warming, pink tinge and reduce the bluish tinge particularly associated with shady areas, while ultra-violet (UV) filters absorb UV light that can otherwise reduce contrast. Many photographers keep one or other of these fitted to protect the front element of the lens, although dedicated "lens protector" filters are now also available.

Of the more creative filters available, a polarizing filter is certainly useful. This filter decreases the glare on water, which can be essential in many scenarios. They also reduce atmospheric haze, adding clarity to shots taken toward the middle of the day. Perhaps most importantly, they can also provide deep blue skies and increase color saturation of foliage by decreasing reflections from waxy leaves. Polarizing filters work best when shooting at 90 degrees to the sun. Remember, though, that a polarizing filter will cut out 1–1½ stops of light, so a beanbag or tripod may become necessary as exposure times increase.

Neutral density (ND) filters are effectively a sheet of dark glass that reduces the amount of light entering the lens, without affecting the color. ND

Above: A polarizing filter enhanced the color of the sky and fir tree surrounding this bald eagle

Focal length: 800mm

Aperture: f/6.3

Shutter speed: 1/800 sec.

ISO: 320

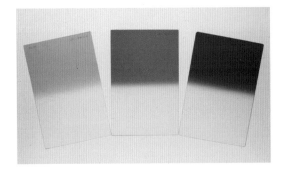

Above: Lee Filters' 1-, 2-, and 3-stop graduated ND filters, showing hard (left) and soft (right) gradient versions.

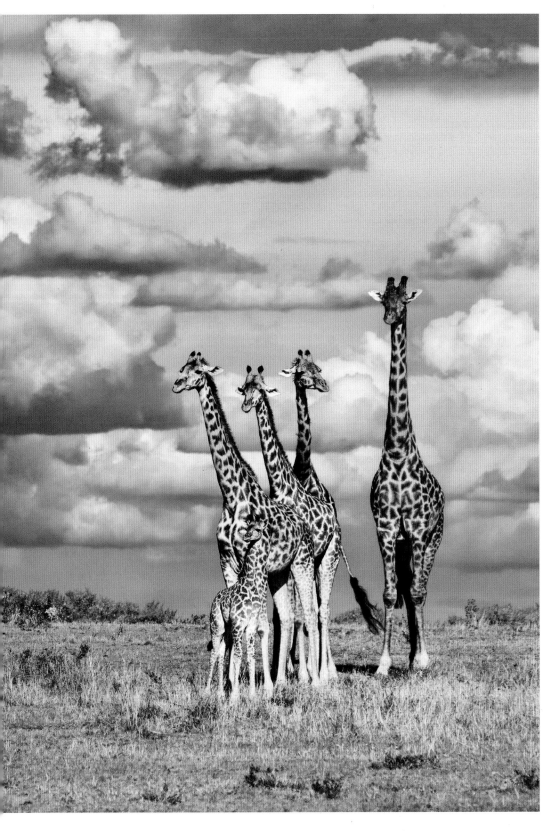

filters enable you to use a slower shutter speed than you would otherwise be able to achieve. However, with fast-moving wildlife, a filter that extends shutter speed is rarely needed; this type of filter tends to be used more to smooth flowing water in landscape photographs.

However, neutral density graduated filters (ND grads) certainly have a place in a wildlife photographer's camera bag. These filters are half coated with a neutral density coating that reduces the light transmission through the filter, while the other half of the filter is clear. They are typically used to avoid the brighter sky portion of an image being overexposed.

ND grads are available in different strengths (typically measured in stops), and the transition between the coated and uncoated parts of the filter can be either "soft" or "hard."

At dawn or dusk, when the sky is much brighter than the land, you may need a 2- or 3-stop ND grad filter, for example. Also, in a scene where the landscape is reflected in water, you can use a graduated filter to darken the upper part of the image to better balance the scene with its reflection and enhance the "mirror" effect.

Left: A polarizing filter helped darken the blue of the sky and define the puffy cumulus clouds that are often a feature of African skies in this image of a group of giraffes in the Mara Reserve. Using a red filter during the black-and-white conversion has darkened the blue of the sky, helping them to further stand out.

Focal length: 320mm

Aperture: f/8

Shutter speed: 1/125 sec.

ISO: 160

Overleaf: A 1-stop ND grad filter was used to tone down the sky for a more pleasing balance between sky and land in this scene of migration herds in the Serengeti.

Focal length: 47mm

Aperture: f/16

Shutter speed: 1/160 sec.

ISO: 250

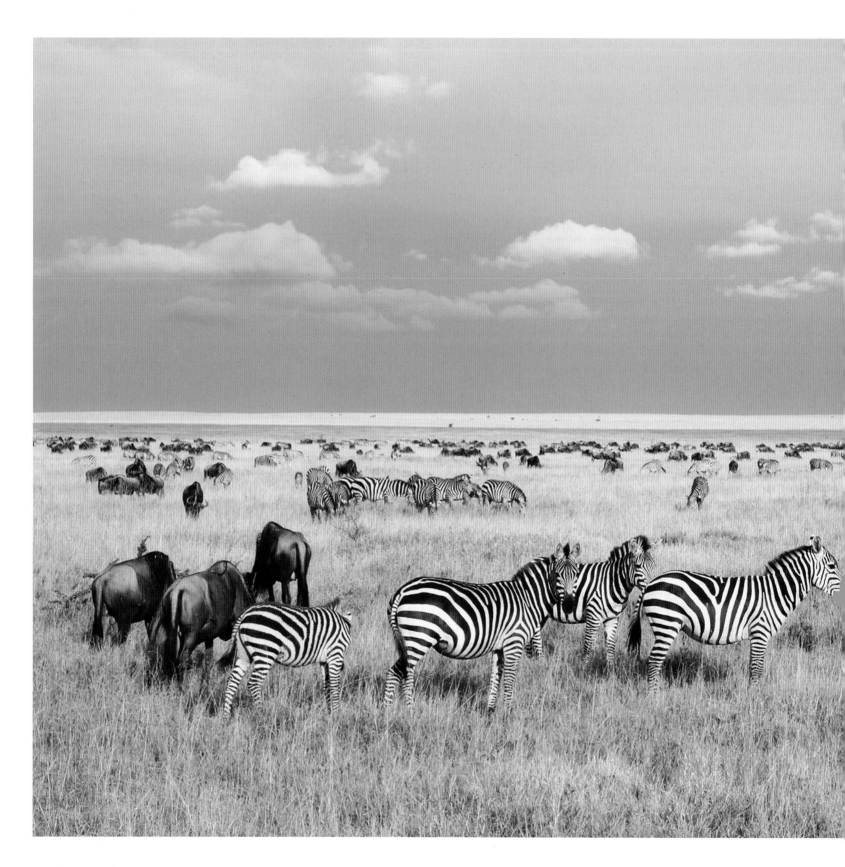

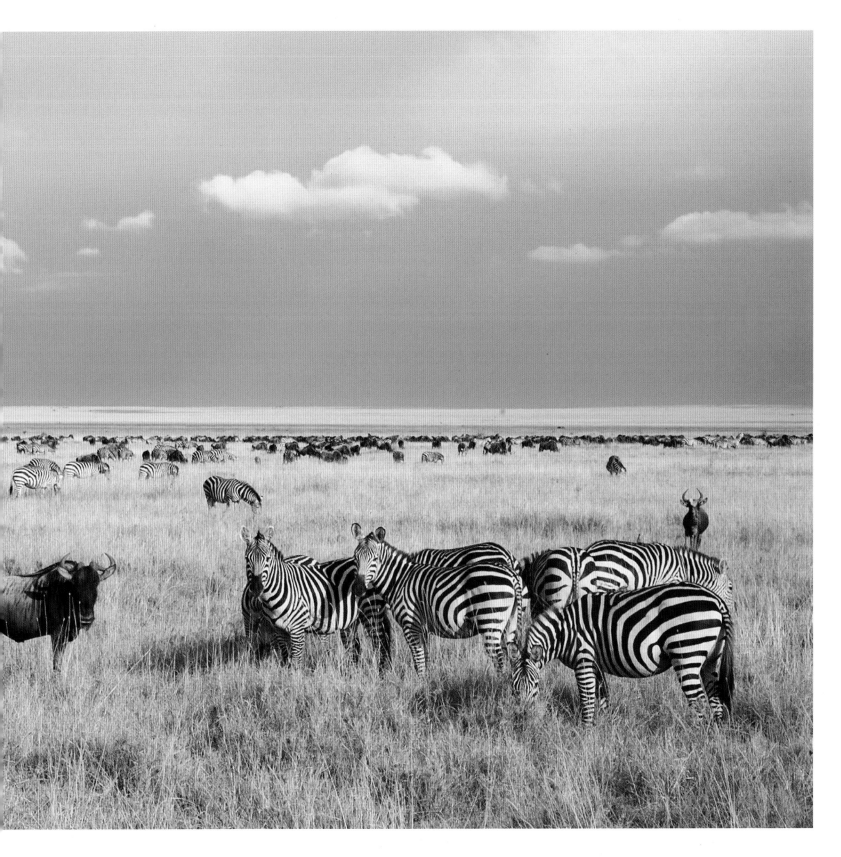

Flash

When choosing a flash, it is a good idea to go for a relatively high-powered model, as this will work over a greater range and increase your options. If considering a third-party one, check its compatibility with your camera for TTL metering and remote triggering from your camera.

Flash extenders such as the Visual Echoes Better Beamer series and Harbor Digital Flash Extenders concentrate the emitted light and extend the reach of your camera's flash range, which can be useful when using long lenses. They also supposedly allow for faster refresh rates and reduced battery consumption because the flash can be used at lower power settings.

Brackets and off-camera cords are further useful accessories enabling the flashgun to be positioned slightly away from the camera.

Ring Flash

These specialist flashes provide an even, shadow-less light. They can, however, leave images looking unnaturally flat. Most modern units avoid this by having more than one flash tube, so various output ratios can be selected giving you some control over the balance of the light falling on different sides of the subject.

Twin Flash

Twin flash units use two small flash heads mounted on a ring that fits to the front of the lens. These are very versatile and the addition of diffusers can help reduce their tendency to form twin catchlights.

Reflectors

Reflectors are very useful, particularly for close-up work where they don't have to be very large and remain readily portable. They can be used in conjunction with natural or artificial light sources. Homemade versions can also be employed using white card, baking foil, or other reflective materials. The color of the surface will influence the "warmth" of the resulting image.

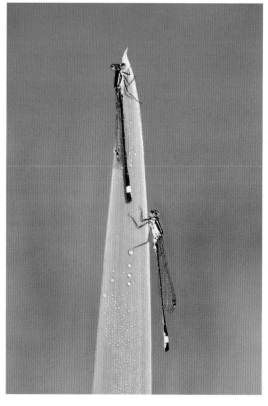

Above Left & Above Right: Using a twin flash unit evened out the lighting on these blue-tailed damselflies.

Focal length: 168mm (macro)

Aperture: f/5.6

Shutter speed: 1/200 sec.

ISO: 320

Tripods

A sturdy tripod is essential, particularly if you are regularly using long lenses, but check that it can comfortably carry the weight of your camera and longest lens. It's also important to have one that will enable you to work close to the ground, so choose one with a center column that can be removed or positioned horizontally. As you'll often be carrying your equipment on foot, a lightweight carbon-fiber model is ideal.

Tripod Heads

Above: My camera and 100–400mm lens on a ball and socket head.

There are three basic tripod head designs. Pan and tilt heads allow independent movement in the three axes of movement (with geared pan and tilt heads providing very precise adjustments, which can be useful in macro work).

Ball and socket heads offer very quick adjustment in all planes of movement at once.

Finally, there are bracket-type designs that are popular with heavy, long focal length lenses, as they offer excellent balance for panning and tilting. Here the lens and camera are often balanced at their center of gravity.

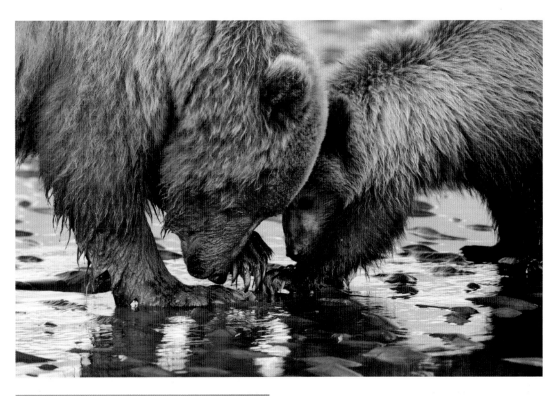

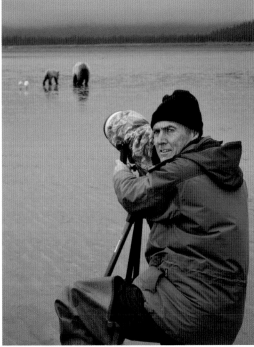

Left & Above: A carbon-fiber tripod and Manfrotto 393 bracket head gives me the stability I need using a large telephoto lens, as when photographing these grizzly bears digging for clams in low light levels.

Focal length: 500mm

Aperture: f/10

Shutter speed: 1/125 sec.

ISO: 320

Chapter 3
Field Craft

To photograph animals behaving naturally in the wild you need to know where to find them and when they are likely to be doing whatever it is you want to photograph them doing. You then need to get yourself into a suitable position without unsettling them. The term "field craft" encompasses the knowledge and skills required to do this.

It is often best to accept your limitations and recruit the services or advice of local naturalists, gamekeepers, and wardens. However, as you shall see, there are various accessories and general principles that can also be of help. With some species you can also consider artificially luring your subjects to where you want them or even creating more elaborate "sets" into which you can introduce or coax your subjects for more staged photographs.

Right: The comforts of a public hide in a country park.

Stalking

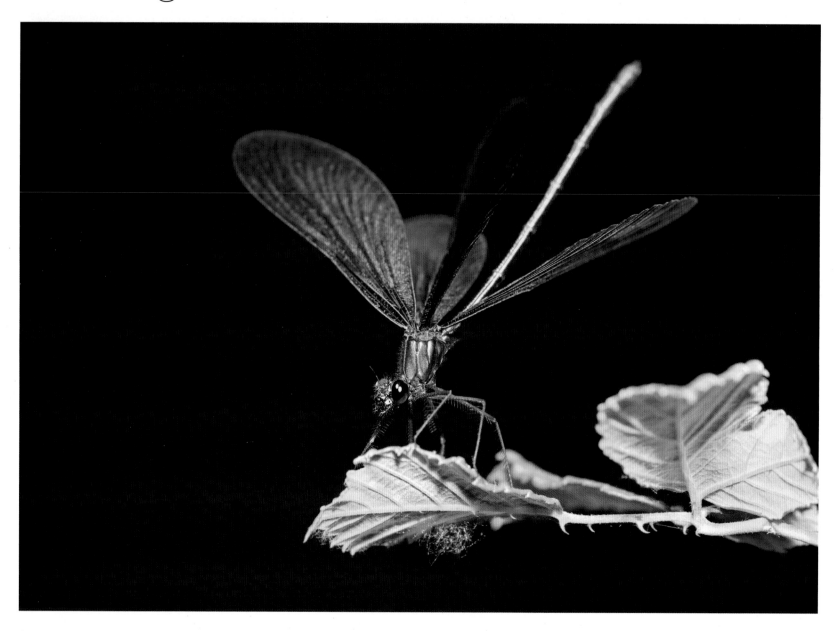

With elusive animals, your first challenge is actually finding them. Knowledge and research will help, but you may also need to spend time in their environment looking for signs of their presence, such as footprints, droppings, and markings.

Try to get familiar with your subject's behavioral patterns. Mammals tend to use regular tracks and have daily routines. Many species have specific nests or resting places and can be seen as they return to or emerge from these—badger setts and rabbit warrens are obvious examples.

Ask yourself where their food sources or waterholes are likely to be. Butterflies, for example, often have a favorite food plant or plants on which they lay their eggs. Territorial animals will tend to patrol, mark out, and survey their territories— dragonflies, for example, often patrol an area, before coming to rest in the same places.

In terms of approaching animals, think about what they are attuned to. Remember that the primary senses of many mammals are hearing

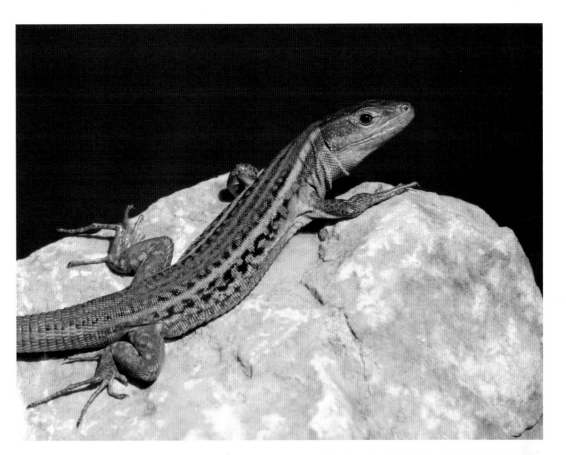

and smell, rather than sight, so it may be important to avoid wearing or carrying anything that has a strong scent.

Birds tend to be both visually and sound orientated. Indeed, a birder skilled in mimicking the calls of birds can often lure certain species to the vicinity with the pretense of being a rival. This tactic should definitely not be employed, however, if there is any risk of upsetting potential breeding behavior—it can be a criminal offence to wilfully disturb breeding birds at or near their nest sites.

Insects have compound eyes especially designed to detect motion, so will respond to any fast or rangy movements you make. In many cases they are also very sensitive to air movement.

Snakes on the other hand are particularly attuned to vibration transmitted through the ground by approaching threats. Like all reptiles, they are cold-blooded and need to warm up in the mornings (especially in the cooler seasons). They will often be found basking on rocks, and as many are territorial, they will often have their favorite

Left: This beautiful demoiselle kept returning to this same leaf, which clearly offered a good vantage point from which to both display and monitor the activities of other males. I was eventually able to photograph it with its wings spread.

Focal length: 105mm (macro)

Aperture: f/7.1

Shutter speed: 1/160

ISO: 200

Right: Early morning is a good time to catch relatively inert butterflies with their wings spread trying to warm up for their day's activities.

Focal length: 168mm

Aperture: f/16

Shutter speed: 1/160

ISO: 250

Above: A roe deer, just as it sensed my presence.

Focal length: 1120mm

Aperture: f/5.6

Shutter speed: 1/800

ISO: 200

places for this. A good time to photograph many invertebrates is also early morning before they have warmed up.

A camouflage coat and trousers will help break up your outline and merge you in to your surroundings. Make sure it is not a noisy fabric and avoid garments with pockets secured by noisy hook-and-loop style fastenings. For some species, it may also be necessary to conceal your head and hands—a camouflage net to drape over yourself as you lie waiting for your subject to emerge from its den or burrow is another option.

Even with a long lens you will usually need to get within the animal's "fear circle." This is the zone within which you will cause the animal to flee if you are detected. The size of the fear circle will vary depending on the subject and circumstances: a grizzly bear preoccupied with making the most of a ready source of protein during the salmon run will be easier to approach than a mother with her cub, for example.

When trying to approach and photograph dangerous or predatory animals on foot, an intimate knowledge of that animal—its body language and warning signs—is essential. Here, it's certainly worth recruiting a good guide, and be sure to avoid blocking any potential escape routes to prevent forced confrontations. Also, constantly monitor your own best routes to safety in case you deem it wise to retreat.

One of the most dangerous situations is if you surprise a dangerous creature—and yourself—by stumbling across them. The appropriate response if charged will depend to some degree on the species and the reason for the aggression.

Tips

Plan your approach strategy. Use a good pair of binoculars to survey the terrain. Can you keep yourself below the horizon until the last minute? Are there trees, rocks, or bushes you can use to hide your approach?

Check the wind direction and, if possible, approach up-wind.

Always move slowly and stop and wait at intervals. Constantly monitor your subject for any sign of unease and freeze if you sense any.

Avoid surprising your subject by popping up at the last minute.

If you're out in the open and have already been seen, don't approach directly and avoid looking at your subject. Appear distracted and occupied with doing something else such as looking for food. You could then try walking in wide arcs, gradually getting closer—this will make you appear less threatening than a direct approach.

Working in pairs will often enable you to get closer. I was once out with a photographer friend trying to stalk a pair of roe deer. I approached through a dense copse, while he took a rather more circuitous route out in the open. He had got beyond them when they spotted him and started to retreat, making their way toward me. I could predict their line of retreat, so was able to get a couple of shots as they passed nearby.

When working on wetlands, it may be possible to wait for the incoming tide to force the birds nearer to you. They will tend to tolerate this more than you approaching them.

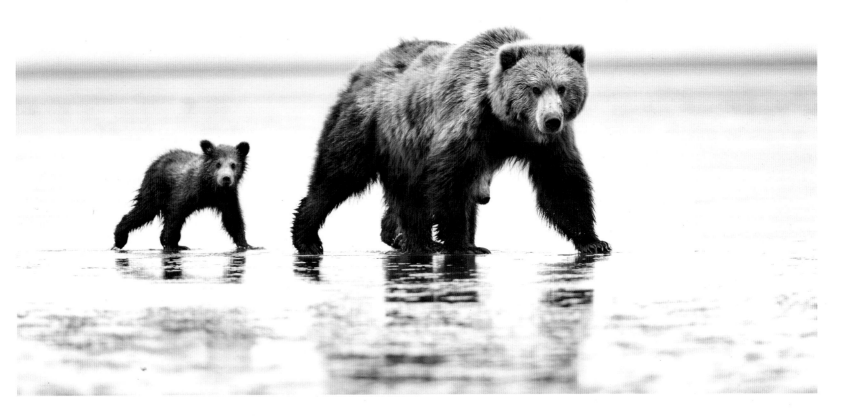

Fortunately, the majority of times it will be a "defensive" response, where you are perceived as a threat to them, their offspring, or their food source. Here the assault will often be a bluff and be accompanied by warning signs. Slowly backing off whilst continuing to face the animal and talking soothingly in a deep voice rather than turning tail and fleeing is often the best course of action.

In a truly predatory attack, however, the animal may be actively following you looking for signs of weakness. An attack, if it comes, may involve no warning. This is not the time to be taking photographs unless you potentially want them to be your last. Maintaining eye contact and making yourself look as big as possible, shouting and, if necessary, fighting back may be more effective. Most predators will not want to risk injury in the pursuit of their next meal.

In some locations the wildlife populations have become "habituated" and are no longer fearful. This is great, as they will carry on with their natural behavioral interactions, even with you in close proximity. However, it is important to remember that they are still wild animals and there is still the potential for an aggressive response.

Above: One of the main threats to grizzly bear cubs is male grizzly bears. Interestingly, in some locations mothers appear to tolerate the presence of photographers nearby, as this means they are less likely to be troubled by males in the area.

Focal length: 700mm

Aperture: f/7.1

Shutter speed: 1/400

ISO: 320

Hides & Blinds

For many very sensitive species, the best way to get close-up shots is to hide yourself away somewhere and let them come to you. For example, with brown hares it may be enough to crouch in the cover of a hedgerow downwind of them and wait for them to pass by.

Hides are especially helpful for photographing birds. Unfortunately, most public hides are designed and positioned more for bird-watchers than photographers and so tend to be too distant and too high. Small, temporary ones offer you much more freedom in terms of positioning.

Vehicles can also act as mobile hides in many locations. This is something I take advantage of on safari in the national parks of Africa, where the animals have become accustomed to the benign approach of vehicles. In other localities, where the subjects are not so conditioned, it may be necessary to conceal yourself and your movements to some degree within the vehicle with some camouflaging at the window.

It's important not to set up your hide where it is likely to draw the attention of other humans or potential predators to the location of your subject, particularly if it is a nest where there are vulnerable young. Perhaps look to position it near a feeding station, adjacent to a water source, or at a roost or display ground. In positioning your hide, consider the light direction and the background in relation to where the subjects are likely to be. Also try to avoid it being out in the open—find somewhere where it will blend in.

Having positioned the hide, it may be necessary to leave it there for the wildlife to get used to it. This may take a few days. Alternatively you could try moving it closer every few days whilst the animals are not present. You will then have to consider how you are going to get yourself into the hide without being seen. If you can't enter it before your subjects arrive on the scene, it is often worth remembering that many animals appear to be unable to count. So, if two people are seen by

the animal entering the hide, when one leaves it will assume both have gone and it is now safer to approach.

Buried hides may be appropriate in open ground and elevated ones in woodland. For animals that live in or around water, a floating hide can enable you to get very close and also provide very low viewpoints close to the water's surface.

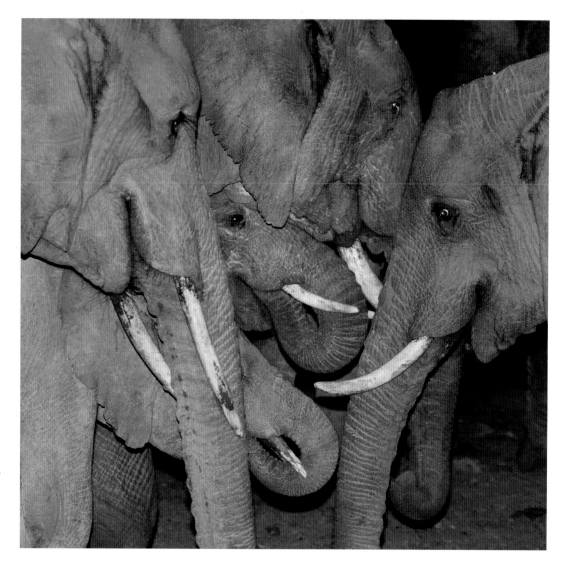

Above: Although they are usually more wary at night, animals can be very relaxed around established hides, enabling some close-up photography. In Africa, some lodges have hides positioned by flood-lit waterholes or, as in this case, salt-licks.

Focal length: 135mm
Aperture: f/9
Shutter speed: 1/60
ISO: 800

Above: Dome hides are available in various sizes and patterns to suit the location.

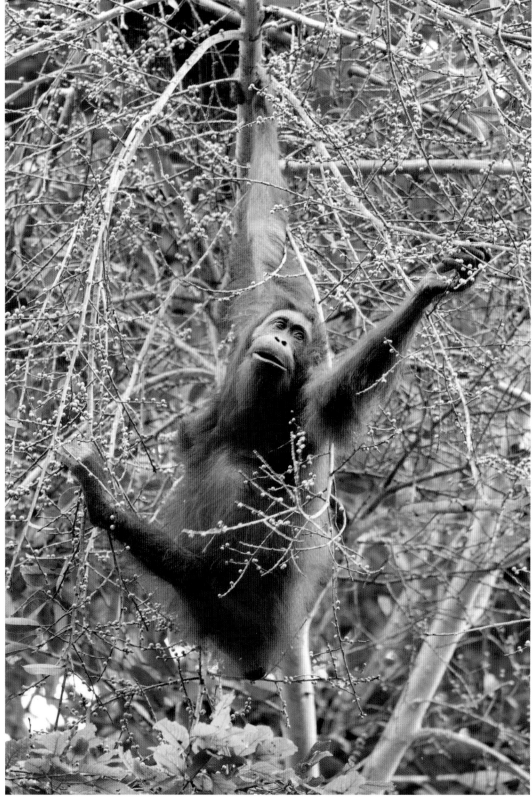

Right: The animals I photographed from a boat in Borneo seemed very relaxed, despite my proximity. Here an orangutan happily carries on gathering food.

Focal length: 800mm

Aperture: f/4

Shutter speed: 1/80

ISO: 250

Remote Photography

Another option open to you is to place your camera in advance, close to where you anticipate some action will occur. You can then retreat to a hide and release the shutter at the appropriate moment using an infrared or radio-controlled trigger. Infrared triggers require a clear line of sight and have a more limited range than radio-controlled systems.

For particularly reclusive species, camera traps may give you the best chance of getting a shot. Here the subject in some way triggers the camera itself, usually be breaking a beam running between a transmitter and receiver.

Tips

Find what looks like a regularly used route. Then look for somewhere on it where you can pretty much guarantee the animal's position as it passes by, such as a gap between obstacles, a branch it will probably walk along, or a crossing point over a stream. Think about its food sources too and where it is likely to go looking for these. Baiting could help lure it to the right spot.

Visualize how the animal is likely to appear on this route and in what orientation. Think about the surroundings—maybe some potential distractions will need removing?

Take test shots to ensure the correct exposure with appropriate shutter speed and depth of field.

Camouflage and weather-proof all your equipment—scrim netting and plastic bags may do the trick. Ensure that any wind won't cause these materials to rustle and alarm your subject.

You may need to leave the equipment (or dummies) in place for some time to allow the animals to become accustomed to its presence.

Above: Leaf-cut scrim covers or netting can be very useful to drape over your equipment (and yourself).

Baiting

For many animals—especially shy, nocturnal ones, such as badgers—this is likely to offer you the best chance of getting some interesting photographs. It may also be your only means of luring species that frequent the higher branches of trees down to lower levels. Again, there are ethical considerations to be made concerning the type of food and also the possibility of interfering with the ecological balance by favoring the animals you're feeding. The food should be healthy for your subjects— a natural part of their diet.

In your photographs you don't want it to be obvious that the animal was baited. If you want to picture the animal actually feeding, you may try smearing something desirable onto something more natural such as peanut butter onto a pine cone or nut.

If you don't want the bait in the picture, you need to consider where you place it. You can then try to capture the animal on its way in to feed—on a perch or something natural for them to be on. This is especially important with bird feeders, as you don't want any unnatural constructions to appear in the image. Try to anticipate where the birds will come from and where they will stop to survey the scene to make sure it is safe.

Bird seed, peanuts, cat food, fruit, carrion, or salt may all be appropriate baits, depending on the species you are trying to attract. Try to break the bait into small pieces so that the animal can't run off with the lot and not return! You will generally have to get the animals used to the bait being there, so adopt a routine, putting the bait out at the same time each day and in the same place.

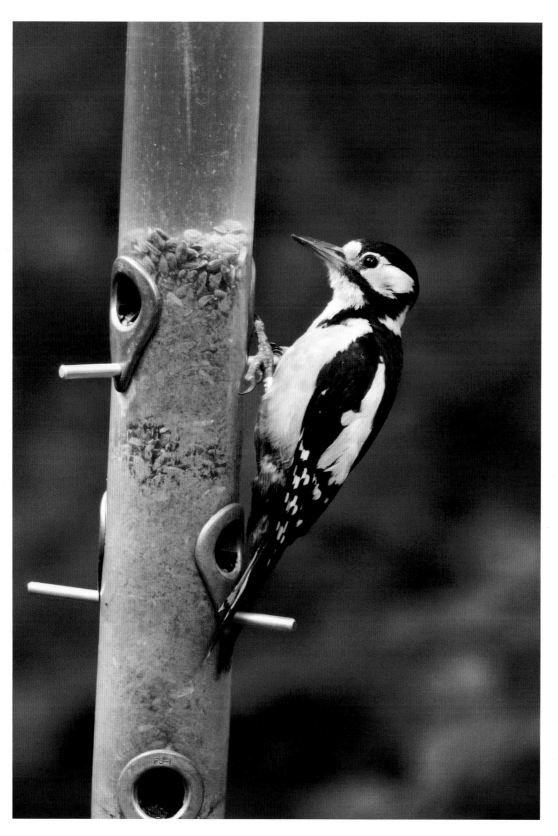

Left: Photographs of birds on feeders are as much about the feeder as the bird, so try to catch them in flight or on other perches en route to the feeder.

Focal length: 640mm

Aperture: f/5.6

Shutter speed: 1/200

ISO: 640

Tips

Visualize the image you want to capture, taking into account the color and nature of the background and any other inclusions you want, such as perches or props.

Position your intended perch according to the light direction at the time of day you are likely to be photographing.

Make sure that objects beyond the perches are far enough away to be rendered out of focus, but also watch out for any colors or light tones that could act as potential distractions.

Consider where you are going to place the feeder so that your subjects are likely to alight on your perch on their way to it. You may, for example, clamp a natural-looking perch to the pole that supports the feeders or attach it to a second, adjacent support.

Nest boxes can be used in a similar way to feeders: once occupied you can set things up to try to catch the adult birds in flight approaching the opening or on likely perches they may use in the immediate vicinity.

Studio & Location Sets

For even more control, you can engineer your photographs by using an indoor or outdoor set. This will enable you to choose your own backgrounds and make use of supplementary lighting, reflectors, and the like. However, you need to have a clear idea of the image you want, so you can set things up accordingly.

Your goal will be to make it look as if the animal is in a natural environment, so think long and hard about the backgrounds and what else you include in the set. You may be able to take your equipment and studio to somewhere the animal naturally frequents, or it may be necessary to temporarily bring the animal onto your prepared stage.

The set may involve enclosing the animal in some way, or luring it to a certain point by baiting. Always plan things with the animal's welfare in mind—action shots of kingfishers diving that are made by luring them to a fish in a transparent container just below the surface are, for example, sometimes frowned upon as there is a risk of the kingfisher injuring itself on the rim of the container.

Usually, it's best to get down to the animal's level, so for smaller animals it is a good idea to factor in a clear view from this level through the side of the set or vivarium. Alternatively, you may be able to raise the animal onto a suitable perch or support. You may need to transport your subject to the set or temporarily house it whilst the set is quickly constructed and prepared—make sure you plan ahead for this so you can ensure the welfare of the animal.

For smaller creatures, including insects, reptiles, and amphibians, a simple vivarium with water supply and somewhere for the animal to conceal itself may be appropriate. If the animal has a high metabolic rate you may need to provide it with food during the time that it is in your care. If there is any risk of harming or unduly stressing the animal though, think again and be prepared to abandon your plan. Always return the animal to where you found it if possible and as soon as you can.

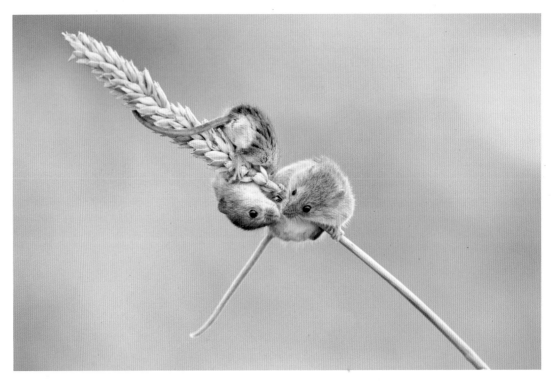

Above: There are various centers where you can photograph a range of species, by entering their enclosures or making use of established sets and the services of a handler. These harvest mice were photographed at Westcounty Wildlife Photography Centre in the UK.

Focal length: 400mm

Aperture: f/8

Shutter speed: 1/320

ISO: 320

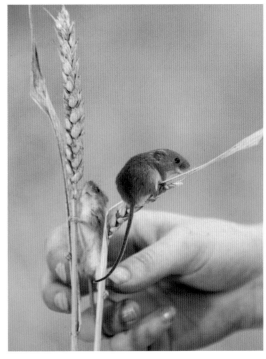

Catching & Handling Animals

Unless you are totally confident that you can handle and move an animal without risk of damage to it or yourself, then consider asking someone with experience to do this for you—many animals are more fragile than they appear.

Nets and moth traps can usually be used to catch flying insects, but moving them from the net to an appropriate place requires skill and a very light touch. This can also make the difference between a good image of a fine specimen and one of a rather battle-worn individual. It is usually preferable to coax or encourage the animal to move into position by its own means.

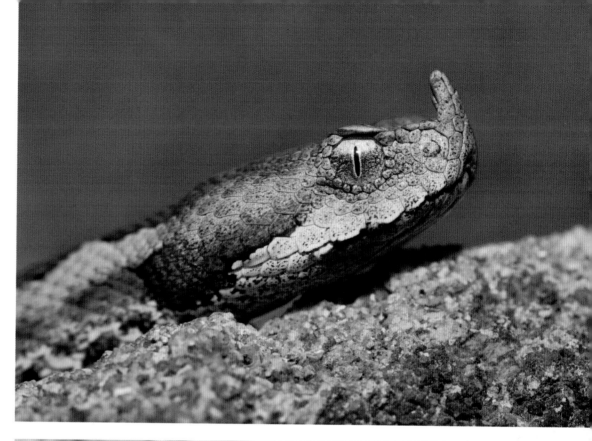

Right: I found this nose-horned viper in a garden in Greece and coaxed it with care (it is Europe's most venomous snake) into a vivarium to confine it temporarily whilst I found a suitable stone and background. I then let the snake gently slide onto the rock. It was early in the morning and the snake was still rather sluggish so it was quite happy basking on the rock for a while before slithering off. I was therefore able to capture the profile I had in mind, showing its distinctive horn and rather menacing eye.

Focal length: 105mm (macro)
Aperture: f/11
Shutter speed: 1/160
ISO: 200

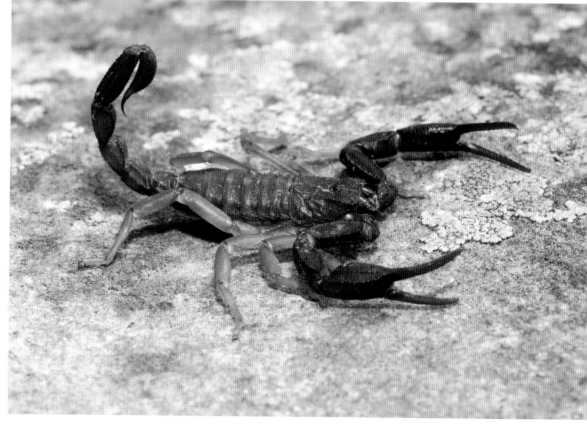

Right: I would often come across scorpions when collecting fire wood in Greece. To get a clear photograph it was often possible to gently coax them away from the debris of the wood stack to a large stone. I always returned them afterward.

Focal length: 105mm (macro)
Aperture: f/20
Shutter speed: 1/6
ISO: 100

Chapter 4
Portraits

Probably the vast majority of wildlife photographs could be classed as portraits. By definition, portraits are simply about showing a "likeness of an individual." They can show the whole animal or just a part, typically the head and face. Again, you can opt for a depictive approach, aiming simply to reveal the anatomy and physical features of the individual or species. Alternatively, you can strive to produce something that will capture an element of your own feelings toward the subject or that will engage and involve the viewer more on an emotional level.

Right: The compound eyes of the horsefly are its most striking feature, so why not go for a tight head-on view?

Focal length: 105mm (macro)

Aperture: f/11

Shutter speed: 1/160

ISO: 160

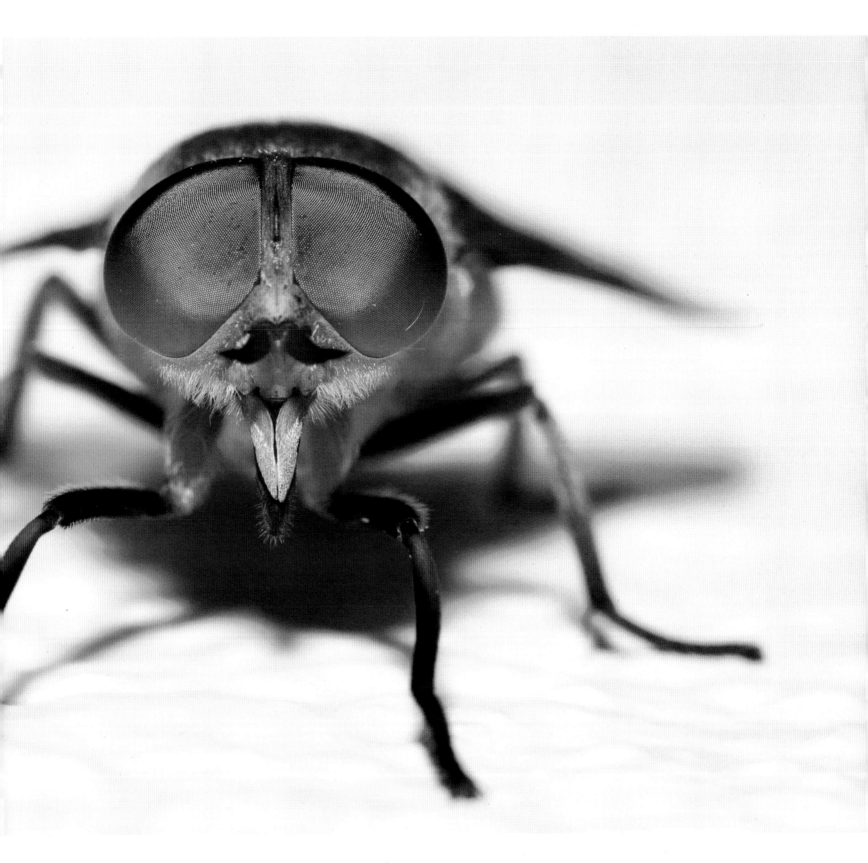

Individuals

Many strong portraits will reveal both the physical characteristics of the subject and also provide an insight into their character. They may also make suggestions about the response the animals engendered in the photographer and vice versa. So, before jumping in, ponder what it is you want to say about that individual. What are the unique traits of that species and also of that individual? What is the best way to reveal these? Consider what lighting, angle of view, or framing will best draw attention to them.

An important consideration is how much of the animal to include. Many portraits involve simply a detailed look at the face. Others may include the head and shoulders or be extended to include other relevant features. Remember that if you choose to crop parts of the animal off, this usually needs to be done boldly so that it is clear that this was your intention. For example, just cropping off the tail or hind-legs often won't work, whereas you may get away with cutting the animal in half (metaphorically speaking), or narrowing it down to just head and shoulders.

In each instance, ask if you are including parts that are not necessary for the message you wish to convey. All your compositional strategies—including cropping—should avoid ambiguity, as a poorly framed image can leave us wondering what the photographer wanted us to look at.

Right: The helmeted guineafowl has a rather extraordinary head. In this portrait the focus falls nicely on this, helped by the soft light.

Focal length: 700mm

Aperture: f/5.6

Shutter speed: 1/640

ISO: 100

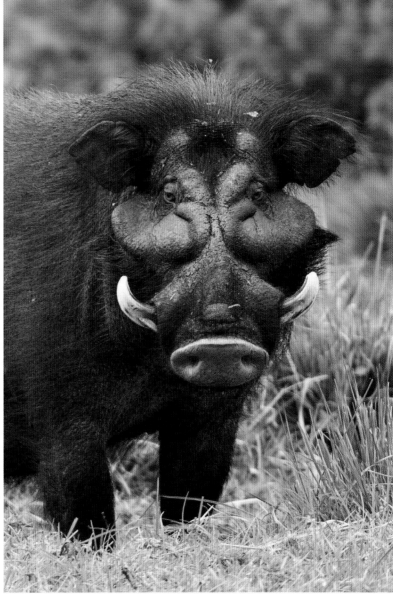

Above: It's not always the beauty of our subject matter that we want to reveal. This profile of a marabou stork shows a design and alert eye that are well-adapted for a life of scavenging.

Focal length: 700mm

Aperture: f/5.6

Shutter speed: 1/500

ISO: 125

Above: The diffuse light of an overcast morning reveals the details of the extraordinary face of a giant forest hog in the Aberdares National Park in Kenya.

Focal length: 1120mm

Aperture: f/5.6

Shutter speed: 1/160

ISO: 200

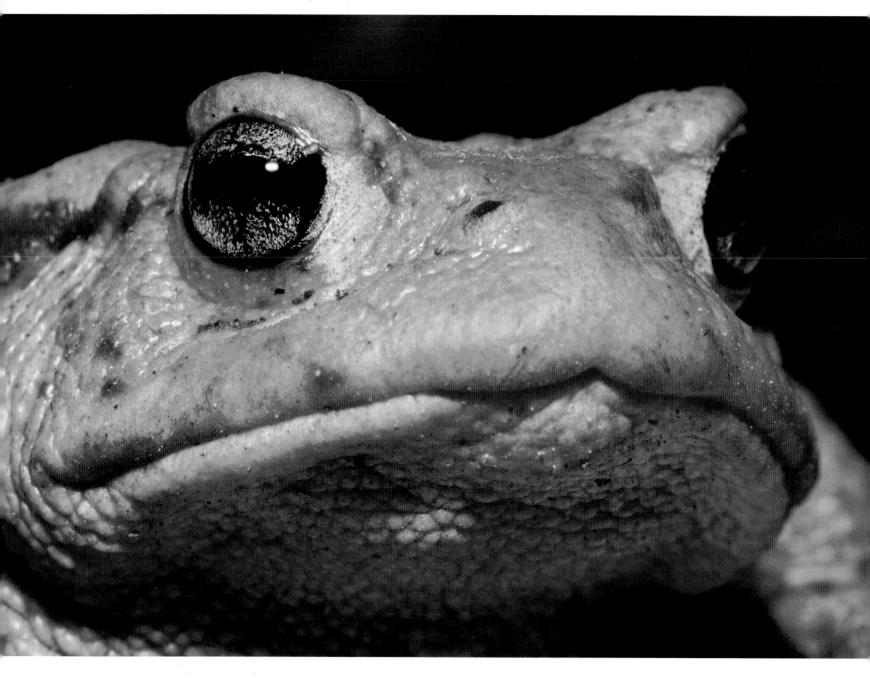

Above: Fill-in flash has provided a catchlight in the eye of this common toad.

Focal length: 105mm (macro)

Aperture: f/20

Shutter speed: 1/125

ISO: 125

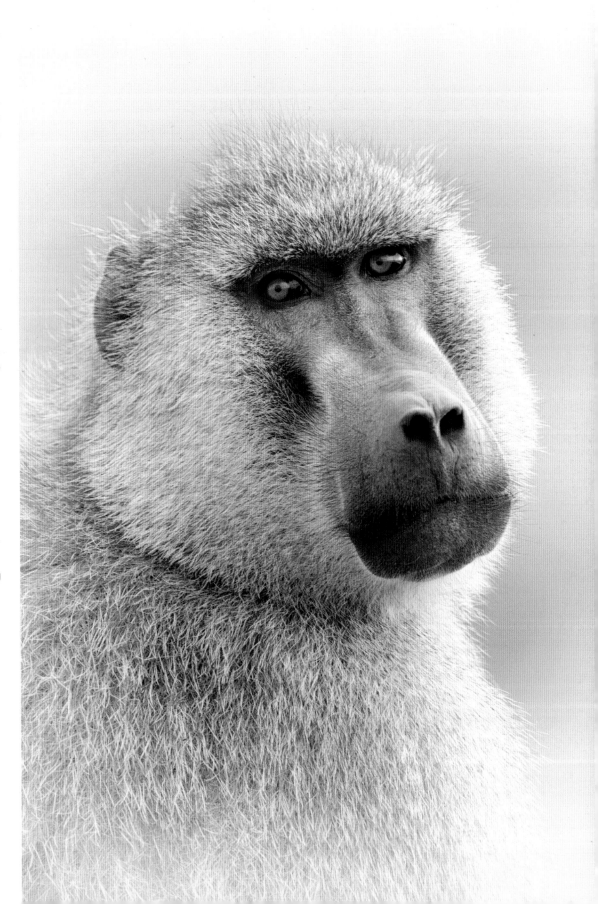

Right: The over-the-shoulder gaze and tilt of the head of this yellow baboon make for a pleasing portrait. Ensuring the eyes are clear and sharp is generally vital in portraiture.

Focal length: 800mm

Aperture: f/5.6

Shutter speed: 1/100

ISO: 200

With most wildlife portraits, it's important that your subject's eyes can be seen clearly and in good light. A general rule is to focus on the eye closest to the camera, but precise focus is critical. With your own body swaying to and fro—even slightly—and also the animal's, there is scope for loss of focus in the split second between focusing using the central AF point and then reframing so that the eye is off-center. Because of this it is often better to focus using an off-center focus point and to release the shutter as soon as focus is achieved.

Catchlights are bright reflections of seen in the eye and these can have a powerful effect on the impact of a portrait. Often it's worth waiting until the animal looks up slightly and you see a slight glint of light in its eye. Fill-in flash can also serve this purpose.

If the light level is low, consider using a beanbag, monopod, or tripod to get the sharpest possible image. You might also try taking two or three shots in succession using your camera's Continuous drive mode—the second shot is often sharper, as it doesn't involve pressing down on the shutter-release button.

Timing is also critical for capturing an interesting head position and gaze. Try to convey your subject's personality and any expressions of emotion by constantly monitoring their posture and body language. Expressions of emotion often come when your subject relates to another individual, so try to be aware of interactions that are going on outside the frame as you concentrate on composing your portrait through the viewfinder. You may perceive expressions of fear, aggression, submission, or alert inquisitiveness—all can make for captivating portraits. Look out also for quirky, unusual, or even humorous expressions.

A sense of connection between the animal and the photographer can also provide for an emotive

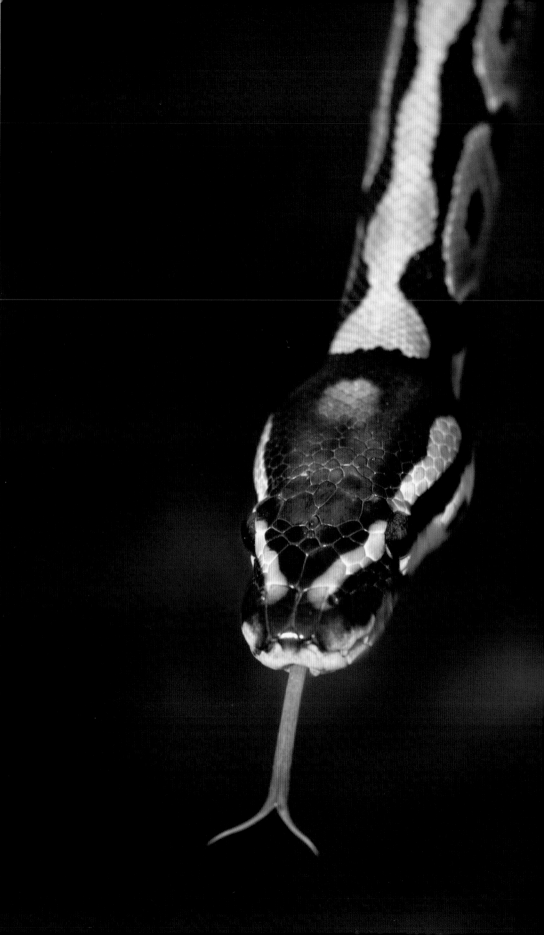

image, so capturing that moment when their gaze meets yours works well.

For mammals, ear orientation can also make or break an image, so be prepared to fire off a series of shots in quick succession. I often find this strategy essential, as flies can often cause animals to blink and flick their ears—something that can easily ruin a photograph.

With portraits, the background can be as important as the subject. Unless there is a message to convey through the background, you won't want it drawing any attention away from the animal, so try to keep it free from distractions, especially bright colors or lighter tones.

For animals in tree canopies, try to ensure there is adequate foliage beyond to avoid white patches of overexposed sky. Soft colors and patterns in the background may actually add to the image and complement the subject nicely.

When composing your portrait, consider whether you want to center your subject in the frame. You may want the viewer's attention to go straight to the eyes and stay there, for example. The rule of "nose room" suggests that if your subject is facing or gazing to one side, it often works well to leave more space to that side for them to face or gaze into.

Don't be afraid to look for new and creative angles. If you are able to get very close without risk, a wide-angle lens may provide a portrait with a difference due to the distorted perspective it will create. Fish-eye lenses are even more extreme, but the resulting bizarre, characterful portraits can be a lot of fun.

You may, of course, also choose to include elements of the creature's environment to provide some context or help complete a story about that individual's unique life and situation.

Right: The forked tongue of snakes like this royal python fascinate us, but catching the moment when the tongue is extruded is easier said than done.

Focal length: 105mm (macro)

Aperture: f/9

Shutter speed: 1/125

ISO: 125

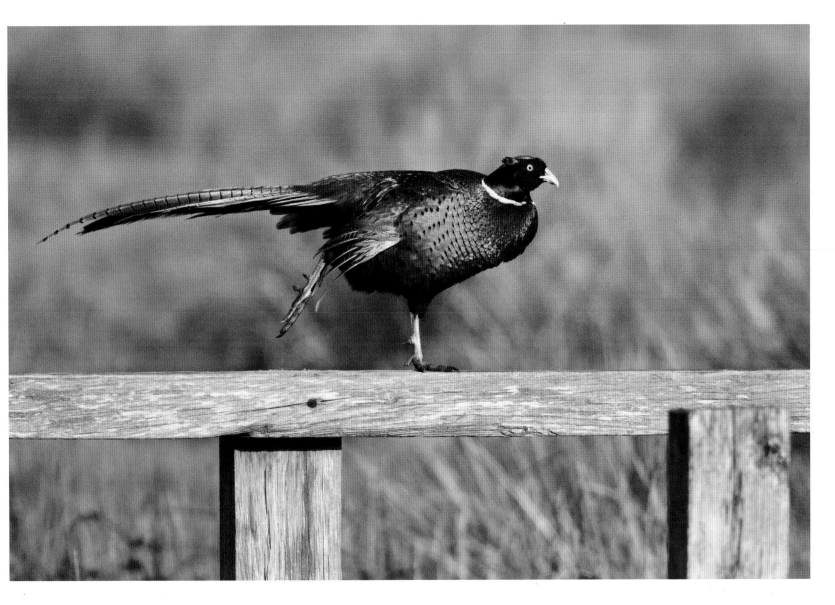

Above: This pheasant struck this pose momentarily, resembling a gymnast on the beam!

Focal length: 1120mm

Aperture: f/5.6

Shutter speed: 1/640

ISO: 125

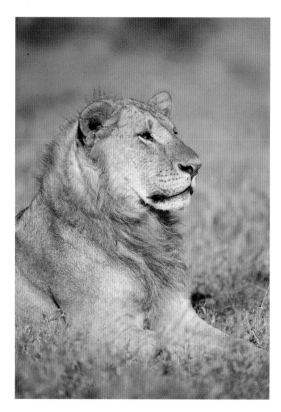
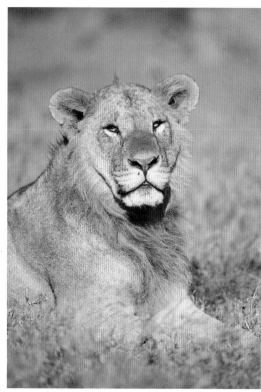
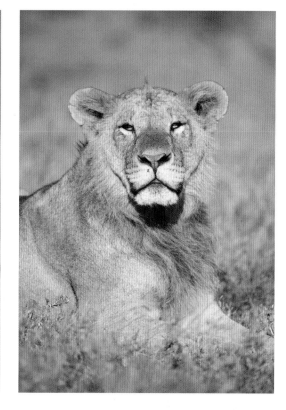

Above: A series showing the importance of precision. If the gaze is slightly off the camera (left and center), it may carry less impact.

Focal length: 500mm

Aperture: f/4

Shutter speed: 1/1250

ISO: 125

Right: By allowing a little space for this captive brown bear to stroll and gaze into we also benefit from the inclusion of some interesting features of its environment—the Bavarian Forest National Park in Germany.

Focal length: 340mm

Aperture: f/7.1

Shutter speed: 1/320

ISO: 800

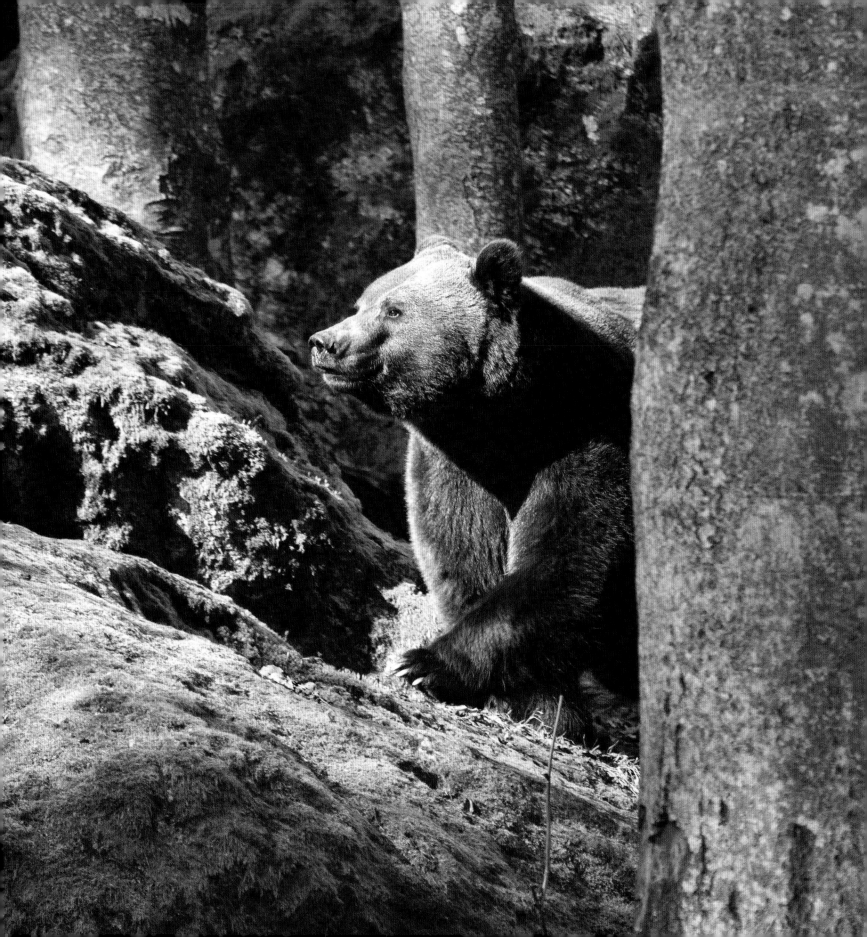

Groups

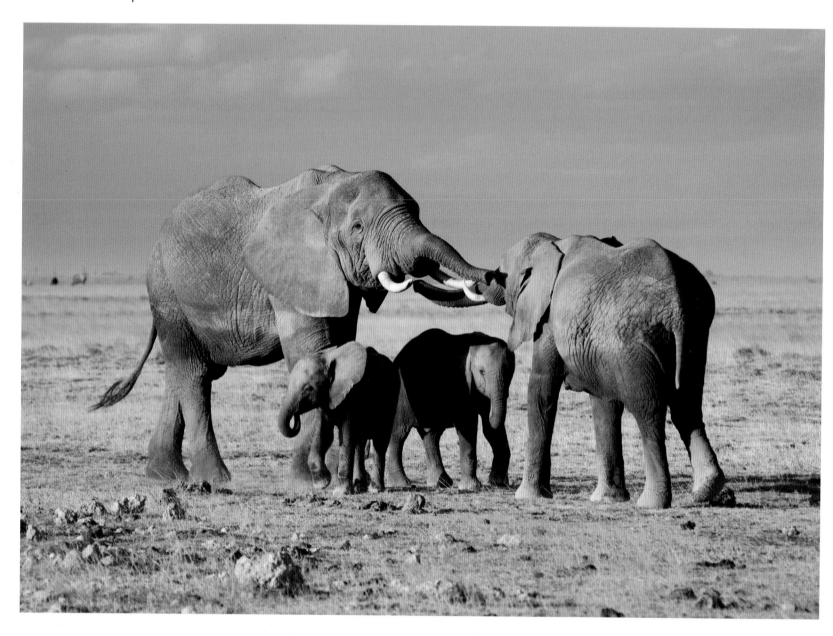

For group portraits of animals, look out for interactions between individuals to capture expressions of emotion or relationship—mother and baby interactions can provide for especially appealing images.

Animals with strong social structures offer bountiful opportunities for captivating images.

I have spent many hours enthralled by the antics of baboons. There is always something going on—a squabble, a sexual advance, a tender moment between mother and baby, or the playful antics of the juveniles.

There are also, of course, those wonders of the natural world that occur when thousands or

Above: I experienced a touching expression of kinship in the Amboseli National Park in Kenya when this bull elephant came from far off to greet each calf in turn and then the mother.

Focal length: 300mm

Aperture: f/8

Shutter speed: 1/160

ISO: 400

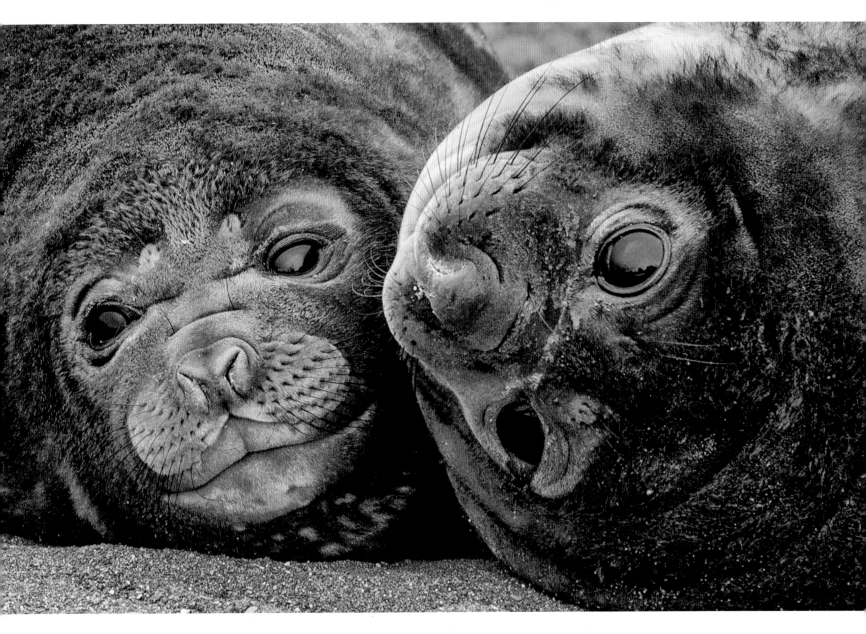

Above: The rounded faces of these elephant seal pups lying side by side, but at very different orientations, makes it a strong image.

Focal length: 200mm

Aperture: f/5

Shutter speed: 1/320

ISO: 250

Left: A moment of humor caught as two olive baboon infants play on the trunk of a giant baobab tree in Tanzania.

Focal length: 500mm

Aperture: f/6.3

Shutter speed: 1/320

ISO: 200

millions of individuals amass for various reasons. The annual great migration of wildebeest and zebra in East Africa, red land crabs marching from the forest to the sea on Christmas Island in the Indian Ocean, and the migration of Monarch butterflies to overwinter in Mexico or southern California are three such examples.

It's relatively easy to research these sorts of events to ensure that you're in the right place at the right time. More often, the problem is dealing with the higher costs due to demand and potentially the crowds of photographers there for the same reason! Again, think about what you want to say about these events through your photographs and how you can best convey this. How might you generate another "take" on the event? In such situations, you might look out for unusual postures or patterns formed by two or more animals in relation to each other. These can make for graphically interesting pictures.

Right: A grizzly bear cub tries to get its mother to wrestle with it.

Focal length: 640mm

Aperture: f/8

Shutter speed: 1/320

ISO: 200

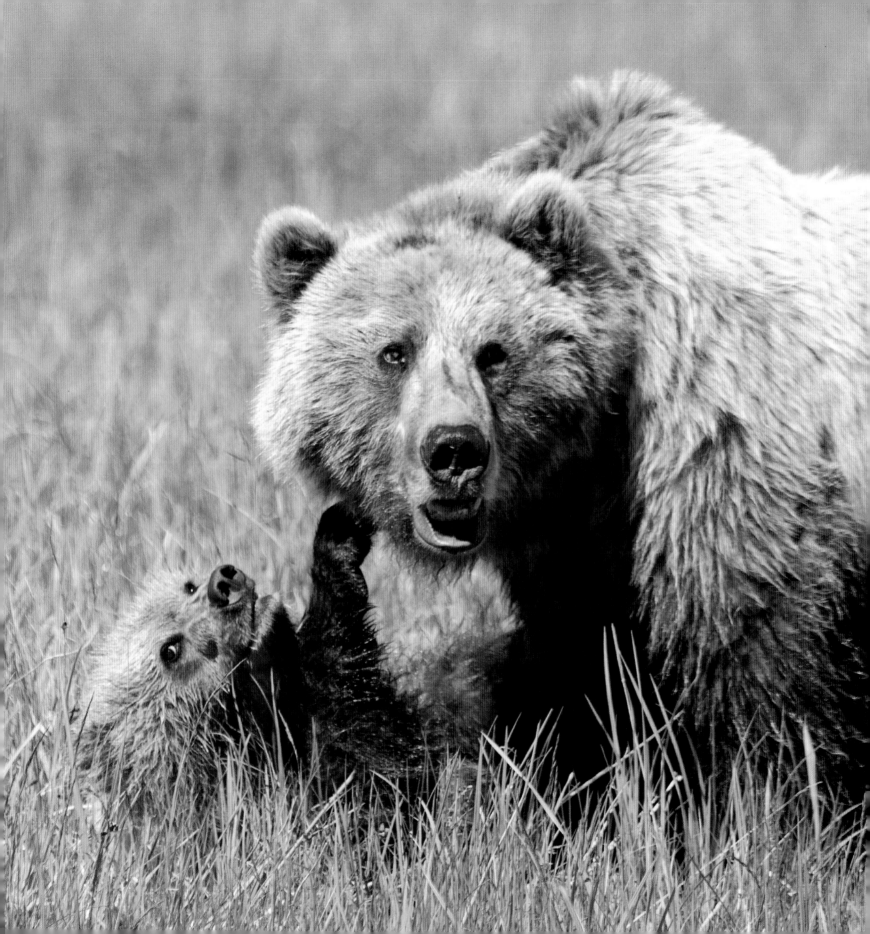

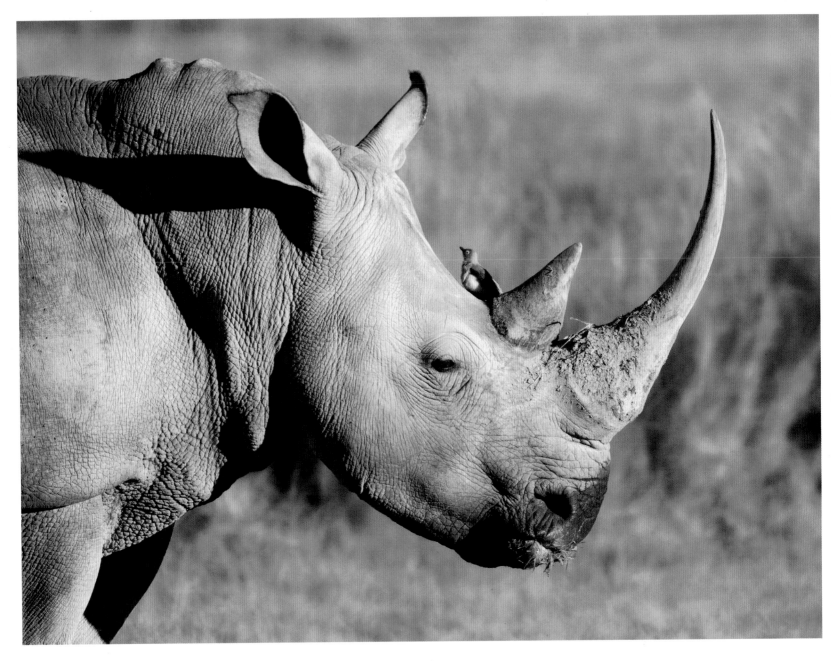

Be on the look out for interactions between species, as these can be particularly interesting. Associations between various species particularly occur where they are forced to come into close proximity due to their mutual needs. In arid areas, for example, waterholes can serve as magnets for all kinds of thirsty creatures.

There are also many examples in the natural world of symbiotic relationships—ones where the lives of two species are closely intertwined to mutual advantage. In Africa, many browsing animals have their attendance of oxpeckers. These little birds skip around on the hides of these animals pecking at the ticks and parasites in the folds of their skin.

Above: The confident association of this white rhino and its attendant red-billed oxpecker adds to the portrait. It provides a little humor and also helps make a statement about their relative sizes.

Focal length: 800mm

Aperture: f/5

Shutter speed: 1/1250

ISO: 200

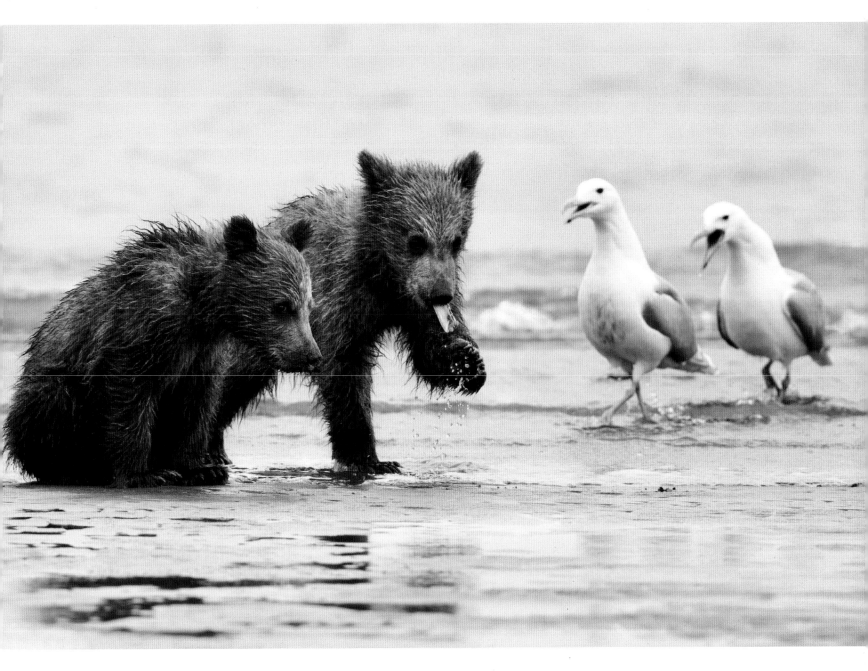

Above: Two diminutive grizzly bear cubs are challenged by seagulls for the remains of a razor clam.

Focal length: 500mm

Aperture: f/10

Shutter speed: 1/320

ISO: 400

Chapter 5
Capturing the Action

Even most budget digital SLRs now have an ability to capture action that photographers could only dream of 20 years ago. However, before we discuss these capabilities, let's first take a look at three standard ways of capturing action and conveying motion in your photographs.

Right: I have taken a number of images of antelopes fighting, but this one of black-faced impala is one of my favorites as it captures a sense of the heat of the battle.

Focal length: 800mm

Aperture: f/7.1

Shutter speed: 1/400 sec.

ISO: 500

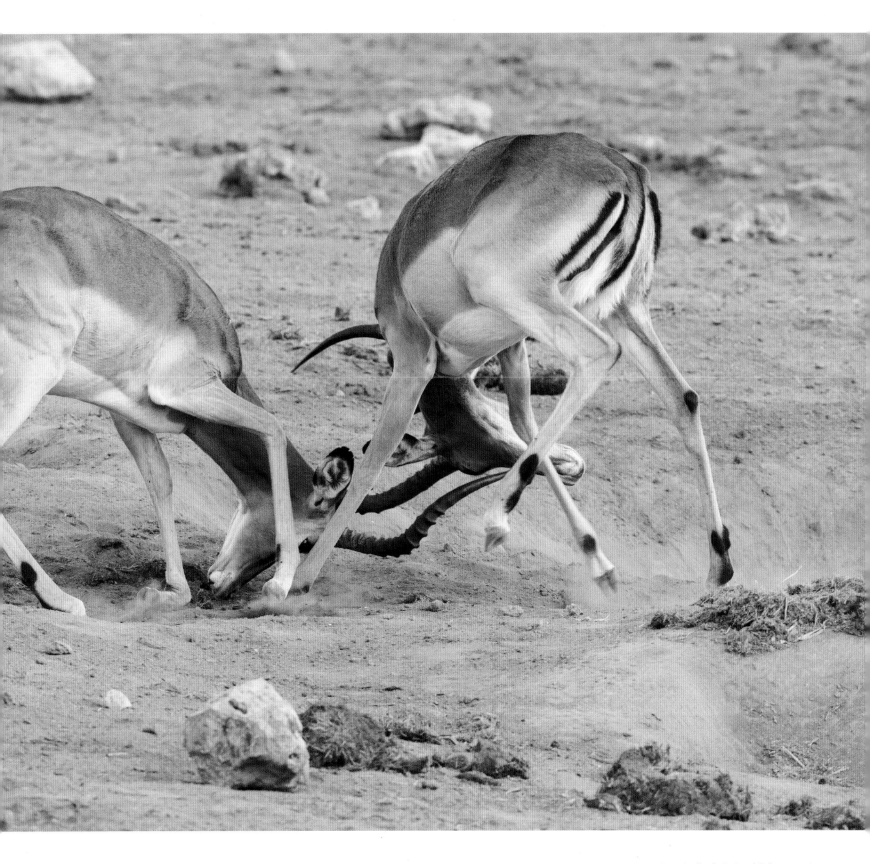

Recording Movement

The first option for recording movement is to freeze it. The shutter speed needed for this will depend to a large degree on the speed of the animal—1/250 sec. may freeze a running elephant, but it is unlikely to stop the flapping wings of a bird approaching its nest, for which you may need to use a shutter speed as fast as 1/4000 sec.

The main consideration is how far the limbs or wings of the animal will move within the frame of the photograph—you can usually get away with a slightly slower shutter speed if the animal is moving toward you, rather than across your field of view, for example.

Even if you're using a fast shutter speed, it is a good idea to attempt to follow the movement of the animal by panning the camera. This will help ensure that the bulk of the animal remains perfectly sharp. An animal moving at 25mph covers about 10m per second, so it will move 1cm in 1/1000 sec.—enough to result in a slight loss of sharpness in your photograph.

Right: This brown bear was charging toward me in an enclosure in Bavaria. The splashes of snow kicked up help to generate a sense of energy and motion.

Focal length: 365mm
Aperture: f/5.6
Shutter speed: 1/3200 sec.
ISO: 1250

Far Right: Freezing whatever the movement of the animal disturbs gives a sense of the energy of the action. Here it is the water disturbed by a herring gull landing in a lake.

Focal length: 700mm
Aperture: f/5.6
Shutter speed: 1/3200 sec.
ISO: 400

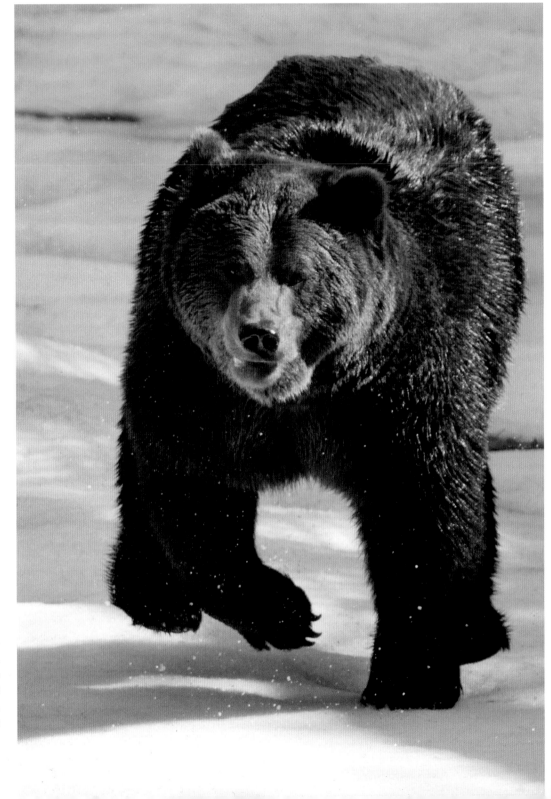

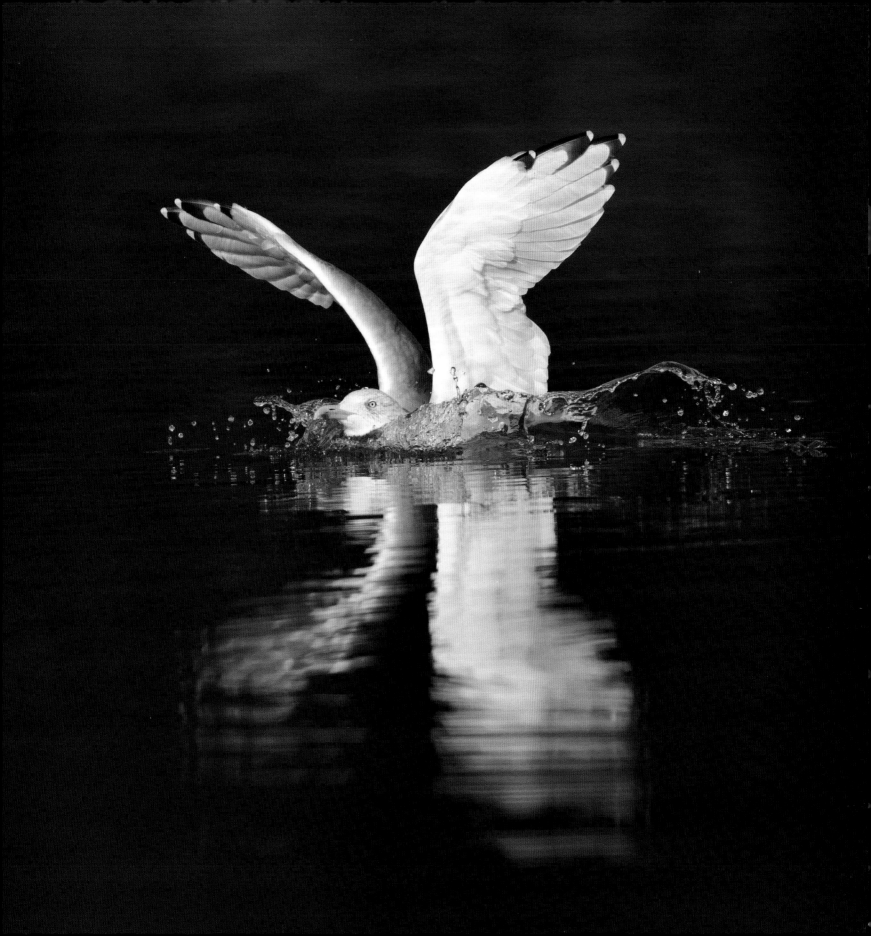

Motion Blur

A second method for recording movement is to create a sense of motion by incorporating "motion blur." You can do this by selecting a slower shutter speed and "panning" your camera to follow the course of the moving animal.

You will have to experiment with different shutter speeds, but the aim is usually to keep the body (especially the head and eyes) of the animal sharp, so this is the point to focus on and follow. With telephoto lenses, speeds of 1/30–1/60 sec.

are a good starting point with running animals. Longer exposures will exaggerate the movement more, at the expense of sharpness.

If the light levels are too low to allow fast shutter speeds to freeze movement, use it as an opportunity to practice panning and try to capture a sense of movement.

This can also be a useful technique to employ to smooth out detail if the background in your scene is a little messy.

Right: Capturing this image with a shutter speed of 1/25 sec. gives us a sense of the young lion being on the move.

Focal length: 800mm

Aperture: f/5

Shutter speed: 1/25 sec.

ISO: 800

Below: There is enough motion blur created at 1/15 sec. to convey a good sense of movement as this cheetah trots across the plains of the southern Serengeti.

Focal length: 400mm

Aperture: f/5.6

Shutter speed: 1/15 sec.

ISO: 250

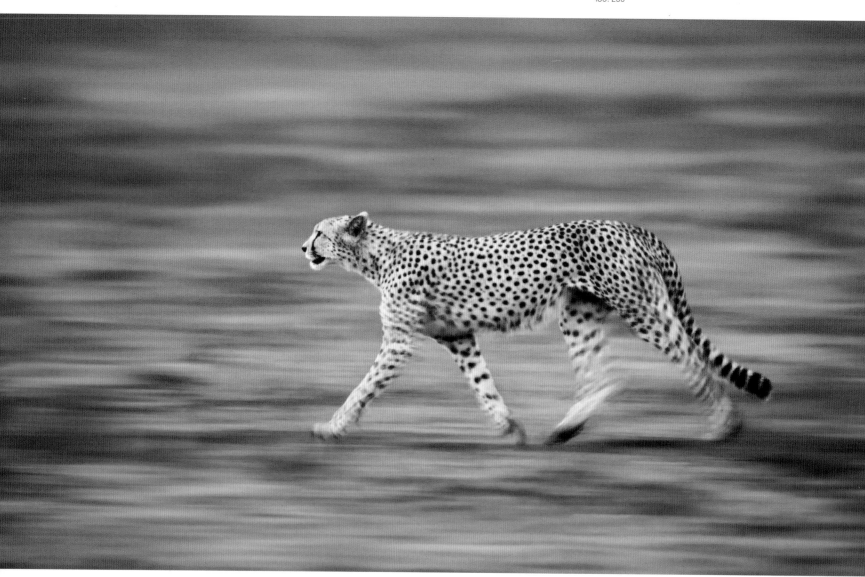

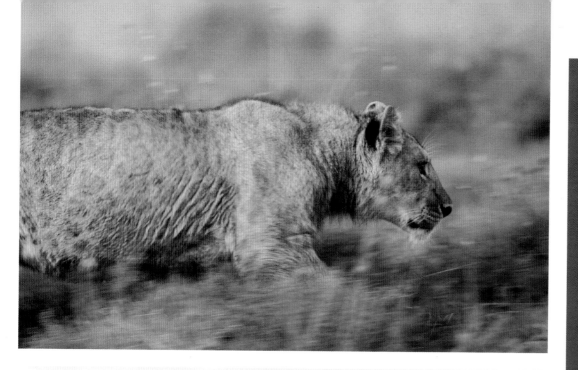

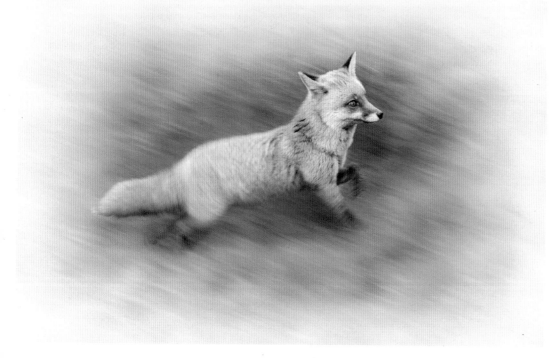

Above: I struck lucky with this image of a captive fox chasing fragments of meat that had been thrown for it. The head is pin-sharp and the motion blur is as it came out of the camera. The conversion to sepia and the addition of the vignette has made it a popular print.

Focal length: 235mm

Aperture: f/9

Shutter speed: 1/80 sec.

ISO: 200

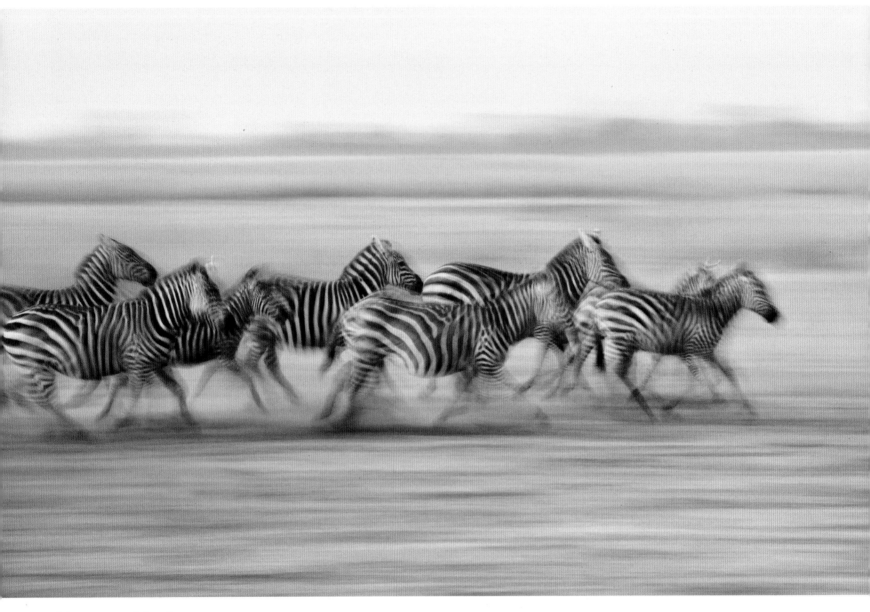

Abstract Motion

Finally, you can get really "creative" and opt for a more abstract use of blur to interpret the movement of your subject.

With each of these techniques, remember to allow space in the frame for the animal to "move into," unless you intend to give the message of the animal running into a barrier or out of the frame.

Above: Low light levels compelled me to adopt an abstract approach as this herd of zebras broke into a gallop.

Focal length: 105 mm

Aperture: f/5.6

Shutter speed: 1/5 sec.

ISO: 1000

Opposite: Even with the use of flash, the wings of this hovering hoverfly are still a complete blur. The fact that their blur is visible actually makes for quite a captivating image.

Focal length: 168mm (macro)

Aperture: f/16

Shutter speed: 1/160 sec.

ISO: 250

Flash

Movement can also be recorded in a variety of ways using flash. Slow sync flash—where your flash is used with a relatively slow shutter speed selected on the camera—can yield some interesting results. This can provide a sort of blending of blurred parts of the image not lit well by the flash with sharper well-lit parts.

You could also try setting your flash to "rear curtain sync" and then panning a moving subject with a relatively slow shutter speed set. The short duration of the flash at the end of the exposure gives a well lit, frozen impression of the moving subject, with darker motion streaks extending behind it.

However, your choice of settings (and whether or not you use flash) will ultimately depend on how you wish to record the action, as well as what is possible. You will need to think ahead, though, because once the action starts there is often no time to make adjustments and corrections. Experience and understanding of behavioral traits will help you predict when and where the peak of the action is likely to occur.

Camera Settings

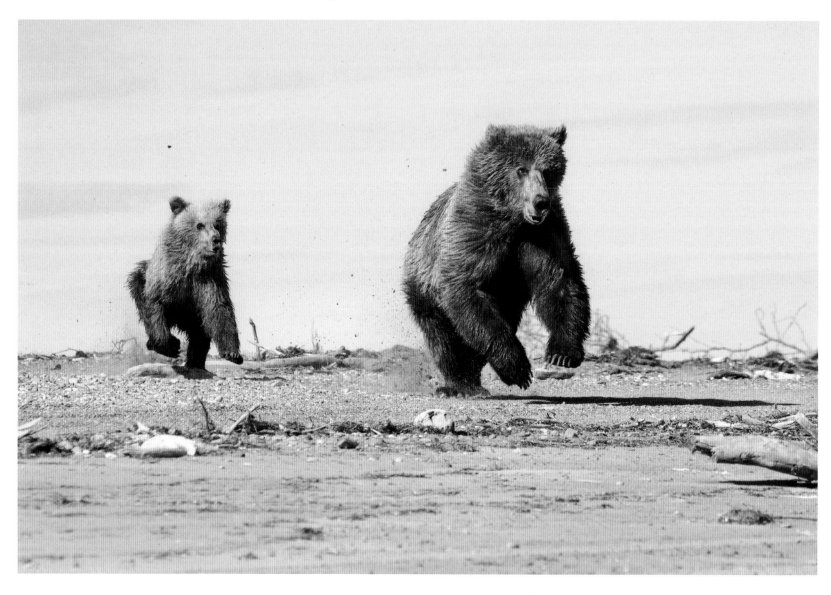

For capturing "the precise moment" during a burst of action or aspects of complex behavior, your camera's Continuous drive mode is imperative. Having a camera that can shoot at a fast frame rate is often an advantage, but the size of the camera's data buffer is also important. This is the number of images you can shoot and store in succession before the camera slows down or stops to clear the data.

You also need to consider the speed of the memory card you're using, as the fastest cards store images more quickly and reduce waiting time if the camera "buffers out."

To reduce the chances of this happening to start with, it's better to fire off short bursts at critical points, rather than long, sustained bursts. This is less critical if you're shooting JPEGs, due to the compressed file sizes.

Above: This image gains impact from the fact that both the mother grizzly and her cub are almost airborne and in a similar phase of their galloping stride. The cub is almost like a shadow to her mother.

Focal length: 496mm

Aperture: f/11

Shutter speed: 1/800 sec.

ISO: 400

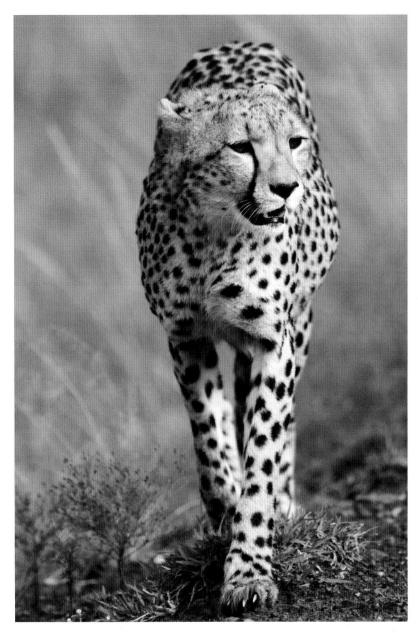
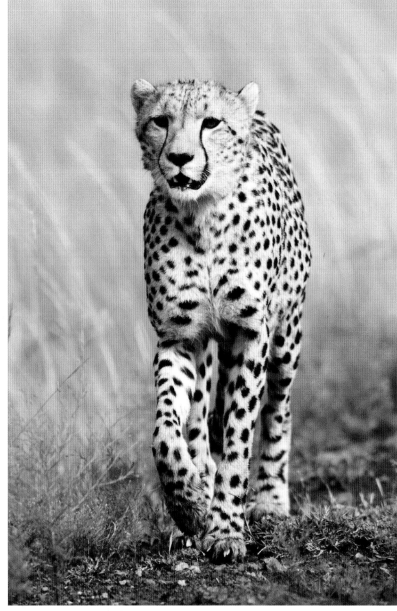

The other setting of choice is continuous/ predictive focus. Start by focusing on the head of the moving animal, and then follow it with good panning technique as it moves, keeping the shutter-release button half pressed.

If you want to compose with the animal's head off-center, select an appropriate off-center focus point (or group of points), but be aware that the outer focus points may not be as sensitive as the central ones, so you should only use them if the light is strong.

Many cameras now offer a facility for automatically tracking moving subjects. The camera will first use the selected AF point, but if the subject moves away from this point, focus tracking will continue using alternative focus points or a larger group or "zone" of AF points. In some cameras, focus tracking can also be adapted to

Above Left & Above Right: Even with a walking animal it can be worth firing off quick bursts, as certain phases of the gait of the animal will look more balanced or give a better impression of motion than others. The second image of this cheetah (above right) is much better, for example.

Focal length: 800mm

Aperture: f/6.3

Shutter speed: 1/320 sec.

ISO: 100

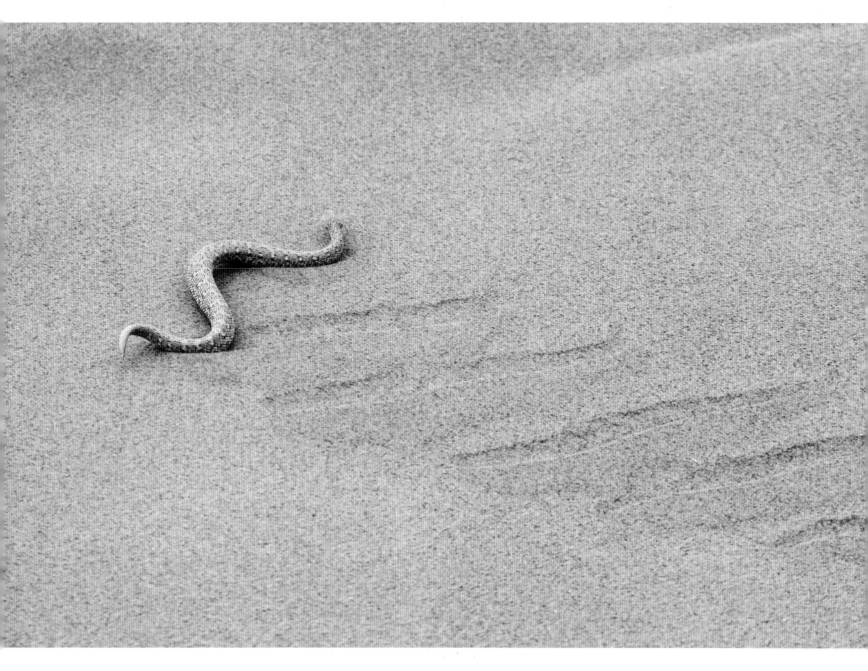

suit the needs of different situations. For example, some Canon cameras allow you to set the tracking sensitivity, acceleration/deceleration tracking, and AF point auto switching, which can be used to best match the focus tracking to your subject and its environment.

Of course, there will be times when auto focusing and tracking are not an option, such as in poor light or when there are too many extraneous elements, such as in woodland or during a snowstorm. In this type of situation, you can use a more traditional focusing method.

If you can predict the animal's line of movement, you can focus ahead of it (perhaps manually) on something in its path and take the shot as the animal passes that point. This is often helpful when the creature is coming toward you.

Above: The pattern in the sand left by this Peringuey's adder was as much the subject as the snake itself, so I used the central AF point to focus with. A relatively small aperture ensured an adequate depth of field.

Focal length: 184mm

Aperture: f/9

Shutter speed: 1/320 sec.

ISO: 200

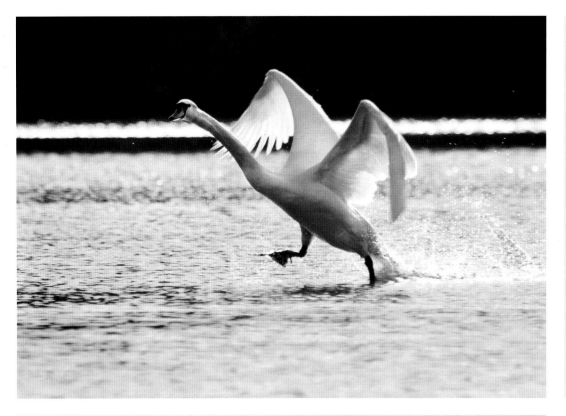

Tips

Many photographers prefer to use "back button focusing" when tracking moving animals. To enable this, a button on the rear of the camera (often the AE lock button) is set via a custom function to act as an autofocus button. This allows you to set the focus using your thumb and to release the shutter at the peak of the action with your index finger.

For tracking and photographing moving subjects you may need to deactivate or change the setting of your image stabilizer.

When you are about to photograph some potentially erratic and unpredictable action, consider selecting a shorter focal length lens to allow a little more room around the animal. Sometimes it's better to crop the image slightly, than find your subject moves out of shot.

Above Left: A large bird, such as this mute swan taking off, should be relatively easy to track, as it will have to head in a straight line and its acceleration will be relatively low as it gets its giant wings in motion.

Focal length: 640mm

Aperture: f/7.1

Shutter speed: 1/500 sec.

ISO: 100

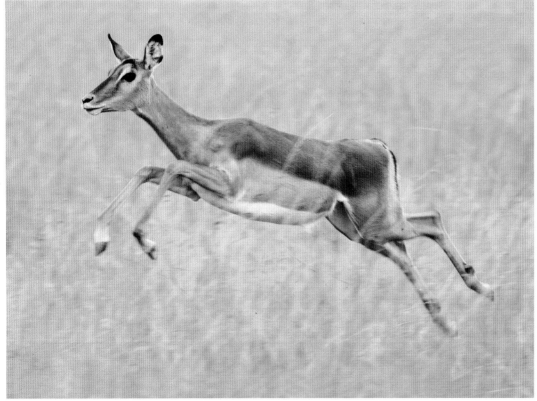

Left: The long grass and erratic movements of a leaping and bounding impala are challenging for most AF systems.

Focal length: 800mm

Aperture: f/6.3

Shutter speed: 1/250 sec.

ISO: 200

Birds in Flight

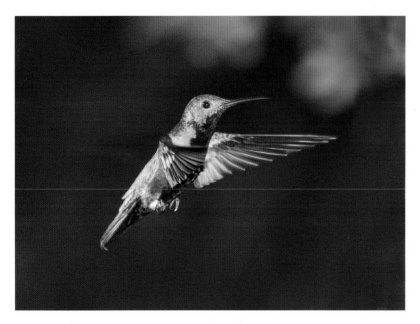

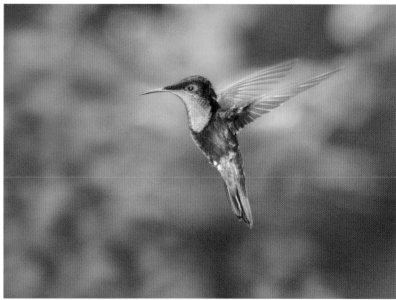

Above: This image of a black-throated mango hummingbird was captured at 1/125 sec. A single flash has helped freeze the movement, but the lack of ghosting around about the wings suggests luck with the timing was largely behind the almost frozen wing beat.

Focal length: 352mm

Aperture: f/5.6

Shutter speed: 1/125 sec.

ISO: 400

Above: A completely frozen image can sometimes appear a little static, so there is no harm in allowing a little motion blur. Here, I am quite happy with the slight ghosting of the wings of this male ruby topaz hummingbird.

Focal length: 528mm

Aperture: f/5.6

Shutter speed: 1/250 sec.

ISO: 400

The shutter speed required to freeze the wings of a flying bird will depend on the species and size of the bird. For smaller birds you will typically need to shoot with a shutter speed of at least 1/1000 sec.

Flight paths are often relatively unpredictable and it can be a challenge to find the bird in your viewfinder and lock your focus onto it. Zoom lenses often make things a little easier as you can zoom out a little, making it easier to locate the bird and attain focus. You can then zoom in again once you're tracking it.

Hummingbirds are a particularly appealing—and challenging—subject. Depending on the species, a hummingbird may flap its wings between 12 and 80 times per second, although its body will be very

still. You can occasionally strike lucky with relatively modest shutter speeds, as the wings are actually stationary for a split second at the top and bottom of each beat. However, to freeze the movement consistently—particularly mid wingbeat—requires very high shutter speeds. Set-ups involving multiple flashes and reflectors are typically used to enable this.

Such set-ups also offer even and natural-looking illumination on both the bird and possibly an artificial painted backdrop. These are often arranged around a sugar water feeder or flower into which sugar water has been syringed. The flashes can then be set to high-speed sync to enable very fast shutter speeds to be used.

Right: Low early morning sun lights the undersurface of this herring gull effectively.

Focal length: 700mm

Aperture: f/5.6

Shutter speed: 1/2500 sec.

ISO: 400

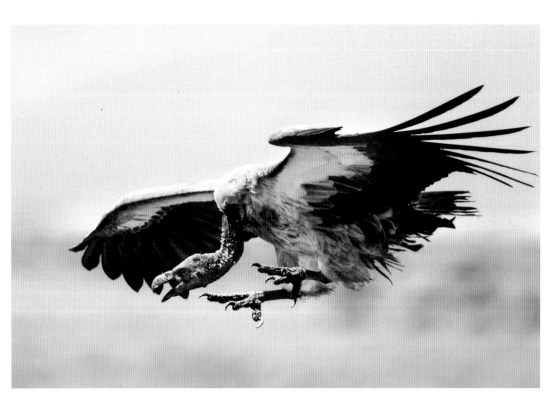

Left: Vultures tend to fly in from all directions to join the melee at a kill, but at least their destination is predictable.

Focal length: 1120mm

Aperture: f/5.6

Shutter speed: 1/800 sec.

ISO: 100

Tips

Work early and late in the day, as the low sun will light the underside of the bird and its wings. If you can get them sunlit against a dark background or a dark, brooding sky, this works very well. Snow and water can also act as giant reflectors, directing light up onto the underside of the bird.

Try to predict the flight path and consider the lighting and backgrounds.

A perched bird will often defecate or ruffle its feathers just before flying, so you can use this as your prompt to start firing off a series of shots. Large birds will need to spread their wings before takeoff, so are often much easier to photograph.

As they leave a perch, birds tend to drop a little initially. Prepare for this by framing a bird that is about to fly in the top corner of the frame.

If you are aiming to capture a bird returning to its nest or a perch, remember that many birds will land facing into the wind.

Allow plenty of room in the frame for wings to spread and take a series of shots so you can choose the one with the most appealing phase of the wingbeat.

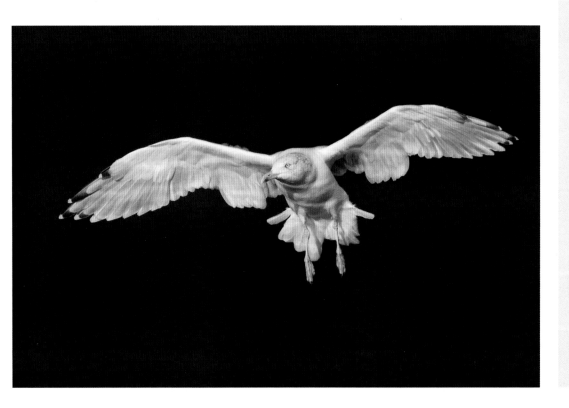

Behavior & Interactions

In the natural world, much behavior is repeated and predictable. For example, offspring in a nest will need feeding regularly and courtship displays are often ritualized, so with experience you can come to know what to expect. Other behavior sequences may be repeated based on recovery periods—courting lions, for example, mate every 20 minutes (you can almost set your watch by it!).

Many animals also have predictable routines and sites for territorial activity. Indeed, things rarely happen spontaneously, so if you are tuned in to the communications that are going on between individuals and listening and looking for cues, you will hopefully be prepared to capture what subsequently unfolds.

To witness natural behavior, it is usually important to keep your distance. However, there are also times when the focus of your subjects is so strongly on their interaction or needs that they barely notice the paparazzi in attendance.

Finally, remember to consider the potential for a series of images to tell the fuller story. When this is an option, formulate your intention in advance so you can set about methodically realizing it as the story unravels.

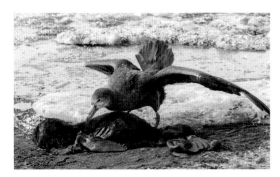

Above: A great southern petrel feeding on an elephant seal pup carcass on South Georgia.

Focal length: 140mm

Aperture: f/7.1

Shutter speed: 1/500 sec.

ISO: 400

Left: We stayed and watched these mating lions perform three times very near to the track we were following in the Serengeti. It is all over quite quickly, so there is no time to adjust your position—you have to just hope that they orientate themselves well for the camera.

Focal length: 105mm

Aperture: f/6.3

Shutter speed: 1/320 sec.

ISO: 320

Right: In the Ngorongoro Crater of Tanzania we came across this male kori bustard displaying on some open ground. He was so absorbed in his performance that he was oblivious of the spectators. The show was impressive on account of how he ruffled up his neck feathers and emitted an incredible booming sound like a bass drum.

Focal length: 800mm

Aperture: f/6.3

Shutter speed: 1/800 sec.

ISO: 100

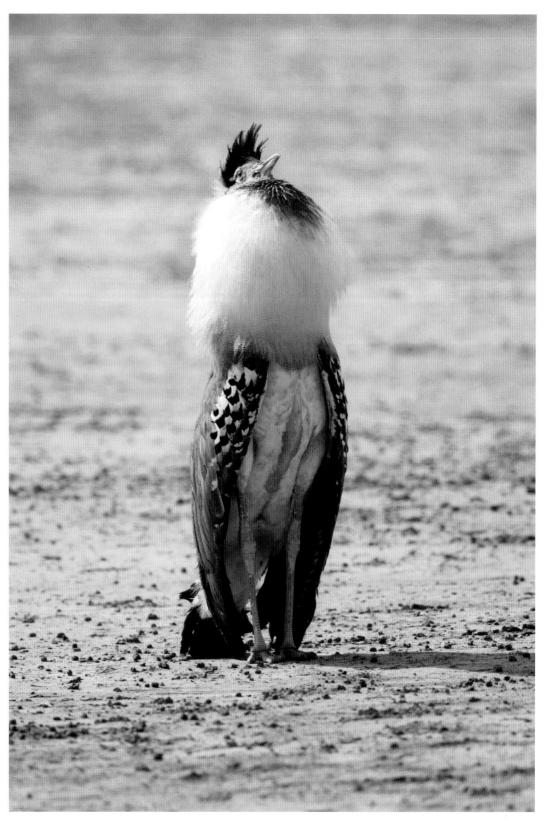

Chapter 6
Close-up

Through close-up photography we are able to view the intricate details of smaller creatures and plants or inspect the finer details of larger subjects. We are able to appreciate and enjoy many patterns, textures, and shapes within the natural world that we would probably otherwise be unaware of.

Right: This scorpion with her young was partly in deep shadow from the overhanging rock. I only had one flash with me, so bounced it off a reflector to the left to try and create a larger light source to give slightly more even illumination and a more natural look.

Focal length: 105mm (macro)

Aperture: f/16

Shutter speed: 1/160 sec.

ISO: 160

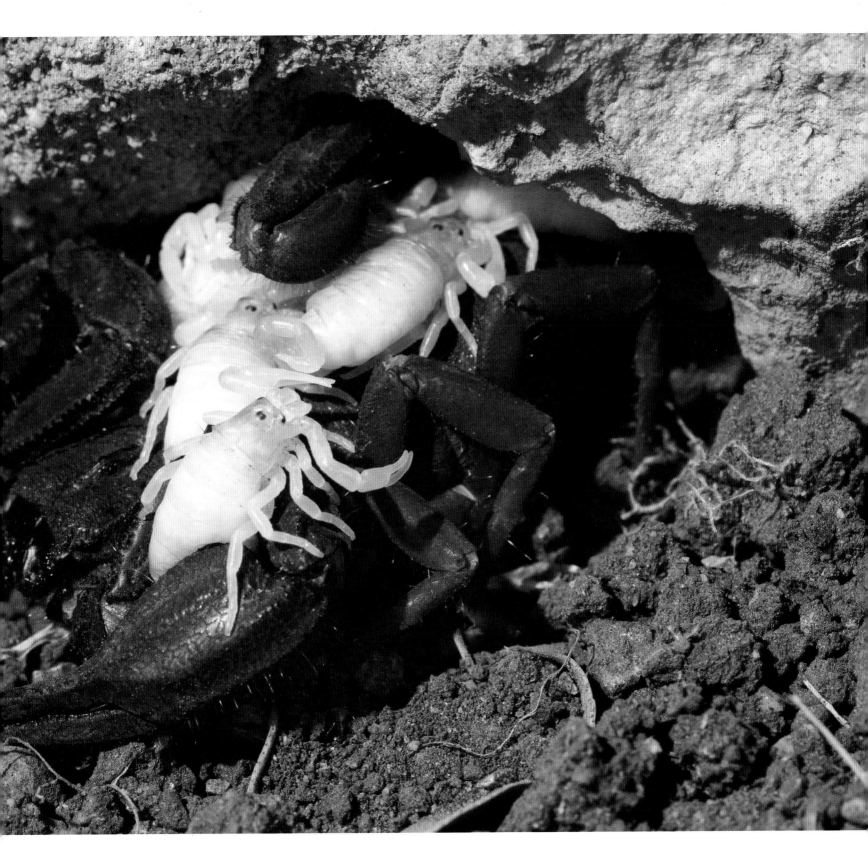

Take time to explore your location up close. We are not generally used to surveying our surroundings in this way and it is often a surprise to see what is there when you look closely enough. If details catch your eye, examine them from all angles, trying to visualize how they would appear as a cropped, two-dimensional image.

Of course, the slightest imperfections will also be magnified and made more evident, which may detract from the overall beauty of the subject. So, take time to choose your subject carefully. The surroundings will also be seen up close and could prove quite distracting so particular care is required in composing the shot.

Overcast days are often ideal for close-up photography, as the softer, more diffuse light helps avoid shadows and reveal the finer details. It's best to avoid windy days, though, as even small gusts can play havoc with carefully set up compositions, and the tiniest amounts of movement can result in blurred images.

Right: A broad-bodied chaser emerges to begin the next stage of its life cycle. Soft, natural light reveals all the details in this dragonfly and its nymphal case.

Focal length: 168mm (macro)

Aperture: f/9

Shutter speed: 1/5 sec.

ISO: 200

Far Right: The bold facial markings of this Roesel's bush-cricket warrant closer inspection. Macro photography enables us to enjoy such wonders.

Focal length: 105mm (macro)

Aperture: f/13

Shutter speed: 1/125 sec.

ISO: 125

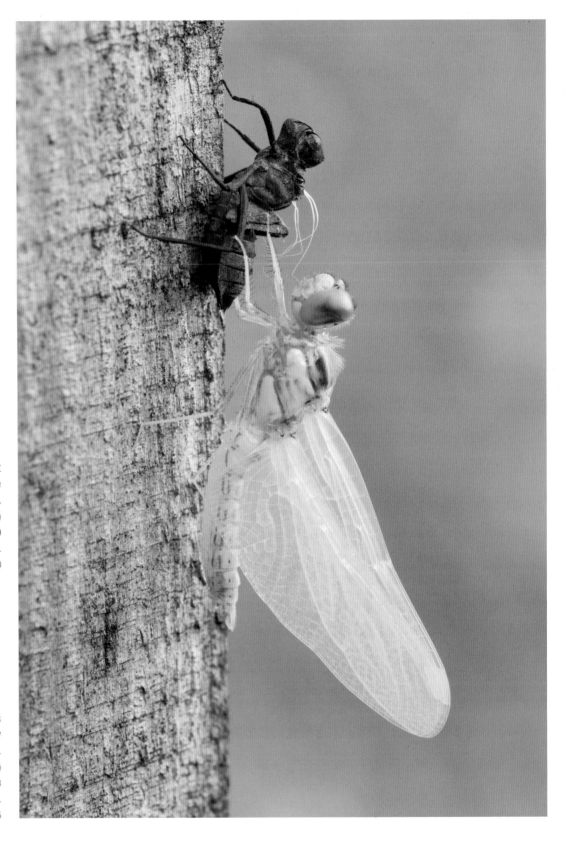

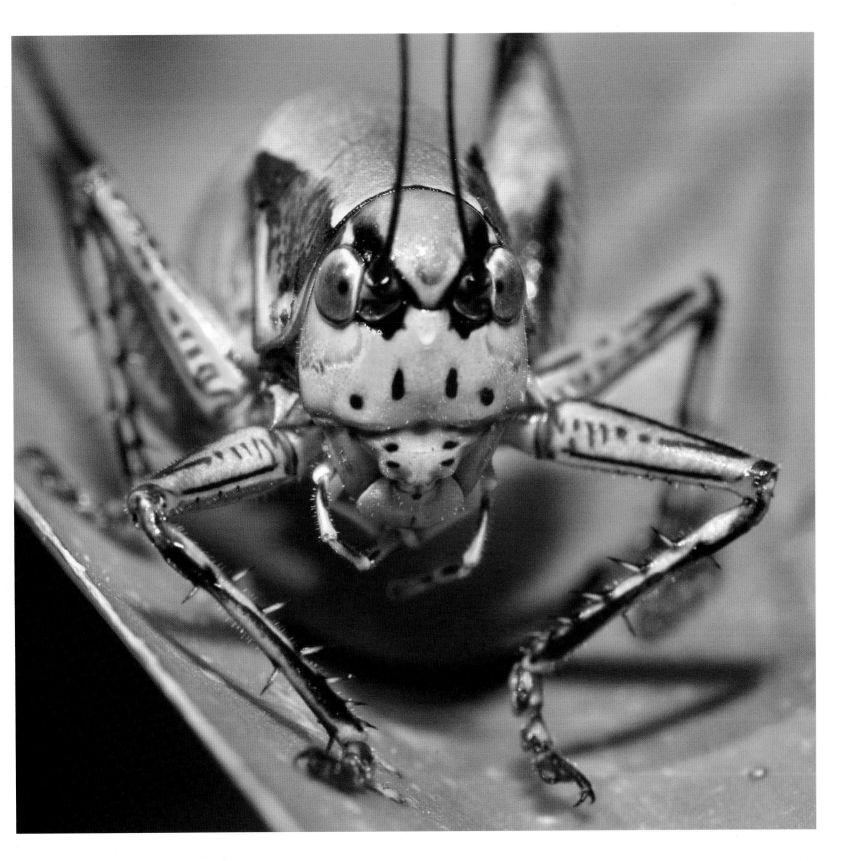

For anyone doing a lot of close-up photography, a macro lens is essential for convenience and image quality. The term macro implies a reproduction ratio of 1:1 or greater. This is a measure of the size of the subject in relation to the size it appears on the image sensor. Thus when using a true macro lens and getting in as close as you can to photograph a fly, the fly would be projected onto the sensor at its "actual size" or larger. For extreme magnifications, specialist lenses can offer higher ratios such as 5:1, although focusing becomes even more critical and auxiliary lighting is often required.

Longer focal lengths are useful for creatures that are disturbed if you try to get too close. For larger "reactive" insects, such as butterflies, a regular telephoto lens may be ideal, but you could consider adding an extension tube to enable it to focus a little closer for frame-filling shots.

One of the challenges faced in this type of photography is ensuring an adequate depth of field. However, avoid using the smallest apertures offered by your lens (usually f/22–f/32), as diffraction means these settings are prone to softening focus.

When you are using a small aperture, a tripod is essential. Using a remote shutter release (or your camera's self timer with static subjects) will also help ensure pin-sharp results.

However, there are times when you will have to prioritize a faster shutter speed, rather than the aperture. Insect movement is very fast and even a stationary insect may end up blurred due to tiny, almost imperceptible movements. For example, a butterfly feeding may be moving its proboscis quite rapidly or quiver its wings.

Tips

Beware of any movement and vibrations that might frighten your subject off—even small movements of your hands and fingers adjusting the camera and lens. Also beware of your shadow moving over your subject if the sun is behind you.

Your point of focus is particularly important in close-up work. Focusing manually will often give you more precision. You can also check focus using Live View mode and zooming in to check it on the LCD screen. On some models you can use your depth of field preview button in this mode to check on this too.

With static subjects, you can increase the amount of the subject that is in focus by using focus-stacking. Here, multiple images are taken from the same place with slightly different points of focus. Software then selects the sharp parts from each of the images and blends them together. Make sure you take plenty of images and that the area of focus overlaps between them, otherwise there will be obvious patches within the image that are soft.

Above: An orb web spider clinging to the undersurface of its dense web could easily be overlooked if you aren't in the habit of actively searching for such gems.

Focal length: 168mm (macro)

Aperture: f/9

Shutter speed: 1/160 sec.

ISO: 400

Right & Far Right: If your subject matter all lies in the same plane you can render it all in focus with a relatively large aperture, as I have done in these two examples.

Right:	**Far Right:**
Focal length: 168mm (macro)	Focal length: 168mm (macro)
Aperture: f/13	Aperture: f/3.2
Shutter speed: 1/60 sec.	Shutter speed: 1/3200 sec.
ISO: 100	ISO: 500

Supplementary Lighting

Supplementary lighting can be invaluable in close-up work, particularly if you need to handhold the camera while using a smaller aperture. One potential drawback is that flash may turn the background black due to the fall-off of the light. It may be necessary to use a second flash to add some light to the background, or to use an artificial background closer to the subject to avoid this.

If you are striving for a natural look, be careful not to make it obvious that flash has been used. It is often better to rely on a tripod and slower shutter speed (if the subject is relatively still) and use flash to fill in any heavy shadows.

Built-in camera flash is not ideal for close-up work, as it tends to be too harsh and the lens is likely to block part of its course toward the subject matter. Placing your lighting away from the camera also gives you more scope to play with the angle of lighting for the effect you desire. Ring flash and twin flash units are excellent options for close-up work.

Right: Sometimes, rendering the background black may help to focus attention on the form and shapes of the subject, as with this praying mantis cleaning its talons.

Focal length: 105mm (macro)

Aperture: f/14

Shutter speed: 1/125 sec.

ISO: 200

Right: Usually, a more subtle use of flash works best,
balancing it to some degree with the ambient light,
as with this spider preparing to devour a damselfly.

Focal length: 168mm (macro)

Aperture: f/9

Shutter speed: 1/80 sec.

ISO: 200

Chapter 7
Postproduction

In wildlife photography you will generally be trying to reflect the beauties of the natural world as they are, so your postproduction work will be minimal. Those familiar with the wildlife in your images will know if you have over-worked the colors, for example, so you must be careful not to overdo the saturation, vibrance, and contrast in particular.

However, some processing is essential if you want to achieve an accurate representation of your perception of the scene that was before you at the moment of exposure. This is partly because our eyes and brain do not work like cameras. In general, though, the processing that you perform will tend to be restricted to subtle measures, as outlined in this chapter.

Right: I spent some time watching these two bull elephants standing beside a waterhole in Namibia and came away with a stack of images. The subsequent postproduction work was minimal, but also essential in bringing out the best in the image.

Focal length: 800mm

Aperture: f/4

Shutter speed: 1/3200 sec.

ISO: 125

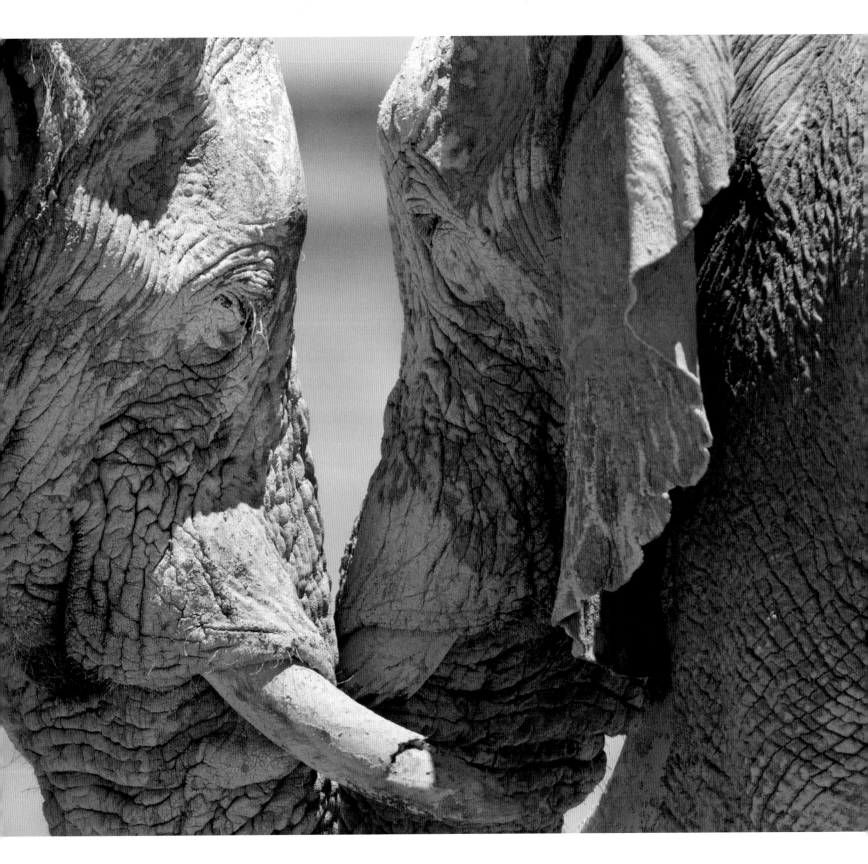

Getting Started

Having downloaded your images to your computer, one of your first challenges is deciding which images to delete and which to work on. You may have a variety of intended uses, so a well-structured filing system will be essential. For example, some photographs may be strong enough to consider entering in competitions, whereas others may simply work well as part of a slideshow for friends. There may also be commercial considerations if you are making selections for stock agencies, calendar companies, or magazine submissions.

Regardless of the end use, judging your own work requires an independent mindset, so the opinion of third parties is often valuable. As the photographer, you might be blind to an image's weakness because it took a lot of hard work to capture it or because it was part of a memorable experience. The passage of time often helps us to become more objective, so it can be a good policy to wait and look through your images a week or more after they were captured. When you are unsure whether a photograph really works or not, or about how you might treat it, it is best to keep the image as a Raw file. In the future, you may see something extra in it, or have learned new editing skills that can enable you to realize its full potential.

When it comes to editing your pictures, it is generally recommended that you set your Raw converter to output the files as 16-bit TIFF files. Adobe RGB is the color space used most widely in the industry—by picture libraries and publications, for example—while sRGB is a smaller space that is adequate for web publication.

Once you have processed the Raw image, it is advisable to store your best images as 16-bit TIFF files. For less valued images (or ones that you are unlikely to want to return to) you can halve the file size by converting them to 8-bits per channel, and perhaps save even more space on your hard drive by saving them as JPEGs.

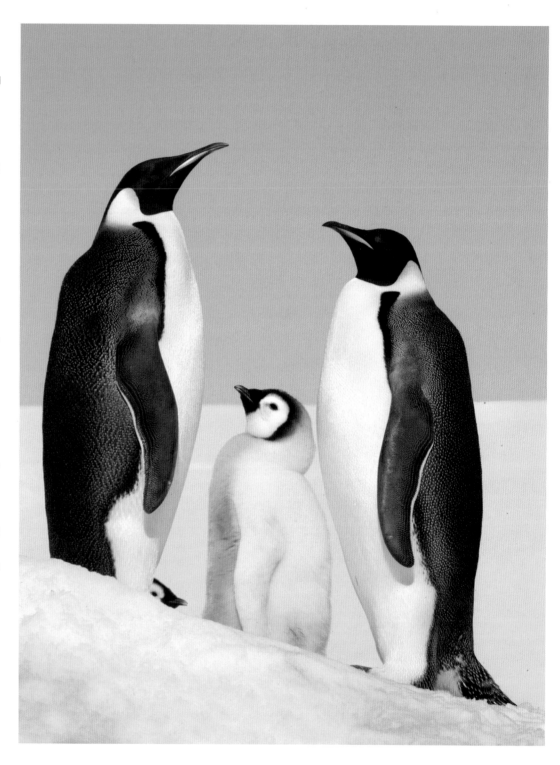

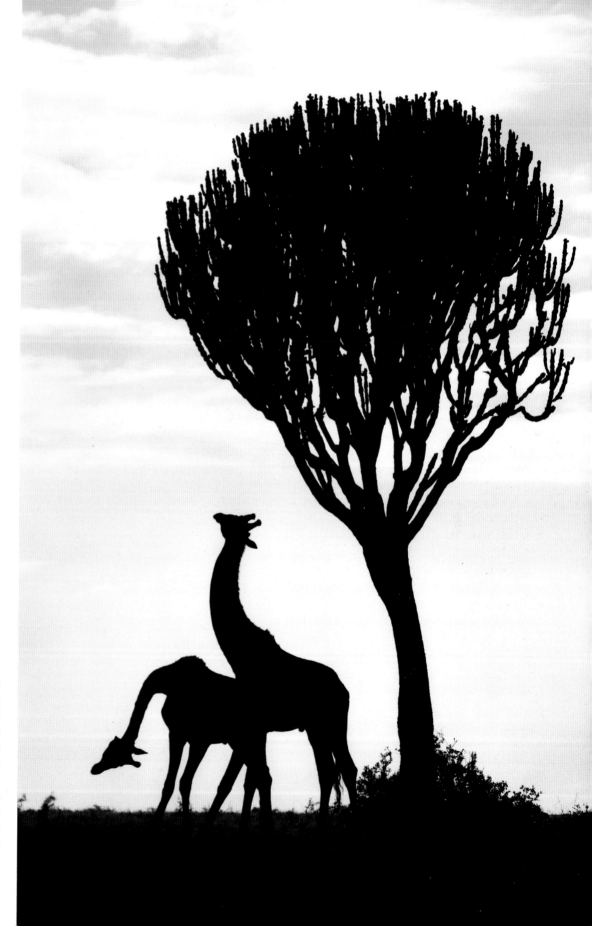

Left: This type of image is always likely to sell well for calendars and cards: it's colorful, simple, well-balanced, and emotive.

Focal length: 250mm

Aperture: f/18

Shutter speed: 1/1000 sec.

ISO: 400

Right: With experience, you often come to envisage the processing you are likely to apply to an image at the time you capture it. The outlines of the necking giraffes and euphorbia tree were what this image was about, so pretty much all detail has been removed from the darker areas through Levels adjustments. The monochrome conversion serves to further emphasize the shapes.

Focal length: 260mm

Aperture: f/8

Shutter speed: 1/1600 sec.

ISO: 160

Localized Tone & Contrast Adjustments

BEFORE

AFTER

Apart from a few adjustments made during the Raw conversion process, I rarely apply the adjustments I make in Photoshop to an entire image. This includes changes to tone and contrast, which will often result in parts of the image becoming too light or too dark (or oversaturated) if the changes are applied to the whole image.

Most image-editing software has some facility for applying adjustments to select areas: in Lightroom the Adjustment brushes can be used, while Photoshop lets you use adjustment layers in conjunction with layer masks. The examples I will be showing in this chapter are worked in Adobe Camera Raw (ACR) and Photoshop, but most image-editing software has similar tools and features, although they may go by another name or work in a slightly different way.

This image of a herring gull landing on a lake was taken early one morning with the low sun illuminating the underside of the bird. Just a small tonal and contrast adjustment was required to further isolate the bird, enabling us to enjoy its poise, form, and texture.

1 Having processed your Raw file, open it in Photoshop and create a new Levels adjustment layer (1). In this example, the black point slider was brought in (2) to clip the black tones and lose all the detail in the darkest areas (in this case the background). However, this may mean that parts of the subject are also over-darkened, in which case you need to "undo" the adjustment in these areas using the mask attached to the layer. To achieve this, select your subject (in this instance I used the Magic Wand tool to make my selection) and click on the mask in the Layers palette (3). You can then use the Brush tool with the foreground color set to black to paint out the mask and undo the Levels adjustment.

2 To adjust the contrast, create a Curves adjustment layer (4). In the Curves panel (5), click on the "hand" icon. This will allow you to pick a tone somewhere in the image and drag your cursor up to brighten it or down to darken it. For this image, I chose a bright area of feathers (6) and clicked to fix this tone, so that it wouldn't be altered by any subsequent adjustments of the curve. If I didn't do that, I would risk "blowing" the highlights.

I then clicked on a slightly darker area of feathers (7). This time, I dragged the cursor slightly downward to darken these tones. In effect, this raises the contrast between the two selected tones, making the feather texture more evident.

3 Again, certain parts of your subject might become a little too dark at this stage. These will typically be the same areas that were adversely affected by the Levels adjustment, so you can usually use the same mask. To copy a layer mask, hold down the Alt key and click on the mask (8). Holding the mouse button down, drag the layer mask onto the layer you want to apply it to. When asked, choose to Replace the current layer mask.

4 All that remained with this shot was to clone out the reflection (which I found a little distracting) and the photograph was finished.

Dodging & Burning

BEFORE

The terms "dodging" and "burning" come from the traditional darkroom processes of exposing parts of the photographic paper being printed on for less time to lighten them (dodging) or for more time to darken them (burning). There are various ways to do this with digital processing, but most image-editing programs offer Dodge and Burn tools.

This graphic image of the shadow of a green bush cricket, seen through a palm frond, serves as an example of a situation in which you might use the Burn tool to selectively darken the darker tones to help the subject stand out.

AFTER

1 Open your image and make any general changes that are needed, such as exposure and contrast adjustments. When you are ready to burn your image, create a new overlay layer by holding down the Alt key and clicking on the Create New Layer icon (1). Name the new layer Burn (2), set the blending mode to Overlay, and check Fill with overlay-neutral color (50% gray).

2 Select the Burn tool from the toolbar (3). In the tool options at the top of the screen set Range to Shadows and Exposure to 5%. This will ensure that the Burn tool only affects the darker tones in the image, and the effect can be built up gently—in this example I used 5–10 strokes of the Burn tool over the insect's shadow to subtly darken it.

3 Working on the same layer, set the foreground color to black and select the Brush tool (4). This will also allow you to darken the brighter parts of your image, but unlike the Burn tool it affects all tones equally. This is argued to be a less destructive way of lightening or darkening parts of an image than the Burn and Dodge tools. (The process is the same if you want to lighten parts of the image, but you would need to set the foreground color to white, rather than black.)

So the effect of each brush stroke is not too radical, set the Mode to Normal and the Opacity to 5–10% in the tool options (5). You can now paint onto the image to selectively darken parts of it. Because you're working on a separate layer you can use the Erase tool to erase any mistakes, or you can paint over them with 50% gray, or add a layer mask and paint using black to remove them.

Revealing Detail

With most photographs, you will often want to show detail in the brightest parts of your subject, as well as the darker, shadow areas. The best starting point for this is to get the exposure right, as this will make it easier to reveal additional detail during the Raw conversion process.

However, if you apply your detail recovery to the entire image it will almost certainly not produce the best results, as the more neutral tones in the image can be adversely affected. Instead, perform the Raw conversion twice, setting the exposure of each conversion for the different parts of the subject (highlights and shadows). You can then combine the best parts of each exposure to produce the final image.

This image of a black-and-white colobus monkey with its infant is a good example of where a "dual processing" approach can be useful—part of the white fur is lit by the sun, but the infant's black face is in shadow.

1 To start with, open your Raw converter and process the image to retain detail in the lightest areas. In Adobe Camera Raw the Exposure, Whites, and Highlights tools will help you create a highlight-optimized version, which should then be saved.

2 Re-open the Raw image and create another version that is biased toward the shadow areas. In ACR you can do this using the Exposure, Blacks, and Shadows tools. This shadow-optimized version should be saved with a different file name.

3 Open both of your images in Photoshop and select the Move tool (1). Hold down the Shift key and drag the darker version of your image onto the lighter one. This will copy the darker version as a new layer, while ensuring that the two images (light and dark) are aligned perfectly. Add a mask to the dark image layer

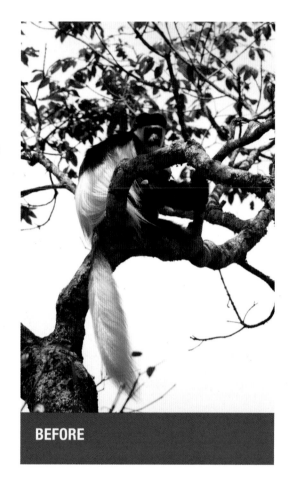

BEFORE

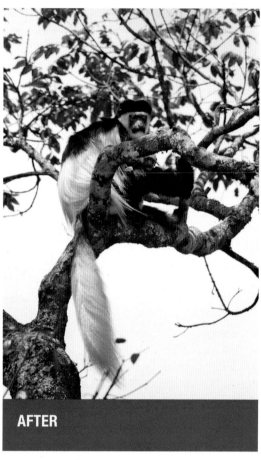

AFTER

by clicking on the New Layer Mask icon at the bottom of the Layers palette (2).

4 The next step is to isolate any areas that you want to "protect" in the darkened image. In this instance I wanted to keep the sky from the darkened image, so I selected the monkeys and tree so that only those areas would be affected by the changes I made. How you make your selection will depend on your image—here I used the Magic Wand tool (3) to select the sky, then chose Select > Inverse to reverse the selection. To ensure the selection wasn't too hard I then chose Select > Modify > Contract, setting the amount to 2

pixels, then chose Select > Modify > Feather (4), again setting 2 pixels.

5 Select the Brush tool and set its Opacity to 30% with a low Hardness value (5). With the foreground color set to black (6), you can paint over the selected areas of the dark image to mask them and reveal the lighter version on the layer beneath (7). Using repeated brush strokes and varying the size of the brush will give you more control over the result, allowing you to "build up" the mask. Any areas that are over-lightened can be corrected by setting the foreground color to white and selectively "erasing" the mask.

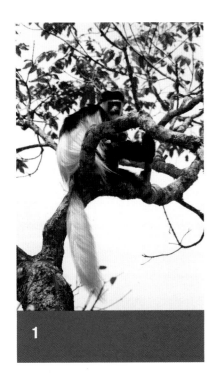

1

3 & 4

2

5

Blurring Backgrounds

In many situations you will want to blur the background in a shot to prevent distant objects from being a distraction. The best way to do this is to use a wide aperture when you shoot, but this isn't always possible—you may not be using a "fast" lens, for example, or you may want to use a smaller aperture to keep detail in the middle distance. In either case, you can blur the background further during postproduction.

In this example, the reeds beyond the European otter are fairly blurred, but they still draw the eye a little; additional blur will knock them back.

BEFORE

AFTER

1 To create the background blur you need to create a second, blurred version of your image to lay on top of the original. However, if you blur the image as it is you will find that the blurred edges of your subject will extend into the background area of your finished image, creating an unnatural halo. So, the first thing to do is to extend the background "into" your subject. To do this, duplicate your image so you are working on a copy. Select the Clone tool (1), and set a low Hardness (2), and 100% opacity (3). Then, clone the background so that it covers the edges of your subject (4).

2 Open the original version of your image, select the Move tool, and hold down the Shift key while you drag the altered version onto the original. Click on the altered image's layer and select Filter > Blur > Gaussian Blur from the top menu bar. In this instance a Radius of 30 pixels seemed appropriate—it's important not to overdo it if you want the blur in the final image to be plausible (5).

3 To refine the edges of the blur, click on the eye icon in the Layers palette to make your blurred top layer invisible (6). Select the Background layer and make a selection around your subject. Zoom in and try to be as precise as possible—keeping details such as individual hairs or whiskers sharp against a blurred background will enable your work to withstand close scrutiny (7). You can add to a selection with further selections by holding down the Shift key, or subtract areas from it by holding down the Alt key.

4 Make the upper blurred layer visible again and click on it so that it's the layer you're working on. Deactivate your selection (Select > Deselect) and create a new layer mask (8). Choose Select > Reselect from the main menu to apply your previous selection to the mask. Again, if your image is to withstand close examination, it is important to get the transition from sharp to blurred in the right place and appropriately graduated, so contract or expand the selection and feather its edges appropriately.

Here, I contracted the selection and feathered it by 3 pixels as I painted with a black brush around the top of the head of the otter (9). I then increased this to 6 pixels along the margins of the tree, as these were partially blurred and a sharp transition would have looked unnatural. Finally, I removed the selection, zoomed in, and carefully painted around the edges of the eyebrow hairs using a harder-edged brush.

1

2 & 3

4

Sharpening

Virtually all digital images need some degree of sharpening. If you are shooting Raw you can add a tiny bit at the outset during the conversion process (the default Raw settings usually encompass this), but any further sharpening should be left until you are outputting your image file in some way.

This is because the amount of sharpening depends on the end use—whether it is to be displayed as a print or digitally as a projected image or online. You may also need to sharpen a little more for printing to matt papers than you would for glossy papers, and sharpen more for a larger print than a smaller one.

As with the previous projects, apply sharpening selectively to the critical areas of the subject, and not to the backgrounds. This will avoid the risk of over-sharpening areas that don't need it, which will degrade image quality. This example shows how I sharpened this image of a common green water snake to prepare an A3-sized print.

1 If you've been working with multiple layers, flatten the image down. Then, duplicate your new Background layer by dragging it to the Create a New Layer icon in the Layers palette.

2 Zoom in to 100% so you can view where the sharpening is most critical and select Filter > Sharpen > Unsharp Mask. Set the Radius slider (1) to 1.0 as a starting point—the Radius determines the size of the area to be affected either side of any edges. Images with fine detail (feathers, fur, and so on) tend to warrant a smaller Radius setting, often as low as 0.4–1.0 pixels, while images with low detail may require a Radius of 2.0–3.0 pixels. Smaller files that are going to be used online also tend to require lower settings.

3 Increase the Amount (2), monitoring its effect on the image. This affects the amount of enhancement of edge contrast (the "sharpening" effect). The Radius slider can then be adjusted again to find its optimal position. In most situations these are the only two sliders you will need to adjust. In this case I opted for a Radius of 2.4 and an Amount of 143%.

4 The Threshold slider (3) dictates how much contrast must exist between neighboring pixels for them to be considered an "edge" (and therefore sharpened). Increasing Threshold limits the sharpening to more obvious edges, which enables you to retain smooth textures in more tonally uniform areas of the image. Here I set Threshold to 7 to prevent the scales from appearing too speckled. Moving one slider may mean you need to readjust one of the others, so play around. However, be aware that sharpening is often overdone. Raise the Amount slider only to where the effect appears to be "enough"—this is usually below 150%.

5 Once you have applied your sharpening you can add a layer mask (4) and use it to undo the sharpening in areas where it is too intense or simply not needed. Check particularly along high-contrast borders where overdoing things will leave an unsightly light fringe or halo. Silhouettes are particularly prone to this.

6 Finally, be sure to save your sharpened image using the Save As option so that you don't overwrite the original unsharpened version as your source image.

3 & 4

5

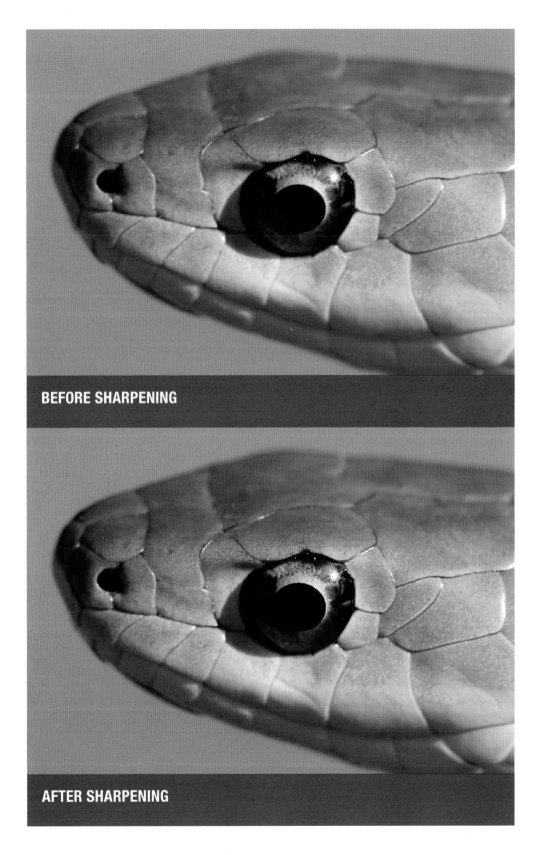

BEFORE SHARPENING

AFTER SHARPENING

Glossary

Aberration An imperfection in the image caused by imperfections in the optics of the lens.

Aperture The opening in a lens through which light passes to expose the image sensor. The size of the aperture is denoted by f/numbers.

Autofocus (AF) A through-the-lens focusing system whereby focusing is achieved through activation of an electronic system in the camera rather than manually adjusting the lens.

Bait Food or water used to lure an animal to a required place.

Buffer The in-camera memory that temporarily stores image data as it is processed and written to the memory card.

Burning This term originated as a description of a darkroom process whereby a portion of the photographic paper is exposed to light from the enlarger for longer, resulting in a darkening of that part of the image. The term is still used when digital images are manipulated to darken parts of the image.

Chromatic aberration *See Fringing.*

Color space A color space is a way of numerically coding colors in terms of qualities such as lightness, saturation, and hue. Color spaces, such as Adobe RGB or sRGB, are device-independent and determine the color range you can work in. They enable you to edit images in a controlled, predictable manner.

Contrast This is a description of the extent to which adjacent areas of an image differ in brightness. It reflects the gradation between the highest and lowest luminance values.

Crop factor A numerical description of the magnification effect produced by using a camera with a smaller sensor than the "full-frame" standard with a particular lens.

Cropping To select and isolate a part of an image with the aim of improving composition or fitting an image to the available space.

Curves The "Curves" tool is an image-editing tool that is widely used to make contrast adjustments.

Depth of field The distance extending in front of and beyond the point of focus that is also perceived as being acceptably sharp. If an object is placed within this zone it will appear to be in focus.

Distortion This is when the picture plane is unevenly stretched or compressed from side to side or top to bottom. It is usually evident when what should be straight lines are not rendered perfectly straight in a photograph.

Dodging The opposite to burning, where a portion of the image is lightened.

Dynamic range The range of tones that can be registered as different tones by the camera sensor. A camera with a larger dynamic range will reveal more variation of tone—and therefore detail—in the brightest and darkest areas of the image.

Exposure The amount of light allowed to strike the image sensor when taking the photograph. This is controlled by altering the aperture size, the exposure time (shutter speed), and the sensitivity of the sensor (ISO). An exposure is also a term used for the process of taking a photograph.

Filter A piece of colored or coated glass or plastic that is placed on the front or within the lens for creative or corrective reasons.

Focal length The distance from the optical center of a lens to its focal point.

Fringing When chromatic aberration manifests as colored fringes along the boundaries between light and dark parts of an image. It is due to the lens failing to focus differing wavelengths of light from the same source point to the same common point on the camera sensor.

Hide (also Blind) Camouflaged barrier or cover behind or within which a photographer can work without being noticed by their subject.

Histogram A graph that reveals the number of pixels registering the various tones from white to black. It forms an illustration of the distribution of tones within the image.

Hue The attribute of color that enables it to be classed as red, green, blue, yellow, or purple. This is related to its spectral position.

JPEG (Joint Photographic Experts Group) A widely used image file type involving some degree of compression to reduce file size.

Layers In image editing, layers are like sheets of stacked glass. You can see through transparent areas to layers below and move one with its content relative to the ones below or change its opacity to make its content partially visible. Using adjustment layers means that tonal and color adjustments can be applied to that layer without actually changing the pixel values of the background layer below. This means that it can be easily removed or modified. Modification is often performed using a Mask.

LCD (Liquid Crystal Display) The screen on the back of a camera on which images and shooting information can be played back and reviewed.

Levels An image-editing tool for altering brightness, contrast, tonal range, and color balance.

Mask A layer mask is used to control the transparency of a layer, allowing you to selectively apply layer adjustments to different parts of the image, and to varying degrees.

Memory card A removable data storage device for digital cameras.

Monochrome A term for an image comprised only of variations of one tone (usually gray tones, when it equates to "black and white").

Negative space An "inactive" area of an image that is empty or doesn't contain subject matter. It is often used as a relative term, compared to the "positive space" that contains the subject matter and elements key to the composition of the image.

Noise Interference caused by stray electrical signals adversely affecting picture quality. Usually visible as colored spots and speckling.

Pixel Abbreviation of "picture element." Pixels are the smallest distinct bits of information that combine to form a digital image.

Prime lens A lens with a fixed focal length.

Raw A versatile and widely used digital file format in which shooting parameters are attached to the file, not applied to it.

Resolution The number of pixels used to either capture or display an image, usually expressed in pixels per inch. The higher the resolution, the finer the detail in the image.

Saturation A description of the purity of a color and thus to some degree its intensity.

SLR (Single Lens Reflex) A camera type that allows the user to view the scene through the lens using a mirror that directs the light to the viewfinder.

TIFF (Tagged Image File Format) A file format supported by virtually all image-editing applications. Unlike JPEGs, the files are not compressed.

Tone The lightness or darkness of a part of an image. In the context of color it describes the shade of that color, which is the quality of that color that varies according to the amount of white or black mixed in with it.

TTL (Through The Lens) metering A metering system built into the camera that measures light passing through the lens at the time of shooting.

Vibrance In image-editing software this refers to the degree of saturation of less-saturated colors. By raising the vibrance you raise the saturation of the paler colors without affecting the bolder, already-saturated colors in the image.

Vignetting Darkening of the corners of an image, due to an obstruction (usually caused by a filter or lens hood) or the optical quality of a lens. It is sometimes added artificially during postproduction to focus attention on the central part of the image.

Visual weight A term used to describe the tendency an element in a picture has to draw the viewer's attention. It can also be used to describe the impression of actual weight that a pictorial element has.

White balance A function that allows the correct color balance to be recorded for any given lighting situation and applied to the image.

Zoom lens A lens that offers a range of focal lengths.

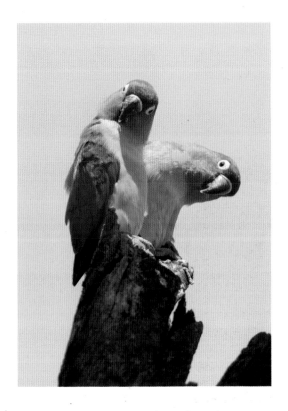

Above: Capturing the moment also applies to those transient nuances of expression that can make a photograph. Here I managed to capture a fleeting humorous look of intense curiosity in this pair of Fischer's Lovebirds.

Focal length: 1120mm

Aperture: f/7.1

Shutter speed: 1/320 sec.

ISO: 200

Useful Web Sites

Photographers

Richard Garvey-Williams www.richardgarveywilliams.com
Chris Marsham www.chrismarshamphotography.co.uk

General

Digital Photography Review www.dpreview.com
DxO Mark www.dxomark.com
Digital Photography www.digital-photography.org

Photographic Equipment

Bushnell www.bushnell.com and www.natureviewcam.com
Canon www.canon.com
Formatt-Hitech www.formatt-hitech.com
FujiFilm www.fujifilm.com
Hoya Filters www.hoyafilter.com
Lee Filters www.leefilters.com
Leica www.leica-camera.com
Manfrotto www.manfrotto.com
Nikon www.nikon.com
Olympus www.olympus-global.com
Panasonic www.panasonic.net
Pelican cases www.pelican.com
Ricoh/Pentax www.ricoh-imaging.com
Sigma www.sigma-photo.com
Sony www.sony.com
Tamron www.tamron.com
3 Legged Thing www.3leggedthing.com
Tokina www.tokinalens.com
Wildlife Watching Supplies www.wildlifewatchingsupplies.co.uk
Zeiss www.zeiss.com

Software

Adobe www.adobe.com
DoF Master www.dofmaster.com
ExpoImaging www.expoimaging.com
Nik www.google.com/nikcollection
The Photographer's Ephemeris www.photoephemeris.com

Wildlife and the Law

BirdLife International www.birdlife.net
Royal Society for the Protection of Birds www.rspb.org.uk
US Fish & Wildlife Service www.fws.gov
The Wildlife Trusts www.wildlifetrusts.org

Parks and Reserves

US National Park Service www.nps.gov
Wildfowl & Wetland Trust www.wwt.org.uk

Photography Publications

AE Publications www.ammonitepress.com
Black & White Photography magazine
Outdoor Photography magazine
www.thegmcgroup.com

Photography Centers

Westcountry Wildlife Photography Centre, UK (see page 114)
www.wcwpc.co.uk

Index

I hope that what has been covered in these pages will help you take your photography to another level. I've stressed the importance of constantly returning to the fundamentals if you intend to consistently produce captivating images. Hopefully, as you peer through the viewfinder, you will now also be asking yourself a few more questions before your finger reaches for the shutter-release button.

Many of the skills required for wildlife photography involve a degree of manual dexterity and coordination so, as with performance in sport, they require regular and persistent practice. It's no good just reading about panning, for example—it's better to get out there and practice the techniques with a well-trained dog fetching a ball. I hope that this book will inspire you to enjoy some experimentation.

I apologize in advance for any errors in identification of the subject matter depicted—I tend to concentrate on my photography in the field and often only come to identification when the photographs are downloaded. Please contact me to put me straight on any errors that you spot!

Richard Garvey-Williams

Acknowledgments

I would like to express here my deep gratitude to Chris Marsham for contributing his wonderful images from Antarctica and South Georgia, and to Spike Piddock, an active member of the Dorchester Camera Club and British Society of Underwater Photographers.

I would also like to express my appreciation of the editing skills of Chris Gatcum and design talents of Robin Shields at Ammonite Press.

AMMONITE PRESS

To place an order, or request a catalog, contact:
Ammonite Press
AE Publications Ltd, 166 High Street, Lewes, East Sussex, BN7 1XU, United Kingdom
Tel: +44 (0)1273 488006
www.ammonitepress.com